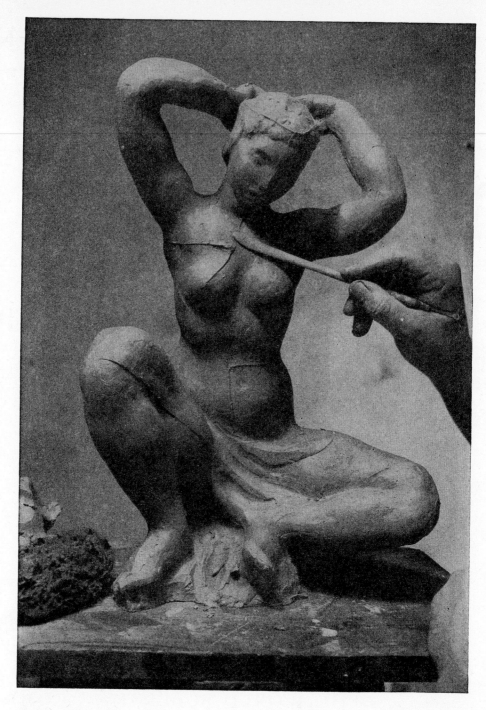

Bathsheba. LOUIS SLOBODKIN. One stage in terra cotta. Removing seams from piece-mold squeeze in preparation for kiln firing.

LOUIS SLOBODKIN

Sculpture

PRINCIPLES AND PRACTICE

THE WORLD PUBLISHING COMPANY

CLEVELAND AND NEW YORK

2HC1256

COPYRIGHT 1949 BY THE WORLD PUBLISHING COMPANY

ALL RIGHTS RESERVED

DESIGNED BY ABE LERNER AND LOUIS SLOBODKIN

MANUFACTURED IN THE UNITED STATES OF AMERICA

To my dear Mother and Father

WHO PATIENTLY ENCOURAGED MY WORK

FROM THE VERY BEGINNING

Contents

CONTENTS

CONTENTS

Sculpture

PRINCIPLES AND PRACTICE

Introduction

——————————————————

Sᴄᴜʟᴘᴛᴜʀᴇ, like all the creative arts, is mainly a process of transferring into some tangible material seemingly intangible ideas.

The first problem confronting every beginner is where to begin, what to grab hold **of,** where to get it, and how to go about using it after he has got it. In preparing this book I tried to recall what main problems concerned me and my fellow students a long time ago and, as we developed a little more, what new problems came along with our advancing sculpture experience and technique. I know these same problems have always harassed all novice sculptors. I have taken nothing for granted. I assume the reader is seriously concerned with developing his knowledge of sculpture and its techniques. And too, I have assumed my reader is, as I was some thirty years ago, an eager novice willing to begin the long, rather pleasant journey over the technical mountains that separate a sincere desire to understand and make sculpture from the technical competence and "know-how" one must have to realize that desire.

There are no short cuts. No modern helicopters or rocket ships can pop a novice over sculpture's technical mountains. For all the compressed air and electric carving machines that rip through a stone, for all the trick and mechanical devices invented for carving, chipping, casting, polishing materials with which sculpture is made, there are none invented yet which will produce the qualities which we recognize as good sculpture. The machines used for producing those qualities are very old-fashioned (as old as man's spirit) and they exist where they always have been developed and sharpened—in the mind and heart of man.

There are many tangling paths which lead the novice astray and waste his time. Some of those paths come to a dead end in technical labyrinths. I have tried to avoid them and to point out instead the simplest and most direct method.

Conscious of the limitations of the uninformed on materials and implements, I have restricted the tools, materials, and methods I use to demonstrate my arguments throughout this book to those which are easily available.

[15]

There are no tools or materials indicated here which are not within reach of everyone seriously concerned with the art of sculpture.

This book begins with the simplest problems that exist in sculpture and goes on to deal chronologically with the many complexities, both technical and theoretical, which face a developing sculptor. The Start, the Method, and the Direction are stressed; purposely the Finish is discussed but not lingered on. A properly started piece of sculpture, properly developed with the patience and sincere effort the work demands, finishes itself. The most dangerous habit any aspiring sculptor can acquire is to stretch a tinseled surface, a polished finished crust, over his own inexperience and lack of development. That is a habit not easily broken.

I have avoided discussing the once-in-a-lifetime problems or opportunities of sculpture. There are no methods here How (and at the moment I can think of no theories Why) a sculptor should blast, carve, and destroy a mountain to make a monument, or cast a bronze taller than the Statue of Liberty. By the time a sculptor is commissioned to create such colossi he should need no instruction or suggestions from this book or any other. Therefore I have limited my drawings and demonstrations to the normal problems and practices that may confront students and others who have not yet had the opportunity to carry through a sincere desire to create their own sculpture, so that they, too, can enjoy the immense gratification we all sense who work at this form of creative art.

I.

First Sculpture

—————————————————————

THERE are many elements required to do sculpture. The three primaries are Time, Material, and Inclination.

Granting you have the last (inclination) let's get the other two, time and material, and make sculpture. At the art school where I studied sculpture a long time ago there was a saying: "Talks like Michelangelo and works like a clown." So I suggest we leave theories and concern for the many other qualities essential to good sculpture for later consideration. These essential theories will develop as the work progresses.

Perhaps you have already decided on the piece of sculpture you want to do. If it is some flyaway shape with many flags or some too ambitious composition let us leave it for the moment.

If you have had no previous experience, it is preferable to tackle a very simple shape. And after you have had enough experience and understand the qualities that make good sculpture, you might continue to do simple, strong, sculptural shapes and have no desire to create flyaway or complicated, broken-up compositions.

So I repeat: Having the inclination, let us consider the other two primary elements, Time and Material.

TIME

All sculpture requires time. No matter how dexterous the sculptor, no matter how well equipped his studio or how good his material, he must allow plenty of time for creating even a small piece of sculpture. Therefore, put aside a certain part of every day or, if you can, certain days every week which you will devote entirely to sculpture. And do not be impatient if results come slowly.

Pick a place to work (kitchen, bathroom, workshop, garret, garage, barn, or what-have-you) that is well lighted. It is best to work in daylight though not in direct sunlight. A cool north light helps the work. If you must do sculpture in the living room, spread sheets of

[17]

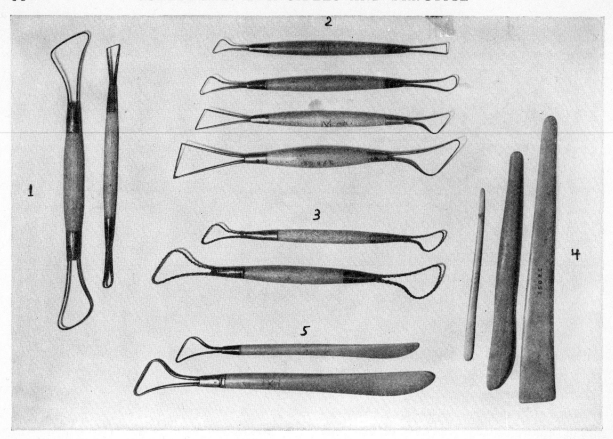

Fig. 1. Modeling Tools

1. Heavy wire end tools—can be used for gouging and plaster carving.
2. Fine wire end tools to be used for clay only.
3. Wire-wrapped wire end tools for pulling together surface.
4. Wood blade tools. Boxwood is best for blade tools. For handles of double wire end tools boxwood is good but not essential. Any close-grained wood may be used.
5. Wood blade and one wire end.

paper over the rugs or furniture near you. Or better yet, if you have a large piece of oilcloth or tarpaulin, spread that on the floor. Sculpture can mess up the house very quickly.

MATERIAL

All sculpture must go through many processes before it reaches its final permanent material, whether it is planned for stone, bronze, plaster, or any other medium. The first sketch of the sculptural idea is usually modeled in clay.

For the inexperienced, I suggest you begin working in *plasteline*. This is a prepared modeling clay that requires no fuss, little care, and almost no inner supports (armatures). Ask for a medium-soft, gray-green plasteline. It is available in all art supply stores and many department stores. Or it can be mailed to you from any art supply company.

Buy at least ten pounds now. While you are getting your plasteline, buy a modeling tool or two. Get at least one blade-shaped tool with a wire end (see *Fig. 1*) and another with two wire ends.

Get a piece of smooth board (pine, preferably) 1 by 12 by 14 inches. Give it a couple coats of shellac.

Work on a solid table—a metal typewriting table, or an oilcloth-covered stool set on a box, or on a couple of boxes set on end and nailed together. A porcelain-topped kitchen table is good.

Swivel-topped modeling stands used by sculptors are expensive when bought readymade and are complicated to build—let's not waste time with them now. Later I will explain how to build a serviceable modeling stand. Meanwhile begin your first piece of sculpture on whatever you have.

Now you have the plasteline. Cut it up and knead it into largish sausage shapes about the size of healthy bananas. Pile them up alongside your modeling table on a piece of oilcloth. Now then, wash your hands and you are ready to make your first piece of sculpture.

SUBJECT

You may already have picked the subject for your first piece. If you have not, here are a few suggestions and if your subject is too far from these ideas, better change it.

The subject must have sculpture possibilities before you try to convert it into sculpture. That is to say, it must have volume, a feeling of weight, simple outlines, and a simple, unified mass. For obvious reasons, smoke, clouds, wispy drapery, or skinny ladies balancing on one twiggy toe do not make good material for sculptural interpretation.

Your first piece of sculpture is to be built with no inner support (armature) so pick a solid unit of shape. Maybe you have seen some husky laborer resting on a park bench after lunch, or a solid young girl sitting quietly on a rock, or a cow munching her cud in the pasture. I have picked these three subjects to demonstrate how I would interpret them in sculpture.

You might find some related subjects. But no matter what you pick be sure the composition has these elements: simplicity, unity, and solidity.

It is a good idea to make a simple drawing of your subject, with no attempt at detail, and refer to it often as you work. *Fig. 2* shows some potential subjects, and drawings which simplify them, for sculptural interpretation.

METHOD

Set your simple drawing where you can see it.

Break small pieces off the clay sausages and build a plinth for your statue. The professional term is *plinth*. A base is the unit of shape on which the completed statue rests. And the base in turn usually rests on a pedestal. Build the plinth about a half inch thick on the shellacked board. It should be roughly in the shape of a flat square, rectangle, or circle—that is decided by the shape of your composition (*Fig. 3*).

Now, bend some of your large clay sausages in the approximate shape of your composition (see *Figs. 5, 8,* and *11*).

Do not stop to indicate any small details but keep building the shape of your composition with smaller pieces of clay in the manner I have shown. Develop all parts of work evenly. Do not try to finish one part at a time. Keep on modeling and developing the general shape of your piece.

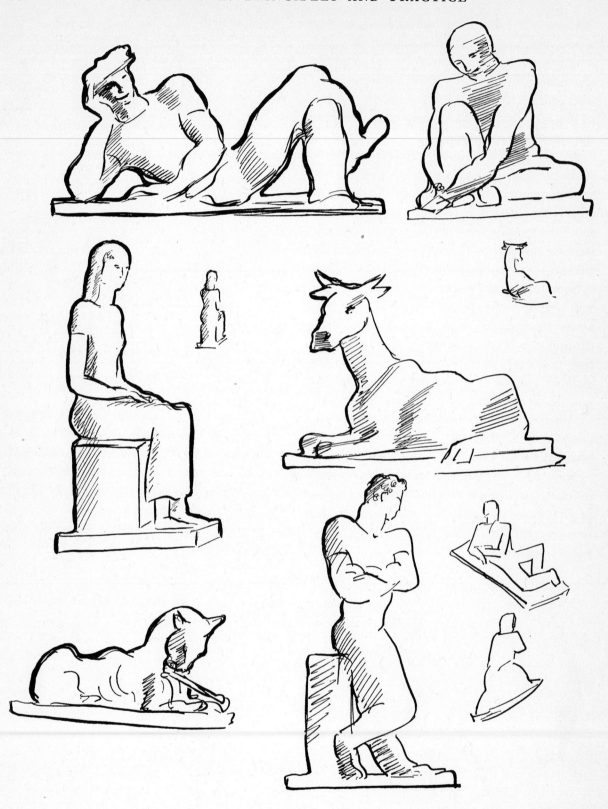

Fig. 2

Here is a good thing to think of as you work. Imagine you see the subject of your sculpture off in the distance (*Fig. 4*). You see the main shapes. They have a certain geometric unity. And that is what you should try to get in sculpture. The details are fused into the main shape or mass.

As you work, always building up your sculpture with little sausages or pellets, do not worry about the cracks between the pieces of clay (plasteline) that you are applying. They will fill up automatically as you work and perfect the shape. Do not try too hard to smooth your work at this stage.

Squint at your work as you model. You will see the shapes better that way. And step away from your work occasionally. Keep turning the board that holds your statue so that you keep developing it all around. Remember you are not working a flat pattern—you are creating an object on three dimensions.

When you have developed your shapes as completely as you can, indicate just a few essential details (see *Figs.* 7 and *10*).

Now your first piece of sculpture is finished in clay. And since I have never known a beginner who did not feel he must preserve his first piece of sculpture for posterity (I know I did)—naturally, you want to cast it in plaster.

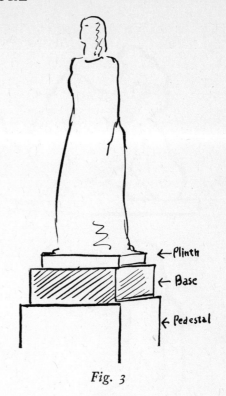

←Plinth

←Base

←Pedestal

Fig. 3

Turn to the chapter on Plaster Casting if you feel you must preserve this piece. I explain there how I cast the finished models. If you do not want to tackle plaster casting just yet, put your model aside. It won't dry up. Or break it up and do another statue.

Practice in handling clay is what you need most right now.

This . . .

. . . becomes this at a distance.

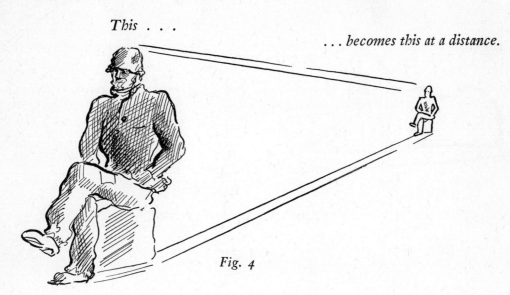

Fig. 4

Fig. 5. Lazy Man

The plinth is prepared on the shellacked board. Large sausages are bent in the approximate shape and movement of the composition. Attach them firmly with smaller pieces of clay pressed between the sausages and the plinth.

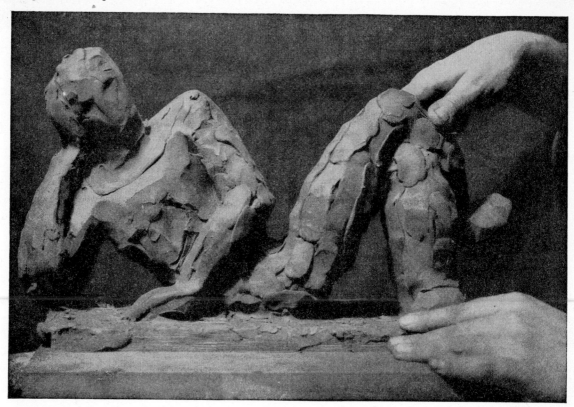

Fig. 6

Smaller pellets of clay are built on the large sausages. Remember—the thumb is the best modeling tool ever made. Use it!

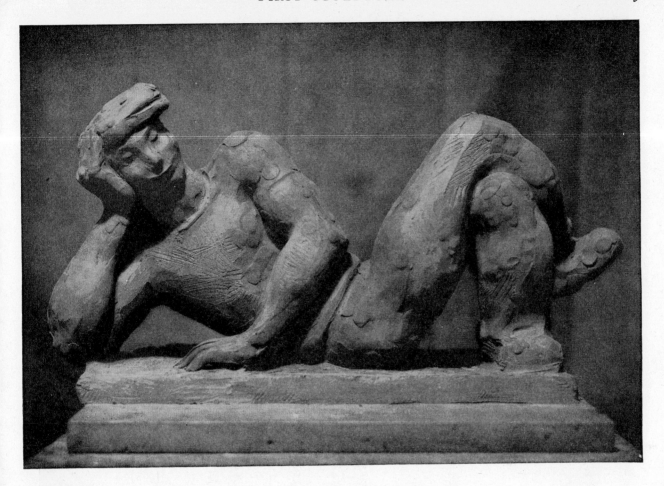

Fig. 7

Quickly roll each piece of clay between thumb and forefinger to a sausage shape (or ball). Apply it where it will do most good. This figure has been built up by large and small sausages and pellets. Tiny pellets, wood modeling tools, and my fingers have indicated the surface detail. Here and there I have used the wire-wrapped tool (the scratching tool) to pull the surface together occasionally, to see more clearly the shape I had modeled. The planes have been made with the same scratching tool, also with the blade of the wooden tool. Here and there I piled more pellets of clay to richen or fatten my surface. I plan to leave the surface of this figure as varied and even as crude as it is now—for I expect (and hope) this surface will look good when it is cast in bronze.

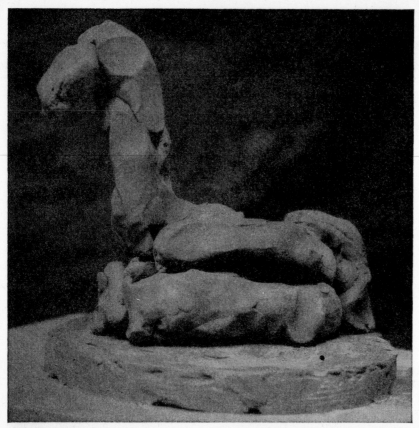

Fig. 8. Curious Cow
Some sausages are made from cows. Here is that idea in reverse. These piled-up sausages on this round plinth will eventually become a cow.

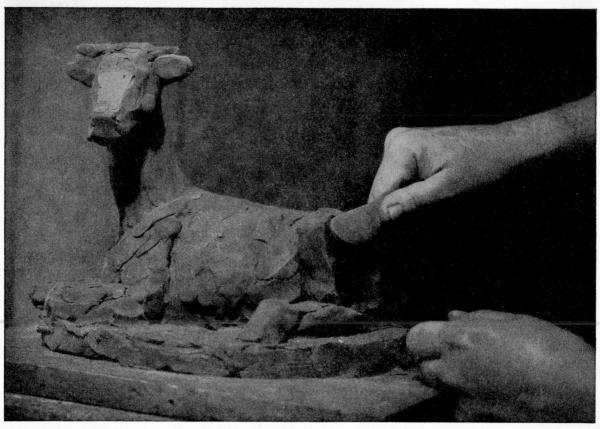

Fig. 9
Again smaller sausages and pellets built up this shape. The blade of the wooden tool is used here to emphasize and develop the planes and angularity of the cow shapes.

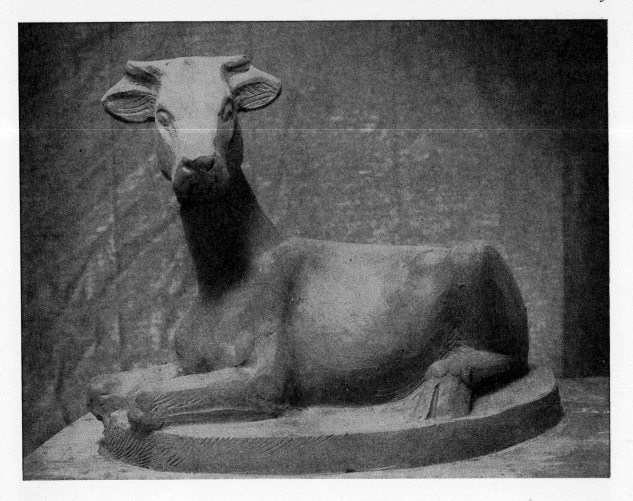

Fig. 10

The surface has been pulled together with cross-hatch scratches of the scratch tool. Then with the unwrapped wire end tool I passed over this surface again. The markings of both tools can be plainly seen in this photograph. Notice that the direction of the tools has gone with the direction of the shape; sometimes across the shape, but rarely. Now and then, the wood blade was used to stiffen the surface of the shape when I felt that was needed. Occasionally, more pellets were added and detail was indicated in the same method as was used in the *Lazy Man* statuette.

Note the ears and horn shapes are fused together to make one shape on each side of the head. That is not natural, but it is better sculpture, less fragile, and it will facilitate the casting of this work.

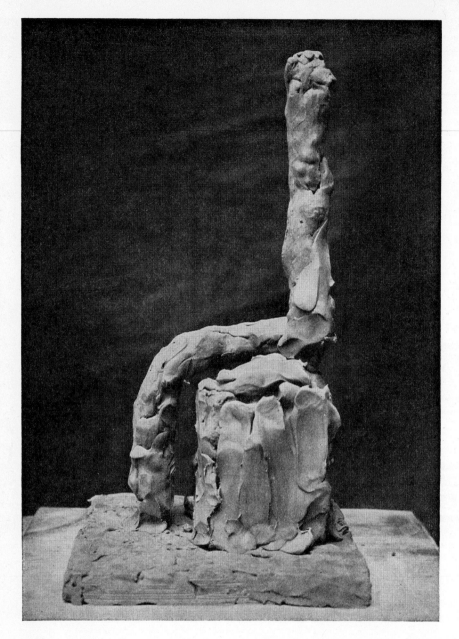

Fig. 11. Girl Sitting on Rock
One need not be limited to reclining shapes in sculpture without
armature. Here is the beginning of an upright shape.

Fig. 12

Here is that scratch tool in operation. This tool can be used for gouging out excess clay, but it is better to use a strong, unwrapped wire tool for that purpose. The thin wires that wrap the scratch tool will wear out quickly. But better than using either tool for gouging is not to gouge at all. I mean by that, if you build your clay up properly in doing a piece of sculpture in the round, you should have very little occasion to gouge into your mass. Try putting your clay in the right places as you build up and you will not have to gouge too much.

Note this is the third sculpture unit. Here again the process is repeated: large sausages, then smaller ones built on, then smaller ones, and yet smaller ones, ad infinitum. You may have begun to suspect that almost all sculpture in clay is built up in that way. And you are absolutely right. It is. Almost all sculpture made in clay (except

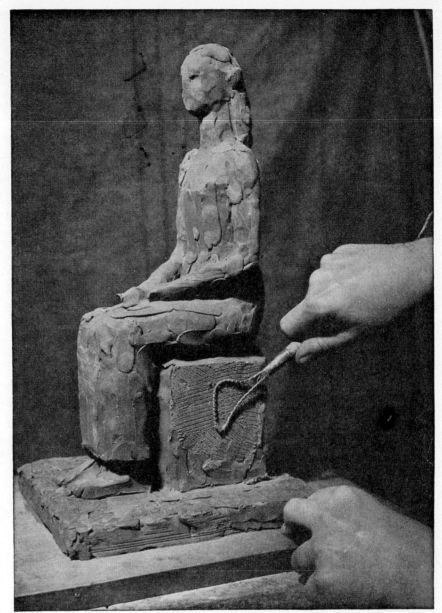

in a few cases which I shall indicate later), from tiny figurines to immense sculpture units prepared for monumental bronze statues and architectural models for colossal stone carvings, are made with this system. Large sausages, then smaller and smaller ones, until the work is done. The difference is in the proportion of the work and the proportion of the sausages used.

BUILDING A SIMPLE MODELING STAND

The sculpture we are going to make from now on is heavier than the little statues you have been working on. I suggest that unless you already have arranged a practical modeling stand, you build one now. Or if you have no facility with a hammer and saw, get some carpenter to build it for you from these diagrams.

A sculptor never has enough stands around the studio, and even if you do suddenly become wealthy and buy a finished modeling stand, you will always find this one handy. You can use it as a pedestal by blocking up the sides with plywood (see *Fig. 13*).

You might as well face it now whether you build this stand or have someone else do it for you. A sculptor must not only be able to model and carve. He must be a passable carpenter and a bit of a plumber. Those last two talents are essential for building the armatures to support your work in clay, preparing bases for your statues, propping up your stone as you carve, casting, etc.

If you do not build this stand yourself, watch carefully the person who does it for you. You might learn something about carpentry—just watching.

Fig. 13 shows the process for building a practical homemade modeling stand.

The lumber used is good finished pine. The method is obvious. Here are a few simple "know-hows" which a rank amateur with hammer and saw might find useful. Cut the appropriate length for the four legs of the stand. Mark out on the floor with a long straight edge the dimensions—lengths and widths—indicated on *Fig. 13*. Lay two legs and cross pieces down on the floor within those marked dimensions. Then mark (with a pencil) the bevels that must be cut on the top and bottom of the legs and on the cross pieces. Now saw along the lines you have marked and then screw or nail the cross pieces and legs together as in I. Then do the same with the other two legs and cross pieces.

On one pair of the legs screw or nail (and I suggest screw) the rest of the cross pieces, as in II.

Then attach the second pair of legs.

III shows the finished stand with top of stand attached and casters screwed into the bottom of the legs. Now give it a coat of paint and the stand is done. Use battleship gray or French gray; they are both serviceable colors for a sculptor's studio. Clay, plaster, and stone dust mix well with the grays.

A. Shows an improvised turntable on the stand. I once salvaged a turntable from a discarded phonograph. Then I drilled a hole into the top of a modeling stand, sunk the axis of the phonograph turntable into it, and now it is a pretty good stand.

B. Shows stand with lengths of plywood cut and nailed to legs. The eaves of the top have been sawed away. With a nice clean coat of paint this becomes a presentable exhibition pedestal for final sculpture.

C. Shows a detail of the stand. You might find this idea useful. Some boards are cut and nailed to the lower cross pieces, making a shelf for tools or clay—it also serves to strengthen the stand.

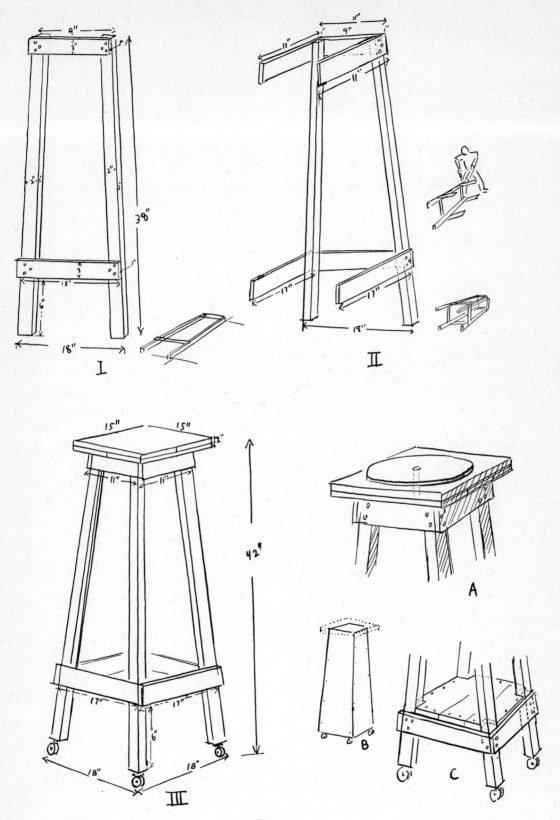

Fig. 13

2.

Modeling a Head from Life

SUBJECT

Jᴀᴍᴇs ᴍᴄɴᴇɪʟʟ ᴡʜɪsᴛʟᴇʀ is not the only artist who did a portrait of his mother. Almost everyone who aspires to be a painter very early in his career attempts a portrait of some member of the family or patient friend. That is true of sculptors too.

But I suggest that, unless your mother is a particularly patient elderly lady, you get your father or some other man to pose for you.

There are many reasons for choosing a masculine head (and one without whiskers) for your first subject. First, a rugged head is easier to do. The shapes and bumps on a man are easier to see. You have something to grab hold of as you model. Smoothfaced ladies or children are as difficult in comparison as trying to find footing on the smooth round shape of a huge boulder instead of the relatively easy scamper over a lumpy hill. Second, you will find a man sitter more patient. Third (and most important), a man sitter is usually less apt to object to the exaggerations and emphasis

on character essential in a portrait head. He will not expect to be prettied up or smoothed over—or he shouldn't.

MATERIALS

It would be best to model this portrait head in wet clay. The clay sculptors use is the same stuff you get out of any clay bank, with little rocks, sand, shells, and debris removed. If you dig up your own clay and can clean it up, fine. If you cannot, prepared modeling clay is available and can be shipped.

You will need about fifty pounds of wet clay to do a portrait head.

Wet clay needs some attention. It should be easily pliable, yet not so soft that it is sticky and clings to your fingers as you work it. If clay is carelessly handled, gets mushy, or is allowed to harden or lump up, it is a very discouraging medium. So let us make some provision to prevent difficulties later.

Prepared clay (the stuff that's delivered to

you ready to work) usually comes in hundred-pound and fifty-pound lots and is shipped in wooden tubs and in cans. Pry the cover off carefully so you will not break the tub. The tub can be used to store your clay as you work. This clay is usually the right consistency for modeling, but if it has dried out a little in shipment, dig deep holes into it with a stick or broom handle. Pour water into the holes, and cover the clay snugly with wet cloths. Let it stand for a few days.

If ever your clay becomes too mushy, dig it out of the tub and pile it on a large, unpainted, unshellacked dry board. Let it stand uncovered for a day or so. Then beat it with a stick, turning it now and then, and knead it the way bakers do dough. When your clay has a smooth, plastic, consistent texture, roll it into loaves (like small loaves of French bread) and pile it back into your container (the tub). Keep your container covered. It is a good idea to always keep your clay covered with a heavy moist cloth. Sprinkle your clay daily to keep it moist.

The same process can be used for the clay you dig up and clean. You will find a large butter tub or galvanized can makes a good container.

ARMATURE FOR HEAD AND NECK

An armature is the supporting structure you must build as a supporting core to almost all wet clay modeling you plan. An armature is necessary, too, for the majority of work you will do in plasteline.

Prepare your armature carefully and avoid the heartbreak that comes when some sculpture you have worked on for weeks collapses or sadly folds over or disintegrates because the armature was poorly fashioned. If the armature is not well considered or is weakly constructed, it might stick out of your sculpture piece and your enthusiasm for sculpture (which I trust you will develop) might receive a setback.

Fig. 27 shows a few simple substantial Head Armatures which can be used more than once.

STRUCTURE OF THE HEAD AND NECK

Before beginning a head from life, it would be best if we came to some understanding on the common structural principles of a head. Not the obvious, anatomical structure, though we shall touch lightly on anatomy too. For in those rare cases when I have seen the anatomical structure of a living head clearly evident through the skin, for example the cadaverous, thin man in the circus or some other sick, wasted person, the effect was ghastly and not at all common.

Then, too, coming to a general conclusion on the primary structure of the head as it is interpreted in sculpture or any other art form, through anatomy alone, is false. Though I grant the majority of human heads have a similar skeleton structure, cranium, jawbone, cheekbone, neck structure, etc., and the usual same number of muscles attached to the skeleton, the function, development, and resulting shape of the muscles vary, to a remarkable degree, with the characters of the individuals. There are laughing people, tearful ones, talkative parrots, silent grumps, thinkers, dullards, gourmets, gluttons. They all use their face muscles in their own particular way and develop accordingly.

Also, fat layers appear under the skin or the flesh sags or tightens, depending upon the

inner person who is pulling those muscles about. The inner man affects the outer one. The spiritual content helps shape the materialistic container. Now then, after that heavy philosophic thought, let us glance quickly at these drawings of the anatomy of a head and go on.

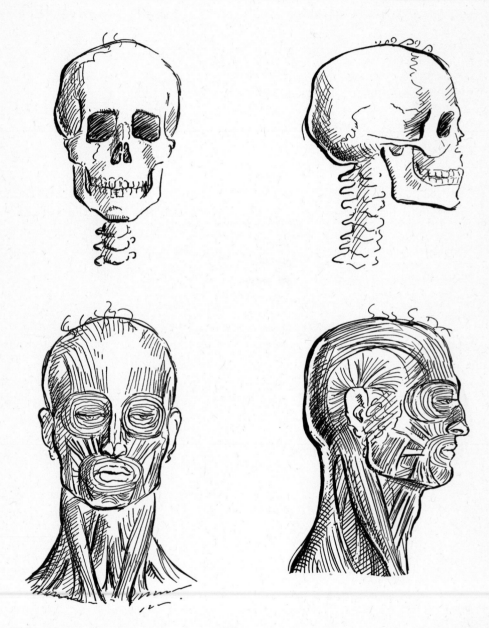

Fig. 14

Here is a simple thought on general head structure. The head and neck are composed of two primary shapes.

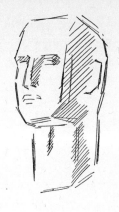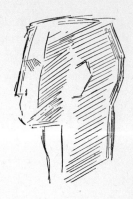

Fig. 17

Fig. 15

In a mature, strong adult that simple principle is most evident. And it weakens at both ends of the age cycle something like this. In fact, this principle does not function in tiny babies or weak old ladies and gentlemen. There, another simple idea on head structure is possible.

Fig. 16

Fig. 17 shows those two primary shapes applied (roughly) to an anatomical interpretation of a head.

METHOD

Here is a quick synopsis of the method—a more detailed explanation follows. (And this method can also be used for modeling a head in plasteline. The process is the same. Just disregard the comments relating to wet clay, etc.)

Granting you now have a solid modeling stand to work on and a strong adequate armature, prepare a pile of sausages of wet clay like those you had for modeling statuettes in the preceding chapter.

Have your subject sit on a high stool or a chair set on a large box, so that his eyes are level with yours. Your armature for the portrait head should be about eye level too.

Your clay is alongside piled up on a convenient stool or box.

Build the mass of your head quickly. Put your clay around the armature, as indicated in *Fig. 28*.

Do not indicate the features of your model or any of the detail yet. Study your subject.

Since all heads (or anything else) take some geometric form, squint as you face your subject. Has he a round-shaped head, a long narrow head, an angular oval, or what?

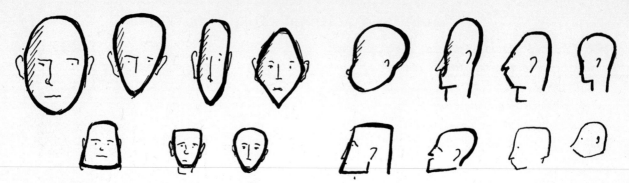

Fig. 18

Build the characteristic shape of your subject. Develop the skull and the neck.

Indicate quickly (for you can change your mind and clay) the placing of the eyes, nose, and mouth on the mask.

Step away from your work often and squint at it and your subject. Do they have the same geometric relation? By that I mean have they a similar geometric shape?

As you work, do not grab at wrinkles or physical blemishes. People do not look the way they do because of little wrinkles and surface lumps. It might be interesting sometime while you are working on this portrait to study, if they are available, photographs of your subject when he was much younger. You will find that though none of the wrinkles and calluses he has collected with age appear in his face, yet he resembles himself. The shape of his face, the general contour of his head, the characteristic forms which make the man look as he does, do not change. If your sculpture is made with that in mind, twenty years from now it will still be a portrait of your subject—and more important, it will be good sculpture.

We have come along far enough to venture our first theory in relation to sculpture. It is a primary theory, and unless it is understood to some degree, we can go no further in your development of sculpture. Of course you can lightly skip over this passage and go on to modeling a head from life, but I advise against it.

THE THEORY OF SHAPE

Time and again throughout this book, with a careless abandon I have tossed about the word "shape." As if everyone knew what "shape" is, as if everyone knew what sculptors mean when they use the word. Let's try to clear that up right now with words and diagrams.

This is the accepted explanation of shape. Shape is the geometric, materialistic limitation of an object. That is to say, the all-over, outer crust of an object determines its shape. Sculptors accept that explanation with reservations. For to them, shape means more than that.

Turn your mind to thoughts about sculpture shape.

Can a hollow unit be a good shape?

Is a cardboard box good sculpture shape?

Why does a cardboard box appear to be what it is, an empty, weightless unit composed of bent surfaces?

Although this box may imitate perfectly a cube of stone with its color, surface-texture, size, it will never satisfy your eye and mind that it has the volume, weight, and solidity of the stone. Why?

Can a hollow shape appear to have weight?

Why does a tube made by bending a sheet of metal look empty and lighter than a rough-surfaced, cast-metal tube?

Why does a machine-turned, high-polished, solid sphere (metal, stone, or wood) look lightweight and thin compared to a crude lump of the same material?

Sculptors speak of "good shape" and "bad shape," "primary shape" and "empty shape."

Good shape and primary shape are the living, growing foundation of fine sculpture, the shapes on which more good shapes may be built or carved. They are essential, well-balanced, and strong.

Bad shapes are sloppy, ill-considered foundations. Bad shapes are either stagnant, stuffed monstrosities or they consist of weightless, frivolous, bent surfaces. Often they seem to be no more than a brittle crust bent around emptiness.

A novice sculptor once told me sadly that he had modeled a portrait head and gone along swimmingly until he began to indicate the eyelids. Then he came a cropper—the eyelids never looked right.

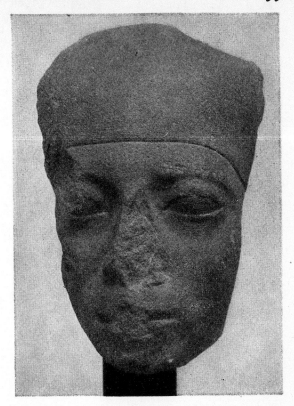

Fig. 20

Egyptian fragment, Middle Kingdom. Brown quartzite. Courtesy Museum of Fine Arts, Boston, Mass.

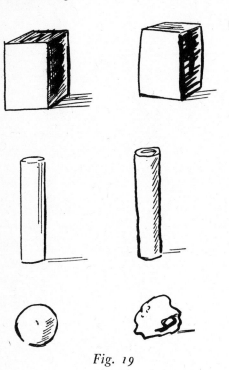

Fig. 19

I have seen (and I am sure you have too) fine sculpture pieces displayed in museums with not only the eyelids ground away by the ravages of time and misfortune but the eyes, nose, lips, ears gone too—even some that were no more than a fragment of a face. Do you think it was the antiquity of the stone or bronze that gave this sculpture piece the honorable place it occupied in the museum? Perhaps in some rare cases that might be true, but more often it was the exquisite beauty of the sculptured piece still retained in the battered, eyeless, noseless, earless fragment of a primary shape that earned this work its rightful place in the world's most important museums.

Had my friend, the novice sculptor who was so sad about the eyelids, indicated a good primary shape for his head, placed the true shape of the face mask on that shape, indicated the presence of the eye sockets in the face mask, placed the eyeball in its proper relation to its socket, he would have had little trouble indicating the eyelid where it belonged.

There is no exact technical trick that can be taught by words, photographs, or diagrams to explain how to create good shape. The theory of good shape must be understood; it must be felt or sensed. Then every sculptor works out his own method. I have found these ideas and methods helpful and practical.

Fig. 21

Good shape exists in all nature, whether animate or inanimate, living full form or convex dead. There is a central inner force which continually seems to grow out at us from whatever side we observe a natural object.

Face a head, an apple, a boulder, or a tree trunk. Do not look at its outlines—face it squarely. Do you see its shape swell out at you? Even the hollows of the shape you are looking at, even the convex forms have a fullness and an outward swell. And the force of its inner growth is not only out towards you as

Fig. 22

you face it—there is a strong, pulsating growth upward and downward as well as outward.

There are two natural forms with which I try to get my feeling about shape over to students and novices. One is a fine ripe apple; the other is a strong, young tree trunk.

First, let's bite into the apple idea. An apple, from the time of its birth as the hard green core of a pink blossom throughout its development to its prime and down the hill of its life to mellow disintegration or (if it is so destined) to its sadder end in an applesauce pot or a cider mill—through all that period the apple grows outward into space in all directions. A ripe apple fairly bursts out as you look at it. In old age, in spite of its furrowed and wrinkled appearance, you are still conscious of a growing inner life in the apple shape.

If you study a living apple and compare it with as fine a facsimile as you can get—a perfectly colored, cotton-wool-stuffed, pin-cushion apple, or one of those remarkable cast wax or plaster reproductions one finds in gift shops or restaurant windows—you will discover the stuffed-apple pin cushion has either a droopy feeling to its shape, or a dead stagnant quality. The wax or plaster reproduction has a stilted weightless quality, a feeling of thinness. Neither of these has the fine vibrant strength and life of a true apple.

Fig. 23

Now to get around the young tree idea.

A smooth-barked young tree has the pushing-out-towards-you force that is present in the apple. This outward force is somewhat restrained compared to that of the powerful swelling apple. But the tree trunk has a remarkable upward and downward inner growth. The painted, empty, paper cylinder with a few green leaves stuck on which is seen in store windows is merely that and nothing more. It does not even remotely suggest a tree trunk to anyone who has taken a good look. That is also true of plaster and cement casts of tree trunks.

Now then, this idea of the quality of a living apple and this idea of the qualities of a tree trunk combined into one idea make up, I believe, the requisite qualities of all good sculpture shape.

All sculpture shape must have the outward growing of an apple and the upward and downward growth of a young tree trunk. If sculpture has not that inner surge, to me it has no shape—it is not sculpture. No matter how polished the surface or how infinite and intricate the detail, how dexterous the carving or modeling on its surface, if all that clever work is merely superimposed on what I feel is a *bent surface* (even though the material used is the hardest granite) it is not sculpture. It is merely brilliant dexterity and of no more artistic value than juggling balls.

A stuffed clumsy shape is just as abhorrent as an empty one and does not belong in any medium of sculpture.

METHOD FOR BUILDING SHAPE

Here is the method I use for building sculptural shape. As I said, there is no exact method or idea which will equip all sculpture aspirants

Fig. 24

so that they can create good shape. This method applies to all sculpture units—heads, figures, compositions, etc. After it is properly understood and practiced, its relation to carving as well as modeling will become obvious. One thing I am sure of—with this procedure you will create at least *volume* and that is an important quality of good shape.

Try this method. Let's apply it to a head you are modeling from life.

Face your work squarely. Always remember the shape you are trying to build up has *front*, *sides*, and *back*. The front of the shape is growing towards you.

Do not yield (too often) to the temptation of applying clay to the outline of your sculptural piece, but build on the *front* of the shape which faces you. Try to remember you're attempting to build a shape that bursts out from within and grows up and down throughout the whole length of your sculptural piece. Apples and tree trunks.

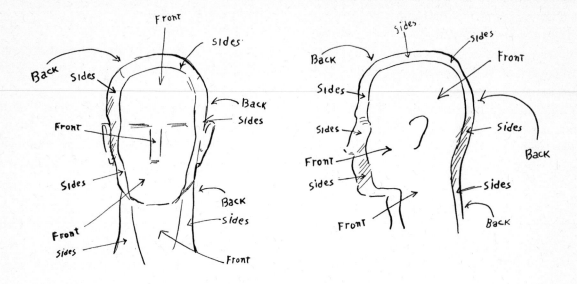

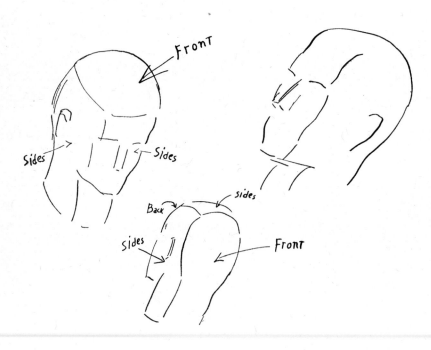

Fig. 25

After the primary geometric shape of your head is established as well as you can get it, build the shapes of the forehead, nose, lips, and chin on the *front* of your face mask. Always with the realization the shapes, even these smaller shapes you are building, have *front*, *sides*, and *back*.

Check the placing of your smaller shape units, ears, eyes, nose, etc., by an occasional glance at the outlines of your work. But do not linger there—stick to building your shapes by facing them squarely and building them towards you.

Build shape on shape.

In summing up, if a formula were drawn up on the Theory of Shape it would run something like this:

Think of apples and tree trunks. Work with a consciousness that there is always a front, sides, and back to the unit you are building, and you may produce good sculptural shape.

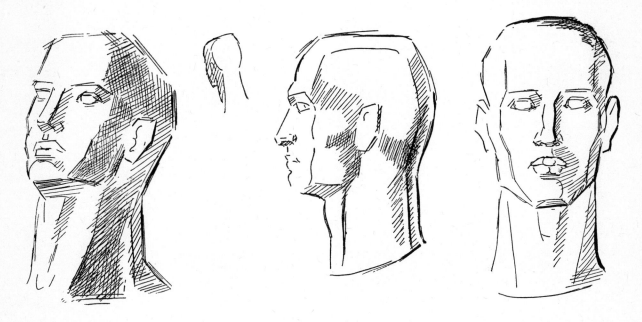

Fig. 26

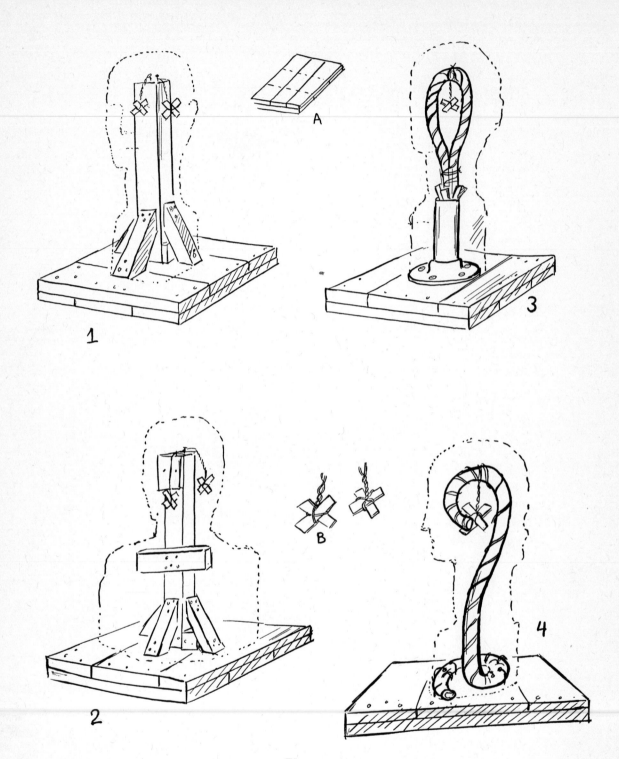

Fig. 27

Fig. 27. Armature for Head and Neck

Prepare a baseboard about 15 by 15 inches square. Nail two layers of board together as indicated on A. Any of these four armatures is practical.

Nos. 1 and 2 are rigid and are made of wood. Wooden uprights 3 inches by 3 inches (or 2 inches by 2 inches) are nailed to the baseboard and supported by struts as indicated. The little cross shapes (B) attached to the armature are called "butterflies." They are simply flat strips of wood about 2 inches long and 1 inch wide, tied together with a galvanized wire and twisted on nails attached to the armatures. They help support and hold the clay.

Nos. 3 and 4 are pliable armatures made with heavy lead pipe. These pliable armatures are preferable to rigid No. 1 and No. 2.

No. 3 is a length of heavy lead pipe bent in a loop with its ends hammered down and thrust into a short iron pipe, which in turn is held to the baseboard by an iron flange. Wedges of wood are driven into and around the lead pipes in the iron pipe to hold them firmly in place.

Galvanized wire is wrapped around the lead pipe loop and iron, and a couple of butterflies are used.

No. 4 is merely a length of heavy lead pipe curled and bent as indicated. Then it is nailed to the baseboard. The nails are driven through the lead pipe and curved over. I prefer this last armature to any of the others. It is one like this No. 4 I used in the demonstration photo series Modeling a Head from Life (see *Fig. 28*). I have made over a dozen heads on this same armature.

Fig. 28. Modeling a Head from Life

Set up your work at eye level so that you all can look each other straight in the eye: your subject, your work, and yourself. First sausages are squeezed around the armature.

Fig. 29

Develop head and neck mass simultaneously. Give as much care to back and sides of head as you do to face.

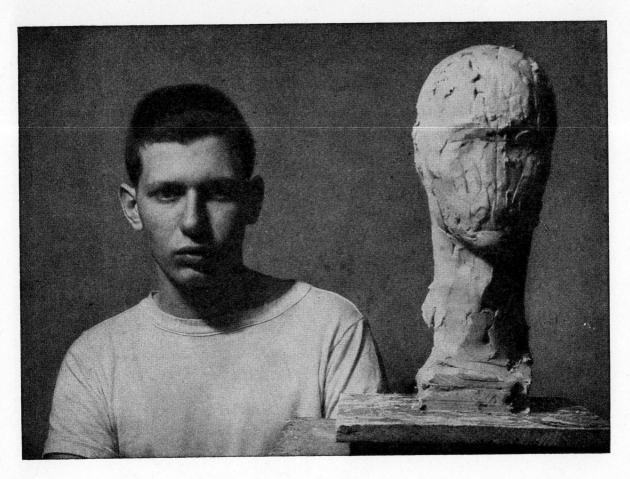

Fig. 30

Main shape of head and neck are developing. Line drawn across face mask suggests possible placing of brows. Line drawn down center of face suggests possible placing of nose, lip center, etc. Begin to build the smaller units of shape. Shape built on shape.

From now on as you work, watch and do not lose the sense of "front, sides, and back" of your main shapes. Keep your hands and tools clean of clay. Keep the baseboard of your sculpture neat. Do not, as some novices do, niggle out little snips of clay from your clay base to build up the face or what you might consider the more important sections of your sculpture head. The base of your piece is as much a part of your sculpture as the nose or eyes. Break off clay from your prepared sausages. Begin building up shape on shape. Occasionally, look at your model and your clay head from above and below.

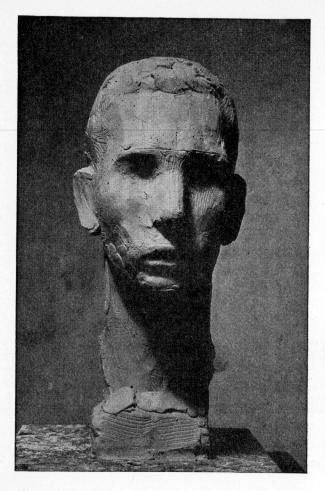

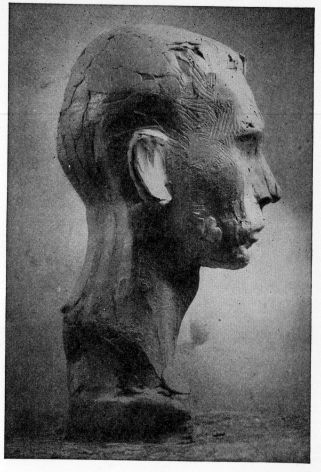

Fig. 31

The nose shape, brows, lips, etc. are built on the primary shape. Eye sockets (waiting for the eyeballs) appear naturally because of the clay built around them. It is the proportion of the contrasting characteristic smaller shapes which will make the likeness (if you have to have a likeness), and not the wrinkles and skin blemishes on the surface. Consider these shapes carefully.

Fig. 32

Note ear shape is indicated as one unit and not built up with squirmy little swirls and lumps of clay. The ear usually grows within the area between the brows and nose tip.

The only modeling tools I have used thus far have been a flat stick of wood, a wood blade, and an occasional scratch with the scratch tool. The front of shape on this side of the head is developing. Note cheekbone and jawbone hardnesses. Planes did it.

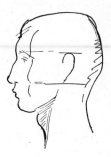

Fig. 33

Eyeballs are placed in sockets. The possible direction of the eye is indicated by planes. Lips, chin, and other units of mask are developed. Here is a common nose structure (common in the sense that it is general). But noses vary so much it is difficult to generalize on a shape formula for all noses.

Lip structure common to all normal human beings. The proportion and volume of these shapes vary, but they are always present in all lips, no matter how full or how subtle the indication. Look for them.

Three units on the upper lips.

Two on the lower.

Do not worry about the color of the lips. Concern yourself with their form.

Fig. 34

A flip of clay has indicated the eyelids. The eye is just a ball, a grape-shaped ball and nothing more. It is the structure around the eye that gives it its characteristic expression, emotional quality, etc. Concentrate on these secondary shapes if you want the eyes of your sculpture head to say something. Do not niggle at these smaller shapes. Indicate them freely. And do not drive gimlet holes into the pupil of the eye. It is not good sculpture. Try to get the feeling of the model's eye and eye shapes. Scratching out the eyebrow hairs, or the lids, or tiny crow's-feet wrinkles will not do it.

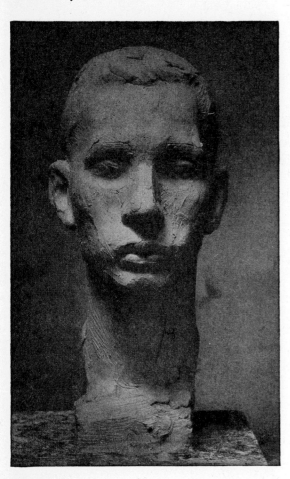

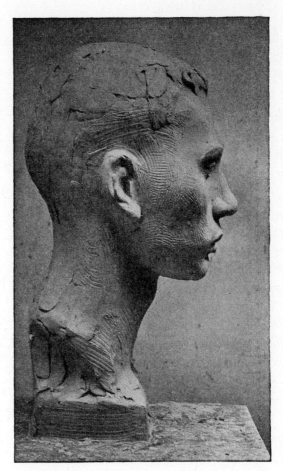

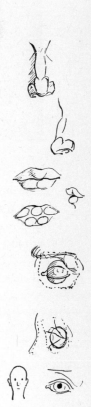

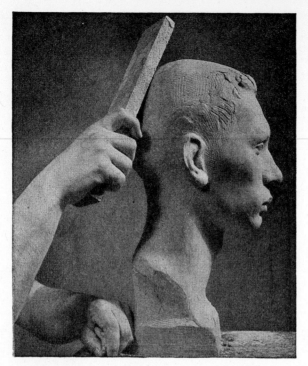

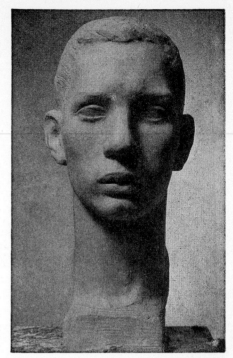

Fig. 35 *Fig. 36*

From now on anything can happen with your head. But whatever happens, do not forget that the front, sides, and back of your main shape must be ever-present. Keep working all around your sculpture piece. There are so many novices I know who are terribly concerned with what to do about the hair on an often shapeless head. Do no more and no less for the hair than you do for the rest of your sculpture head and neck. The hair is not any more important or difficult to indicate. It consists of shapes. Study its shapes for the characteristic movement and mass and indicate it freely. Do not dig into the skull in an effort to color a strand of hair or to carry through a permanent wave.

My son Larry who posed for me had a crew haircut. His hair made a nice solid mass.

Now, one final statement on modeling a head and neck from life. As you carry your work forward, keep the essentials of good sculpture in mind. Even towards the end after you have indicated the surface detail, begin to question yourself. Are the indications you made essential or can they be eliminated? Do they interfere with the simplicity, the strength, and the flow of the whole unit of shape? Have you indicated the fullness and flatness of both the soft and hard smaller shapes?

Remember your clay has not the luminosity of living flesh and skin. The same hollow or convex form indicated in clay as it might appear in a living head becomes a deep, dank, destructive hole in clay. The delicate line that appears on the flesh, on the clay becomes a broken crack.

Is the hollow you indicate necessary? How shallow can you model the depression and still retain the effect you see in your living subject?

Simplify, solidify, unify, clarify your shapes.

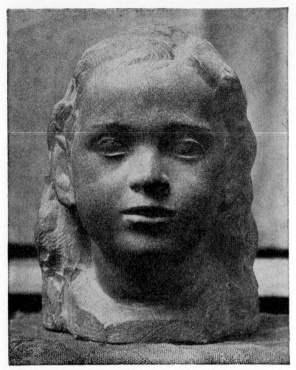

Fig. 37. Barbara
This little girl had a springy mass of wavy hair.

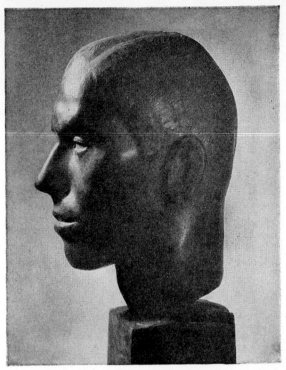

Fig. 38. Fritz Steffens
The gentleman is a slick-haired architect.

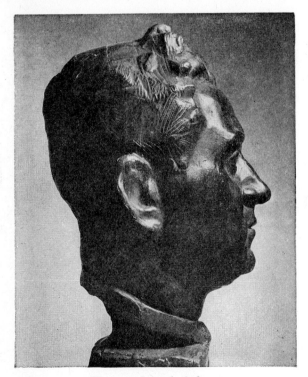

Fig. 39. Joseph Schron
A curly-haired lawyer.

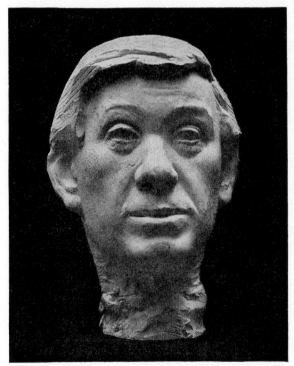

Fig. 40. A. Walkowitz
A silvery, straight-haired, famous artist.

In each case, I tried to compose the hair shape to the whole sculpture unit and tried to preserve the hair character.

CARE OF ALL CLAY SCULPTURE IN PROCESS

As you model, sprinkle your clay occasionally with water to keep it from drying up and to preserve its malleability. Use one of those bug sprays if you can get one, or, if you can't, spatter some drops on your clay with a dipped sponge. There is another method like the one used by some Chinese laundrymen when they press clothes: a couple of mouthfuls of water spurted through tightened lips in a thin spray —not a very hygienic procedure—not recommended.

After sprinkling your clay, wait until the water has been absorbed before you return to modeling, or else you will find yourself slithering around on a slimy surface instead of adding and constructing shape.

Whether or not your subject poses every day, be sure your clay is kept moist and workable.

After every session with your model clean up your baseboard, gather up stray lumps of clay, and clean your tools.

Wrap up your clay head with damp cloths. It is best to use thin, soft cotton cloths (an old shirt with its buttons removed or pajama coat, etc.) for the cloths that directly touch clay.

The cloths should be wrung out thoroughly. A dripping wet cloth suspended on clay will dry out quicker than a damp one—the water siphons off too quickly, or so it seems to me. After you have neatly tucked your cloth around your clay, wrap an oilcloth around the cloths and secure the edges of it firmly (with wooden clasps, clothespins, or a cord tied around) to keep the dry air out and the moisture in. The purpose of this process is to retain the moisture of your clay. If you have a better system, or materials such as a piece of oiled silk instead of an oilcloth, or a piece of plastic sheet, try it out. But whatever you use, be sure to use lightweight materials, or to arrange your covering so that it does not put too much pressure on your clay work.

As your modeling advances, you might find it feasible to insert temporary galvanized wire, as I have indicated in this sketch, before wrapping your damp cloth around your model. The weight of your cloths resting on the wires will keep them from blurring your modeling.

Fig. 41

Or if your surface detail is so precious to you and you have the energy, build yourself a waterproof oilcloth box as I have indicated below.

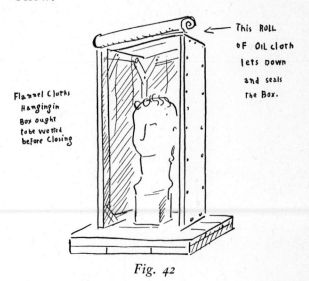

Fig. 42

Personally, I never use one. For I believe if surface detail is so dainty it cannot withstand the light pressure of a cloth, it is best that it be wiped out. And I am grateful to my clay cloths for doing that to my work occasionally.

The ideas and suggestions I have written here can be applied to all work in clay, except certain pieces which I shall indicate further on in the book.

If you have carried your head through as best you can and want to preserve it for posterity to your everlasting glory (or shame), cast it in plaster, the intermediate material to bronze and many other permanent mediums of sculpture.

There is a chapter on plaster casting further on in this book wherein I demonstrate how you can cast a life-sized head with little more than just some plaster, a few bent pipes, and a little straight thinking.

3.

Modeling a Figure from Life

STUDYING THE HUMAN FIGURE

I AM not sure I know why the novice sculptor should begin modeling and drawing from the nude model as early as it is feasible. Perhaps it is because by understanding our own design and structure we become better equipped to branch out and understand the structure of all design. In the same sense as we are advised by the philosophers to know ourselves, so we will better know and sympathize with all mankind. If we know our own human shapes, we will know the shapes of all growing living things.

I do know that all the sculptors for whom I have any respect—whether they be the representational sculptors who do work easily understood by the layman, or the more obscure, curiously interesting experimental sculptors who do abstract shapes—all have had a traditional training. By that I mean they have studied for years from models in or out of life class. And they advocate study from life for all novice sculptors.

One might argue that since it is study from living shape that is important, why not study

from animals first. They are more available than nude human models. Somehow that does not work out. I have known sculptors who worked first from animals as their models through their earlier development and have had some difficulty switching to humans. In fact, the human figures done by these sculptors who specialized in animals have, as a rule, an animalistic, inhuman quality.

Sculptors who start their study of natural shapes from floral growths also develop peculiarities. Their work usually has certain static qualities which they rarely overcome. On the other hand, sculptors who study from the nude branch out from interpretations of our own human shapes in sculpture to acquire a more sympathetic understanding of animal and floral shapes because of their life study.

From time immemorial sculptors have worked from the nude human body, studying its shapes, flow, nuances, and articulation.

Life classes are a comparatively recent development. A long time ago, to the best of my knowledge there were no life classes. The artist did not need them since the majority

of the great art cultures flourished in equatorial or torrid belts of the earth, and people walked around so lightly clad that the true shape and movement of the body was not obscured by cotton padding or woolen pleats. Naked thighs, buttocks, and breasts were as familiar a sight as the face or hands are today.

There were great art epochs in the northern climates where people had to protect their bodies from the weather. The beautiful Eskimo carving and the early Gothic sculpture seem to negate this argument. But all the rest of the world has used the nude as a fundamental development. Anyway, since any esthetic argument, when driven in a corner, shrivels up and dies—let's carry it no further.

This quick and rather skimpy resume of man's art history suggests that the study of the nude body is a necessity in the development of a sculptural epoch. If that is true of a sculptural epoch, it is undoubtedly true of the development of the individual sculptor. So, with no more time wasted on the 999 other reasons why you should study from life as soon as possible, let's get on.

If you can get into a life class, good. If not, I suggest you persuade one of your young friends to pose for you. They needn't pose stark naked if they are squeamish about exposing themselves. Your model could pose with a bit of a shield or even a snug-fitting jersey covering. Remember, it is not the skin blemishes you are concerned with. It is the study of the shape.

On occasion I have asked the model to wear skintight sweaters and drawers for classes of life students who had some difficulty seeing the shape of the model because their eyes saw no more than the skin wrinkles and blemishes. That experiment has often proved successful and the majority of those students developed a sense of shape.

But there is a lot to do before you start working from life in clay.

First let us come to some conclusion about the basic structure of the human figure as we did in the chapter on a head from life.

An understanding of anatomical structure is not enough. Though I do not hold with a prevalent contemporary fad that maintains the knowledge of anatomy is detrimental to the development of the novice sculptor, neither do I believe that such knowledge will guarantee creativeness.

Learning things and then unlearning them so that they can be tucked away in some corner of the subconscious is the best way to equip your mental processes for any form of creative work. It gives you a mental background, a reserve that you draw on as you encounter new unsolved problems in esthetics. Note that this is the first time I have used the word "esthetics," the science of beauty.

A sculptor—(let's go the whole hog and say) every artist—should know the human figure so well that it becomes a motive, a symbol of shape and movement that he can create at will and not be burdened with the necessity of hunting for a particular model, with some very individualistic physical development to fit exactly some composition when the occasion arises.

One of the stories about Michelangelo (and there are a thousand such stories) tells of the reply the great Michelangelo gave to the question: Who was the model for the magnificent full female figure called *Dawn* which reclines on the Medici Tomb? The master sculptor turned from his carving and replied by pointing to a withered old man, a color grinder, who worked around his studio.

Whether or not this story is true is of no importance. What it suggests to me is that Michelangelo like many other mature sculptors knew

the human figure so well that he used any living being as a reference. That he had learned anatomical structure and then unlearned it. So that only a glance at the withered old arm of his color grinder stirred the knowledge in the back of his mind and recalled the potential articulation and bounding movement that might happen in a full, rich, feminine arm shape.

Now then, to emulate Michelangelo and all other sculptors who unfortunately work in climates and conditions where humans walk the earth clad in disguising heavy cloth, let us take a few short cuts and give anatomy its just due —but no more than that.

ANATOMICAL STRUCTURE OF THE HUMAN FIGURE

To begin with the skeleton then, the texture, chemical composition, and marrow of bone do not concern the sculptor (we are not doctors). Our only concern with the bones of the body is to what degree they affect the outer contours of the body. We have a little more interest in the structure of the muscles because of the variety of shape and movement that results from that structure.

Simply then, here is how a muscle works and affects shape and movement.

The muscles of the body consist of a fibrous tissue attached to bones for the purpose of moving them (and us) about. The tissue structure of a muscle is not unlike the flesh of a juicy orange.

This drawing represents a dormant muscle.

When the mind decides we ought to go

Fig. 43

about our business it sends its messages out. The muscle called to action thickens and shortens and pulls the tendons attached to the hinged bones—we move—forward, backward, up or down, twist or turn.

Fig. 44

Move around thinking of that. You can feel swelling and stress in your own limbs and torso as you do it. If you were doing a figure in sculpture, and you felt in yourself the movement of your model, naturally you would build shape on those related parts of the clay figure where you too felt the stress and strain.

What actual muscles function? What do they actually do? What are they called? Does it really matter? No. You felt certain swells on the inner or outer sides of your arms or legs, neck or torso. Build your shapes to the extent and importance you felt the movement demanded, and I am sure the unnamed, unknown muscles will be somewhere within that shape.

Here are the main masses of the muscles in the body and some idea of their function. I supply no names for them. The only muscle I can name with any certainty is the bicep; that one I know because I enjoy reading accounts of prize fights.

If you want to know more about the names of muscles and bones get a good gory medical book and learn them all. This is a book on sculpture.

So that the placing of anatomical structure in the body may be more easily understood I

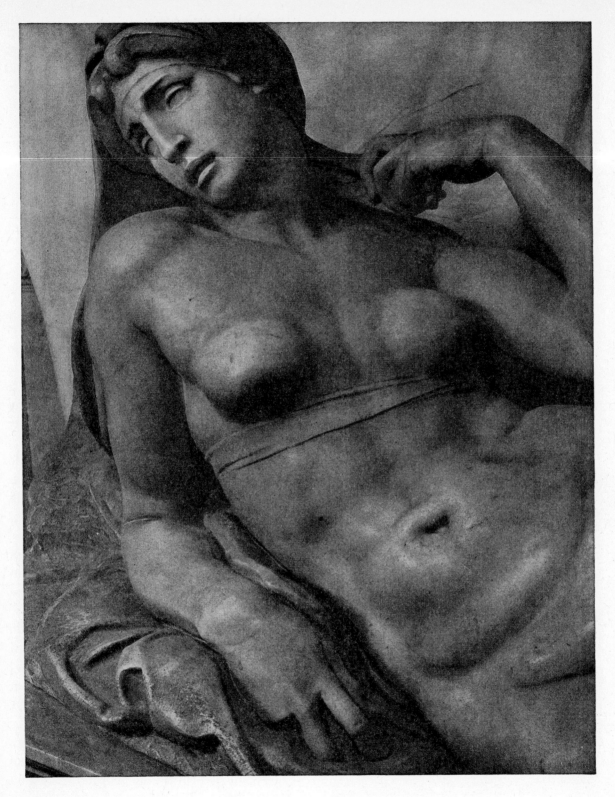

Fig. 45. Dawn. MICHELANGELO.
Detail from the Lorenzo de' Medici tomb, Florence, San Lorenzo. Carrara marble.

have had two living models photographed for your edification; then I have dissected them. I have removed the three fasciae of skin and some of the disguising fat that hid their muscular structure. Also, I have indicated the skeleton's place in their bodies.

The models pictured here are good sculptor's models, fine for life study. They are both young, solidly shaped people. Although the young male model has not reached his full development nor is the young female model

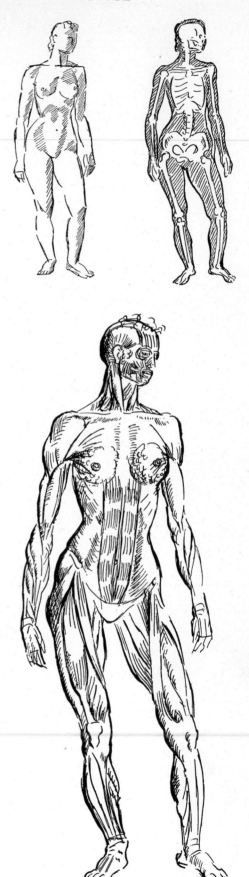

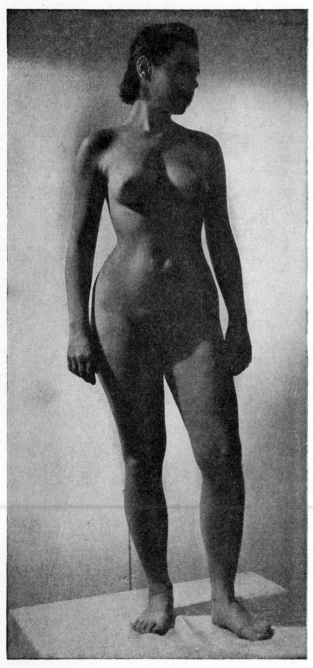

Fig. 46

Fig. 47

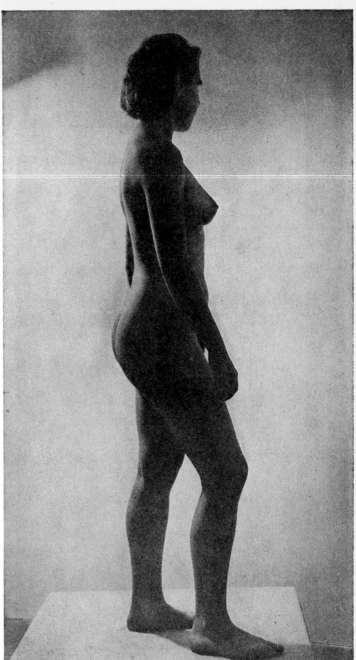

Fig. 57

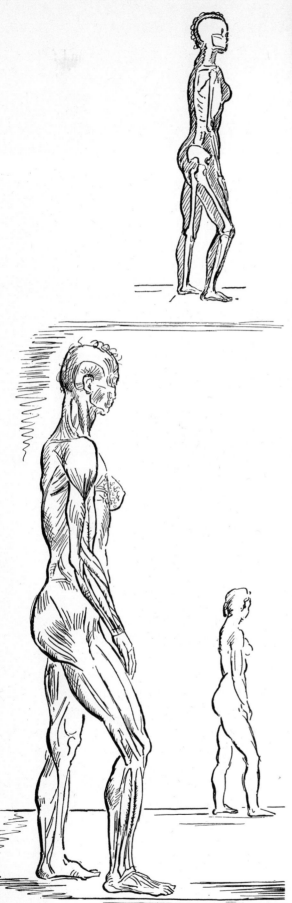

Fig. 56

Now, if you have copied these charts as I hope you have, tear your drawings up! Tear them up into little pieces and throw them away. They have served their purpose. It would be wise, if you can, to study the human skeleton now and then, an actual skeleton. Study a good anatomical plaster cast if one is available, but do not linger with either the dry skeleton or the dead cast too long. Look at moving living beings as much as you can.

BASIC STRUCTURE OF THE HUMAN FIGURE

On the following pages are some drawings and ideas I have found useful regarding the basic structure which can provide the core of shapes on which superstructure and smaller shapes of the human figure can be built.

With these ideas on the core shapes plus some anatomical knowledge, a novice should be able to get some semblance of the human figure. And as he studies from life, he (you) might add ideas of his own on the basic structure of human shapes, or discard these ideas completely as his own theories develop. Time and again, on looking through collections of drawings by the European masters, I have seen small drawings—just notes—that indicated these masters had developed and practiced individual ideas on the basic shape structure or core of human figures. The Egyptians, Hindus, Chinese, early Greeks, and the majority of the artists in the great periods have each developed human figure ideals which served as a conventionalized basic structure for their interpretation of the human figure in painting, drawing, and sculpture.

Not only did they create and follow these conventional cores, but they also limited the movement and composition of their interpretation of human figures to certain esthetically proven designs. The individual sculptor had a very small area within which his own esthetic inventions could go wrong. Craft knowledge, esthetic theory, and the appreciation of the real qualities that make good art was passed on from generation to generation. Working with so fine a traditional training in good material, and with long years of technical development, is it any wonder so much fine sculpture was made during those great art periods?

These drawings of core structure indicated here are the result of studying many ideas embodied in the Masters (naturally as I see them) and some ideas of my own after many years of studying from life. You might disagree with these ideas and find some of your own that better suit what you want to do with the figure shape. Let me warn you not to be too hasty in the beginning in forming your own ideas on the core of shape. Study the Masters, study the nude model (for years) before you come to any final decision on structure (and if you come to any final decision before you are eighty—heaven help you). A too early hardening of the arteries of the mind concerning whatever it is that makes the basic structure of a fine figure will result in a puny, dry, lifeless shape. Yes, what I am warning you against is your early death as a creative sculptor. Keep your ideas pliable (but not loose), growing steadily with no hysterical, spasmodic conclusions and you might, as did Michelangelo, Titian, Renoir, and many other great masters, go on discovering and executing new and fresh ideas for the core of human structure until you have reached a ripe old age.

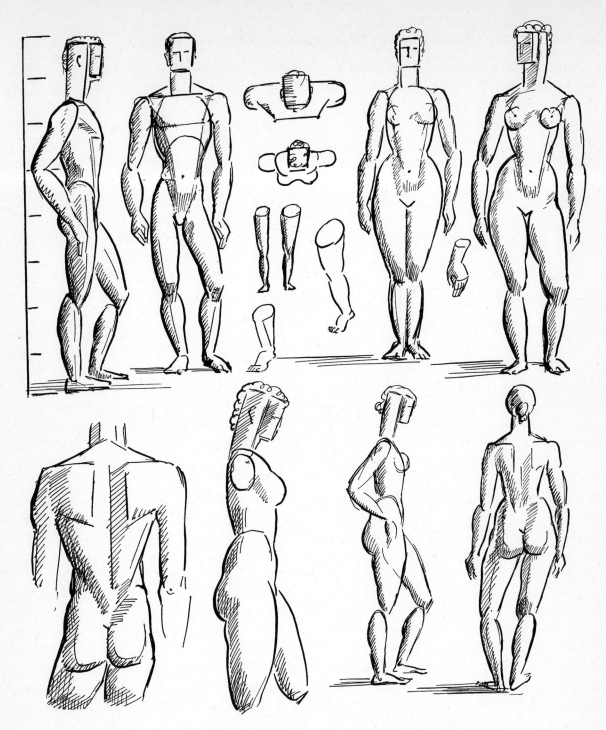

Fig. 58. Male and Female Principles of Structure

The male figure has a broad-shouldered, flat upper torso that wedges into his narrow hips. The female upper torso (exclusive of the volume of the breasts) is comparatively small and wedges into her broad hips. The female breasts are built on the shape of the thorax (rib basket). The male breast shapes lie like flat square flakes on its thorax.

The thigh shapes on both figures do not end at the crotch but continue up on both figures on either side of the lower wedges of the torsos. Both male and female thighs are full-shaped, front, inner thighs and back but the outer sides of both their thighs tend toward flat shapes. The thigh shape on both male and female does not end at the kneecap. It continues down and includes the whole knee joint in its over-all shape. The lower legs of the male are harder and scrawnier than the flowing female lower leg. The feet are wedge-shaped.

The arms of both male and female are attached and pivot, and swing free at the shoulder—the way a doll or mannikin's arms do. The male is naturally stronger and harder shaped than the female. The back of the upper torso of both male and female tends to be flat and is planed as indicated in the drawings.

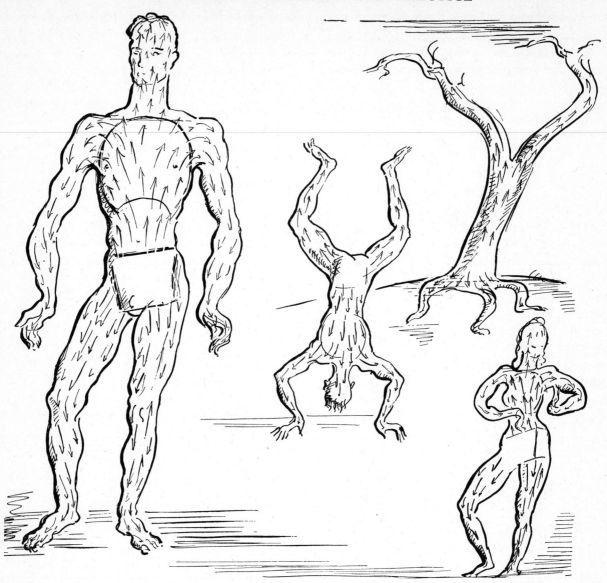

Fig. 59

Although it is said that a man should stand firmly on his own feet (legs), the true structural base of a human figure is the *pelvis!*

The legs sprout from the pelvis and so does the rest of the torso and from the torso grow the arms, neck, and head. The torso with its pelvic base is like a tree trunk. The arms, neck, and head are upper branches; the legs and feet are strong roots. If the branches or roots are smashed up a bit the figure (the tree) still functions. But a broken pelvic shape ruins a figure completely.

That happens with a tree, too. Some branches and roots may be chopped away and a tree lives on, but you kill a tree by chopping through its trunk base.

Next to the pelvic shape the thorax (rib basket) is the most important shape in a figure. Structural liberties (bent bones, curious exaggerations, or a broken flow of shape) may be taken with the limbs, neck, and head, but be wary of any tampering with the primary pelvic and thorax shapes—particularly the pelvis. If you

break your pelvis the whole figure falls to pieces.

In contrast to the isolated units of shape indicated on the preceding page, this figure stresses the unified flow and growth of shape from the pelvis. The legs grow down from the pelvic structural base in a spiral movement. The arms grow out of the torso with an easy continuous flow. They are not tied to the shoulder shape in a muscle-bound knot. They grow and swing from the shoulders freely. There is a feeling of *air in the armpits*.

The combination of these two ideas, the one depicted on the preceding page (a hard definite core idea) and this fluid surging movement (along with a lot of other thoughts), go into making a complete figure.

Fig. 60

The contrasting male and female shape principles are seldom obvious in very young children. Baby girls and baby boys are rarely distinguishable one from the other unless they wear blue or pink (or nothing at all). And if you observe carefully the other extreme in the age cycle—very old people—again the male and female shape principles tend to fuse and become indeterminable. The toothless babes and the ancients have other points of resemblance to each other. It seems to me that not only do the baby male and female and the ancient male and female look alike, but they look like each other. By that I mean youth and age both have heads large in proportion to their bodies, their legs are weak and their arms are puny compared to the bulk of their torso. Their necks are thin and weak and hardly an adequate support for the bulk of their head. The big difference in youth and age is in this quality: Whereas the soft flesh of the ancients sags and drips from their frame, the shapes that make up a baby (soft flesh, too) spring away from its small bones with vibrant new life. Youthful fat seems to have an axis. In the aged there is none.

Fig. 60

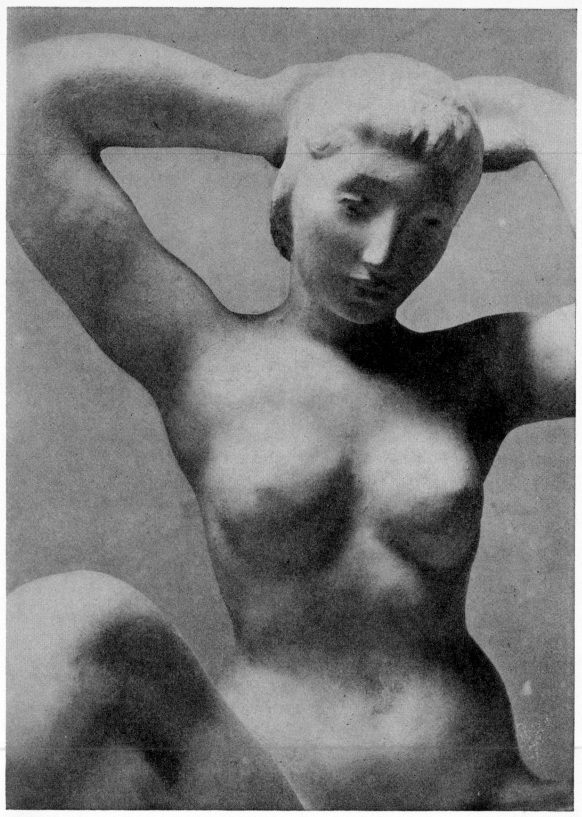

Fig. 61. Bathsheba. LOUIS SLOBODKIN.

Detail from the life-sized plaster. Here is that "arms growing out of the torso with an easy continuous flow" idea applied to a sculpture figure. It is a bit exaggerated here but serves its purpose as an illustration for the idea.

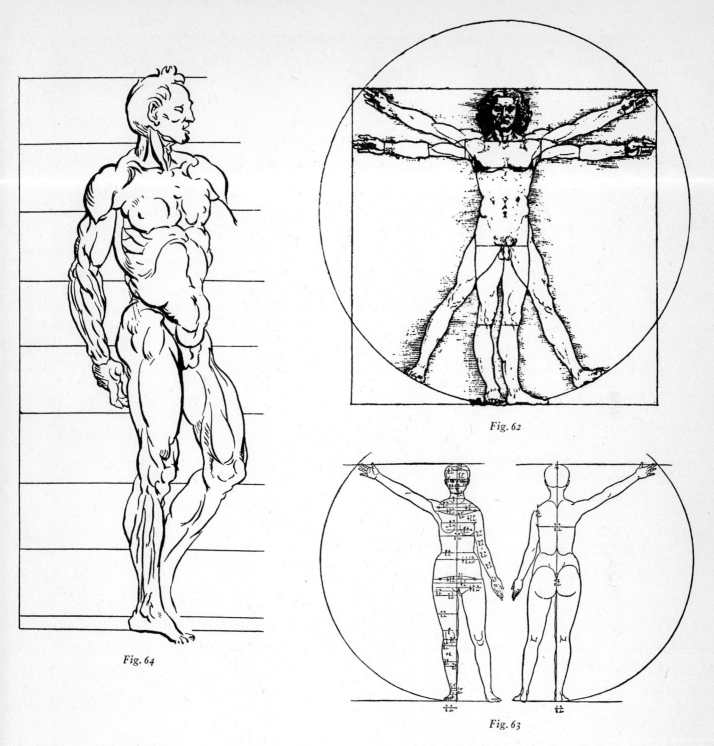

Fig. 62

Fig. 63

Fig. 64

Here are some core figure drawings by the Masters.

Fig. 62. Leonardo da Vinci's drawing *The Proportions of the Human Figure after Vitruvius*. This proportion sets the 7½ heads to a figure scale that is said to be normal. Of course that proposition varies with adults and bears no relation to the proportion in babies etc.

Fig. 63. Proportions of the female body by Albrecht Dürer. Dürer and da Vinci seem to agree here on the proportion of adult male and female. The tiny figures on this drawing are exact measurements that Dürer indicated as a core idea. I question whether he carried them through in any of his final work. His beautiful paintings and engravings were not hemmed in by any mechanical rules.

Fig. 64. Drawing (after Michelangelo) of the proportion of a mature male.

Here is indicated a proportion that is a little better than 8 heads to the figure. The 8-headed figure is said to be the Greek ideal. I imagine it represents the ideal of the Hellenistic and later Greeks. The early Greeks (the Archaic) used various proportions. Some very early powerful pieces I have seen have used what seem to be 5-headed or 6-headed figures. Some when they sought a long narrow shape indicated 9-headed figures. Proportions have varied with the esthetic problems.

ARMATURES FOR CLAY FIGURES

Fig. 65 demonstrates the progressive steps for making pliable armatures for standing figures.

Since a "half life-size" figure is usually the largest life study that can be conveniently handled by a novice, any dimensions indicated here will be for that size, although the method explained here applies to all figures in the round from 1 foot to 8 feet high.

Six feet is a "life-size" unit in sculptors' studios and any fraction of "life-size" is calculated from that dimension: one-third life size is 2 feet, one-quarter life size is 1½ feet and one-half life size, of course, is 3 feet.

While the plumber is making your back iron (A), go to one of the big hardware stores or plumbing supply establishments and buy: 14 feet of ⅜-inch thick lead wire, a roll of pliable galvanized wire, a handy light pair of pliers (get a pair with one of those wire-cutting gimmicks).

Now, back in the studio with your back iron made and firmly bolted to a good baseboard—keep an eye on this *Fig.*—here are the three steps for making a figure armature.

Step I. Cut a length of lead wire 7 feet long. Bend it double and shape it in the way indicated in 1 on the *Fig.* Then slip the two ends of lead wire down through the T joint. Leave it there.

Step II. Bend and double the rest of your lead wire, and push the ends up through the T joint as indicated in 2. Then bend and shape it as indicated in 2. Leave it there.

Step III. Wire (with galvanized wire) the lead wires together as indicated in 3. The heavy black lines across the armature at the neck, shoulders, and through the torso show galvanized wire cut in short lengths, twisted

double, then pulled and tightened around the ⅜-inch lead wires. C is a detail of that operation.

Now cut small wood wedges and gently but firmly hammer them into the space between the lead wire going through the T joint and the T joint. There will be room. When you are through wedging around the lead wire in the T joint, the lead wire should be firmly held in the joint.

Cut a long length of galvanized wire and after attaching it to the top of your armature twist it around and along the whole length of the lead wire as indicated—around the torso lead wires, down the legs etc. Cut more lengths of galvanized wire and wrap it around the arms of your armature.

Finally, make a few "butterflies" as in "Armature for Head." Attach them at the points indicated, and you should have a good half-life-size figure armature. I use this method for all size figures from 1 foot to 8 feet and I never (not almost never, I mean *never*) have armature trouble when building up a clay figure, and I have built up a lot of figures. Therefore, I guarantee this method if it is carefully followed.

A bad, loose armature or stiff, rigid one is one of the most discouraging and distracting elements that I know of when working in clay, so take a little extra time to be sure you make a good armature.

As I said, all figures from 1 foot up to semi-rigid 8-footers are made with this process. The only variation in the different size figure armatures would be in the strength, weight, and proportion of the materials used.

Armatures for figures 2 feet high (one-third life size) or less are made with proportionately reduced baseboards and back irons. Instead of ⅜-inch lead wire, heavy soldering wire (available at any hardware shop) is used. The gal-

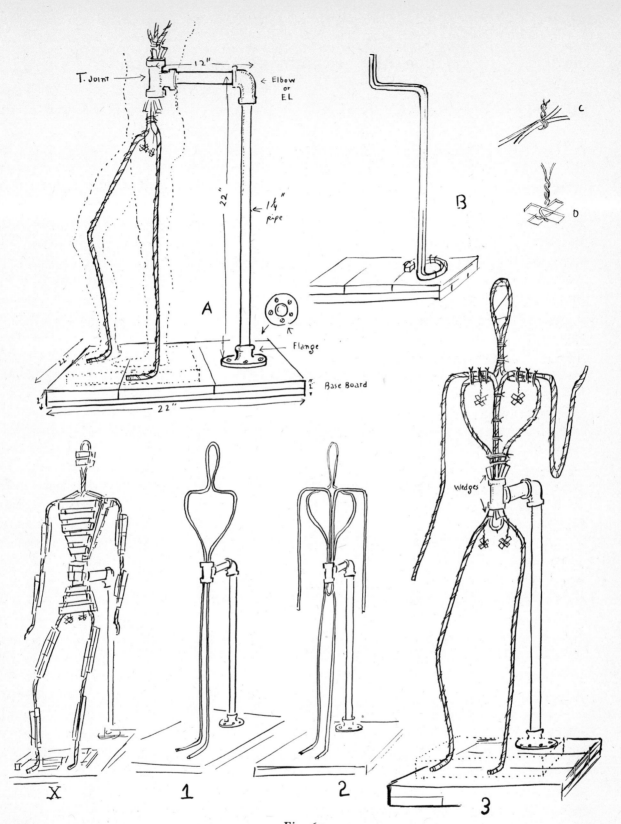

Fig. 65

A is the baseboard and back iron.

For the baseboard nail together a 22-inch by 22-inch board (use good lumber—1-inch finished pine).

The back iron is the supporting rigid angle that supports the whole clay figure. It must be well fitted and attached. Unless you are a good plumber, give a tracing and the dimensions of the back iron indicated in A to a professional plumber. Have him cut, thread, and put together your back iron: "T" joint, a short length of pipe, an ell joint or elbow joint, another length of pipe, and a good, broad, *high-collared* flange. If you do not know exactly what I mean by those mysterious words in the preceding sentence, let me assure you your plumber will. Or, use the words as I write them. Bolt the back iron down to the baseboard as indicated. It must be bolted down solid—that's *important!*

B is the back iron made of a forged square iron rod. This type of back iron is used for clay figures in most of the studios of Europe. I prefer the plumbing fixture of a back iron we use here—for many reasons.

vanized wire used for attaching and wrapping around is thinner. No butterflies are used.

In armatures for figures two-thirds life (4 feet) to any size up to over life size (8 feet) heavy lead water pipe is used instead of the ⅜-inch lead wire. The back iron pipes are naturally heavier and stronger and the galvanized wire is proportionately heavier too. Need I say the baseboard must be built like a rock?

And, too, lengths of wood nailed together with cross pieces of wood and slats are wired to the heavy lead pipe armature as in X on *Fig. 65*. That tends to lighten the load of clay such an armature must carry. Also, the wood stiffens the lead pipe so the armature will not sag. Armatures for figures beyond 8 feet must be made of wood and rigid iron supports.

A few final notes on figure armatures.

The T joint of the back iron should enter the small of the back of the planned clay figure. It is best placed there since it allows maximum study and work on all parts of the figure. Also, it allows possibilities for all types of change in the action of the torso and the limbs as the work advances.

In making armatures for any size figure allow enough leeway for a clay plinth.

One never, *never* builds (or buys in an art supply shop) an armature made of rigid wire or springy metal for a small life study. These armatures are useless—a waste of time and money.

In the following pages I demonstrate how to build up a female life study, then a male life study. Models have not been used for either of these figures. The methods here incorporate the essential principles that have been discussed so far. And they emphasize, even exaggerate, the primaries which I believe the novice must always keep in mind as he studies from the living model.

BUILDING A FEMALE FIGURE FROM THE LIVING MODEL

Arrange the female model in some pose which will emphasize her femininity (nothing coy, no cloying sweetness. That's not femininity—it's nausea). See that the pose is a simple one, one that she can hold. Get some variation in the arm and leg movements to provide as much study as possible. Keep the torso clear—no arms thrown across the torso shape.

Fig. 66

The armature should not relate to the potential sculpture figure in the same sense that a skeleton does to the living model. Rather try to bend the armature so that it follows the axis of the main masses through the limbs, torso, neck, and head. Were the armature to occupy the place in the clay that the bones do in the living model, it would come out to the clay surface now and then, the way the bones come to the surface of the front and inner sides of a living leg, and it would not function as it should—merely as the inner support for the clay.

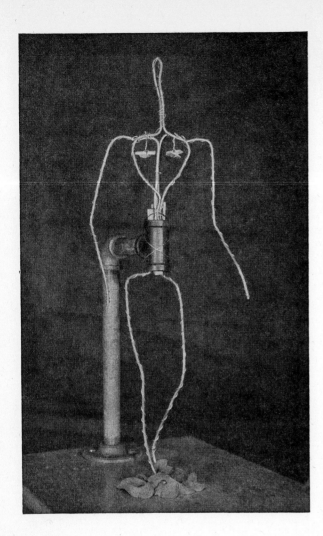

Fig. 67
The movement of the figure is already indicated in the bent armature. Note the feminine principles are present even now.

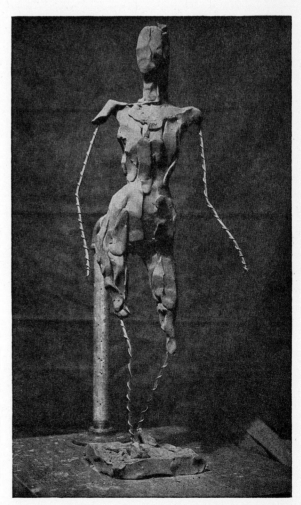

Fig. 68
From the beginning, lay on your sausages with your final shape objective in mind. The clay need not be packed and squeezed all over your armature as you start. The wrapped wire and the cohesion of the clay will hold your sausages. Have faith and build shapes. Note the broad pelvic shape and narrow thorax carry through the feminine principles. Compare this photograph with the one of the male figure at this stage.

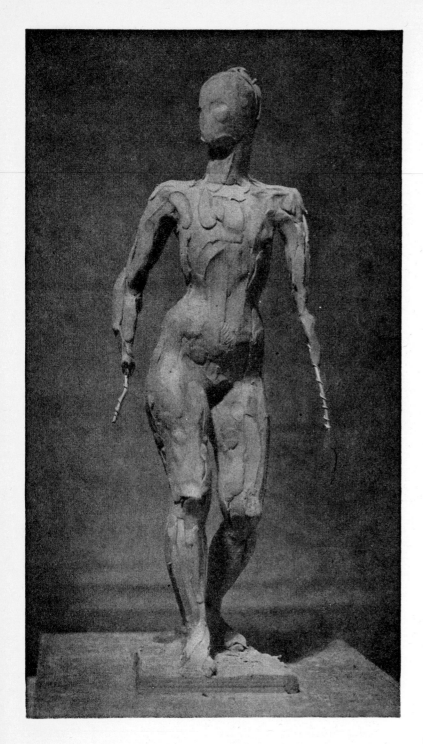

Fig. 69

Shape advances. (Remember that "front, side, and back" idea.) The movement of the figure flows through from the tip of the head to the toes. The development of the extremities is retarded until the shape of the rest of the figure is pretty well established. That prevents the smaller units from drying up.

Keep your clay plinth clean.

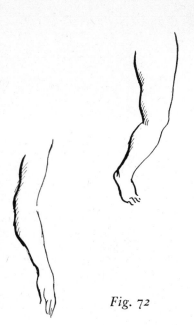

Fig. 72

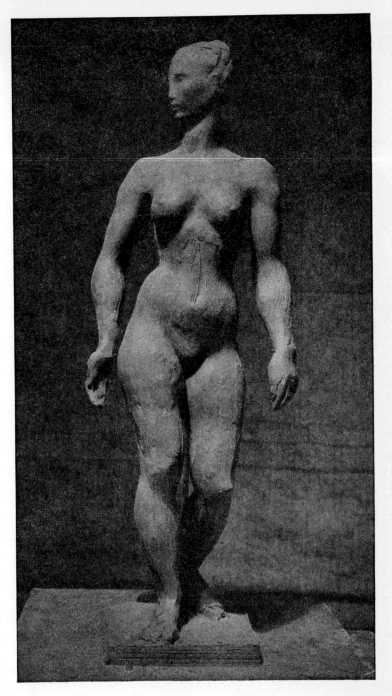

Fig. 70

Shape built on shape.

Do not lose yourself in the dainty modeling of the fingers, toes, or head features. It is the whole body you are concerned with. Concentrate on that. You cannot observe the nude figure outside of the life class or your studio. But you can study face, hands, and some feet along the street all day long any day of the week. Just mass the face, feet, and hands in your life study. Compare these feminine shapes with the photographs of the male figure carried to a comparative stage.

The surface lines indicate the movement of the torso and can be drawn on or erased time and again. Note the fullness of the inner shapes of the legs and arms. Notice, too, a sense of "air in the armpits" of the figure. There is a tendency among novices (and some mature sculptors too) to crowd the shape of the arm against the torso instead of allowing it to grow out naturally, hanging freely. The Oriental masters, the greatest Greek sculptors, and the Egyptians have all preached in their sculpture figures the principles of the full inner shape of the legs and this "air in the armpit" idea.

Fig. 71

BUILDING A MALE FIGURE
FROM THE LIVING MODEL

Have your male model assume a simple pose which will emphasize (and not exaggerate) his masculinity. Keep torso shape clear. Vary arm and leg movements to allow for study of inner and outer shapes.

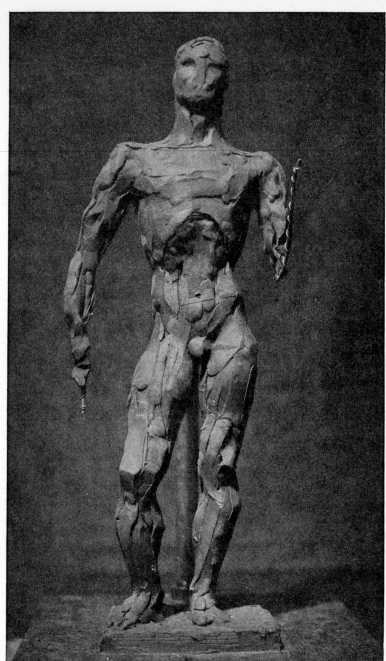

Fig. 73
Compare this first indication with the female figure in the same stage. Note the larger proportion of the thorax to the pelvis.

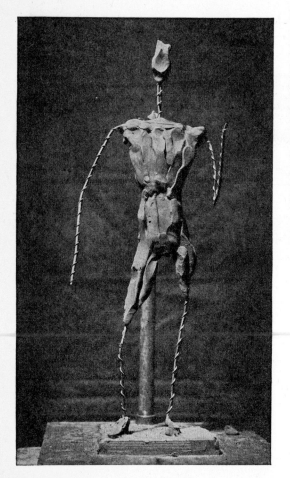

Fig. 74
Sausages take their ultimate shape even now.

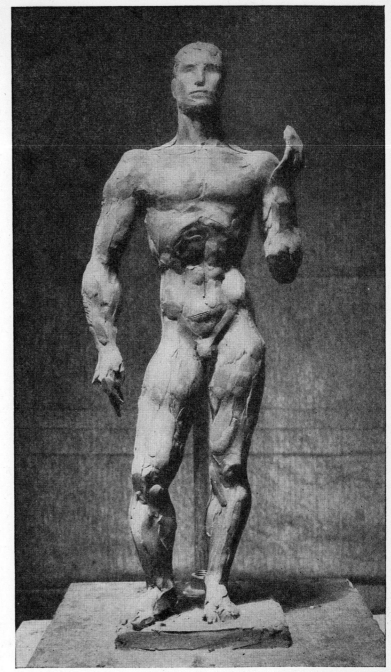

Fig. 75
When you have carried your figure this far I suggest (though I know you will be reluctant to accept my suggestion) that you *tear down your clay model*, and start all over again from the beginning! In fact, it would be best if you made no attempt to develop the first five or six figures you model from life beyond this stage. Your work in life class is not an end in itself. The real struggle to create fine, strong sculpture will come after you have trained yourself, and life class is only one of the training camps, modeling from life only one of the maneuvers before you put up your real fight to shape earthy materials into spiritual realization.

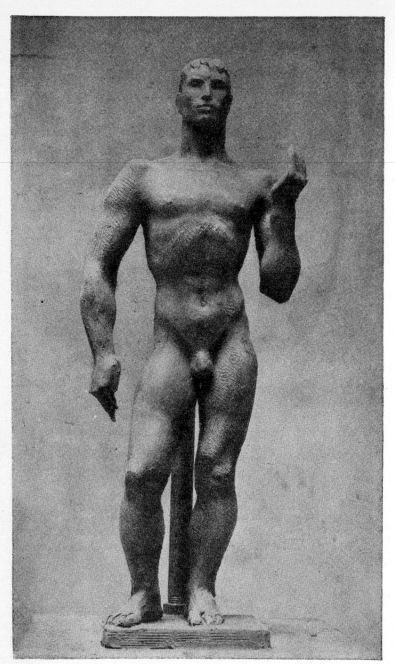

Fig. 76

After half a dozen (or a dozen and a few more if you will) figures have been built up and *torn down*, carry your modeling from life further. When you feel you have developed some facility and can make a good start, clear up your main shapes with a scratch tool or whatever method you find best, and concentrate on a part of the whole figure. Develop a leg, an arm, or a torso. Go as far as you can. As you carry through adding detailed shape on shape, keep it simple. Having indicated surface shape, try as I suggested in the "Head from Life" chapter to eliminate again. Later on, try to develop a complete figure and go as far as you can.

FURTHER STUDY OF HUMAN FIGURE, WITHOUT MODEL

Homework Away from Life Class and Study of Parts

Working on a life study after class when the model stops posing is vacuous effort.

Your life class study is only an exercise and should make no pretense of being a creative piece of sculpture any more than a medical school dissection is true surgery, or punching a bag a prize fight. Leave your work alone when the model dresses and goes home.

If you have the energy for more study, draw from the nude in some other class or sketch from anyone, man or beast, that you can find. Train your eye to see quickly and try hard to understand what you see—not just the surface but the growth and movement of all living shape. As you study from life and build figures, here is something else you can do to train yourself to know and interpret the human figure. Visit the art museums and study the figures by the old masters. If your city has no museum, or a poor collection of sculpture, you can get some study from the photographs, reproductions, and art books at the library.

Do not linger too much with the very realistic or representational sculptors. There is little you can gain by studying their usually fleshy stone or bronze figures. Concentrate rather on the Egyptians, the early Greeks, the simpler Chinese, the so-called primitives (Negro, Mayan, Pacific Islanders), and similar work. The varied sculpture figures produced by these varied peoples can teach you more about the essential primary shapes of the human figure than the fleshy realists. Michelangelo, Dona-tello, Jacopo Della Quercia, Nicola Pisano, and the earlier Italian Renaissance sculptors are better for you than Cellini, Giovanni Da Bologna, Sansovino, and a lot of others who dealt more in flesh than they did in sculptural shape. Don't misunderstand me. I am not condemning the realists. I am just saying the shape makers are better for the student's development, and it so happens those first sculptors I listed please my sculptural palate more.

In studying the masters I suggest you occasionally concentrate on parts of the figure and study them carefully. Say a knee (not just the cap, but the whole jointed shape). Compare the various ways and with what ingenious simplicity they indicated a knee shape. Compare arms—how varied and how related their interpretation of an arm shape could be. Then a torso unit. . . .

Such study will do more for the development and understanding of the human figure and how it may be interpreted than diddling on a clay figure with your limited knowledge after the model has gone home.

STUDYING ANIMALS IN CLAY

It is my conviction, and I repeat it here, that it is best for the novice to start studying from the living human being. By that I have no intention of discouraging those who have the opportunity of studying animals as extra-curriculum work away from life class. If you can draw or model at the zoo or make studies of domestic animals on the farm, go to it. Draw or model the animals in clay out in the open if you can. It is the next best thing (after life class) to studying at the museums. Besides, it's good healthy outdoor work.

ARMATURES FOR ALL ANIMALS

Because of the variety of animals and the astounding variety of proportions of species to species—and the various proportions which exist in particular species—I shall make no attempt even to approximate the size and proportion of these armatures. Among the dogs for example, from dachshund to St. Bernard there are hundreds of varied proportions. An exact proportion cannot be set down any more than an exact set of ideas on their anatomy or basic structure.

The anatomy of the particular animal you intend to study can be found in natural history museums and books devoted to your subject. Observe the skeleton well: the proportions of the animal are controlled by his bone lengths. And since animals rarely run to excess fat (aside from the pigs, hippos, human beings, etc.), his bone framework is usually the actual shape of the beast. You should attempt to come to some conclusion on basic structural cores of the particular animal you're drawing or modeling.

Visit your art museums, look through art books, and study the masters, both sculptors and painters. See how they interpreted the animal you have chosen to study. Here, as in the human figure, those artists who simplified the animal shapes can teach you greater truths than the realistic animalears (that's French for animal specialists) who model and isolate each hair on the beast's hide as if their life depended upon it.

ARMATURES FOR SEATED FIGURES

To the chagrin of lazy models I have always insisted that a seated figure is not a good pose for life class study. Too much of the figure is lost as the model limply sags on the model stand. But sometimes (say one out of ten figures) the model should be studied in a seated or reclining position. The novice sculptor can concentrate on the thicknesses of shape looking down or up at the thorax, limbs, etc.

The armatures for a seated or reclining figure require no backiron. The lead wire or pipe

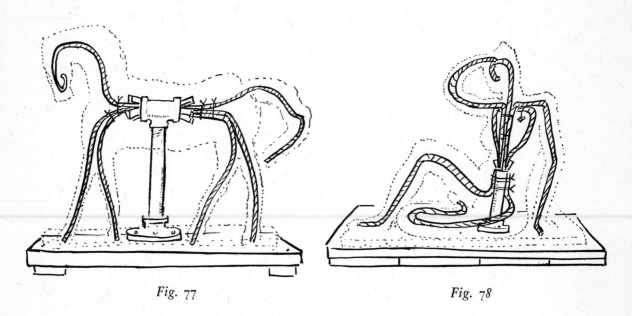

Fig. 77 Fig. 78

can be attached to a block of wood or a strong box nailed to the base, or it can be built on a strong pipe screwed into a flange.

Armatures for clay compositions (small) vary with the shape problems.

DRAWING FOR SCULPTURE

All sculptors must draw. Throughout this book I have repeated that the novice should (as sculptors do) make drawings of his sculptural ideas before he goes on to the mediums of sculpture.

I assume everyone can draw. And to those who bleat they cannot draw a straight line, let me answer nonsense. No artist can. And furthermore, sculptors almost never use straight lines. You could draw when you were a child, since every child draws beautifully. So draw now as a sculptor should.

Sculptors draw no better and no worse than any other of the plastic or graphic artists. And that holds true of everyone who aspires to do sculpture (including you). A sculptor's drawing generally differs from others in the attitude he takes towards his drawing. To him drawing is not an end in itself; rather it is a means to an end. The usual qualities—delicacy of line, tonality, perspective (or the lack of it), sensitivity of indication—mean nothing to a sculptor in his drawings. His only concern with drawing is to indicate a shape or a study of relation of shapes quickly, since a shape idea can be realized quicker on paper than it can through the ordinary mediums of sculpture.

A mature sculptor rarely lingers on a line as he draws; he seems to try to draw both sides of a shape at the same time. He draws usually with chalk, graphite, or brush, and he uses his thumb and fingers freely in his attempts to model the illusion of shape on his paper.

The sculptor novice (you) should draw with those ideas in mind. And I suggest you draw continuously. Draw anything and everything everywhere and draw from the nude as much as possible. Draw shapes, heads, hands, animals—and draw both sides of the shape of all things at once. Use the side of your crayon (conté crayon is a swell medium for sculptors) so that you will not be tempted to draw a thin, timid outline. Use your thumb and smear your shapes into existence.

When you have realized the shapes as well as you can, try to nail them down with a line. One of the best methods I have found for studying from life is to indicate the shapes and movement of the figure with a quick layout indicated with *charcoal*. Brush away the charcoal drawing (enough of it will cling to the paper to be seen). Then start all over again with dry *red crayon*. Perfect the shapes as best you can. Smear them into existence. Finally try to nail down with a definite line in *red crayon*. And last, try again with a *black crayon* drawn over the red to limit and define the shapes. Working with these three mediums, *charcoal, red crayon,* and *black crayon,* you can work and rework your shapes. These mediums used with this method are so malleable and allow so much freedom they approximate (closer than any other drawing mediums I know) studying from the nude with clay.

In drawing from the nude work freely, with your elbows loose, on large sheets of cheap paper. You are not trying to make nice drawings. You are trying to learn to see shapes, the growth of shapes, and the movement of shapes —quickly. I remember many eager students who now have grown up to become fine solid sculptors (and incidentally, brilliant draftsmen) who drew on huge sheets of wrapping paper and newspaper.

Draw on anything, but draw and draw shapes and movement only. The decorative curlicues and the sensitive, dainty (heartbreak-

ing) line have nothing to do with your development as a sculptor.

Concluding this sermon on drawing, it might appear paradoxical that I have drawn with a pen throughout this book. These drawings were made as diagrams for this book and not for sculpture. Pen lines were a more practical medium than chalk to demonstrate these ideas. My drawings for sculpture would be difficult and costly to reproduce since I work with the materials I have indicated here and they are not for public consumption. I use chalk, crayon, and brush, and I scrub and smear freely.

4.

Permanent Materials

EVERY medical student before he is accepted in his chosen profession takes the Oath of Hippocrates.

I believe it would be wise if all novice sculptors were to take a similar oath before they carried on any of their work in the permanent materials of sculpture. That oath could read:

"I shall try to understand and get as much practice in all the mediums of sculpture as I can during my life span. I shall respect and sympathize with the natural character of all materials with which I work. I shall never abuse the beauty or logical growth of my material by forcing obvious stone shapes into fluid bronze (or like mediums) nor shall I butcher wood or stone and destroy the nature of those fine materials with shapes that belong to other mediums. And I shall never let my sculpture be overcome by materialistic limitations nor shall this expression of my spirit become slave to other gross manifestations."

That might sound pompous—but a profound respect for materials is essential.

There are so many technical pitfalls and so much craft knowledge and practice necessary for converting sculpture shapes into some permanent form, that many expert craftsmen in the field of professional sculpture specialize in only one (rarely two) of the many methods for Casting Plaster, Bronze, working Terra Cotta (firing clay), Cement Casting, Stone Casting, Wood and Stone Carving, Stone Setting, etc.

For example, in plaster casting, the first permanent material we will consider, there are many time-honored techniques and methods. And there are as many trained craftsmen devoted to each technique. They seldom specialize in more than one method of plaster casting.

WASTE MOLD. In this process, the simplest and most practical of the plaster casting processes, a negative mold is made and one reproduction in plaster is cast. During this process the negative mold is broken up and the original clay model is usually destroyed.

GELATINE, GLUE, RUBBER, OR OTHER PLIABLE MOLDS. In these processes, multiple reproductions are made usually using a waste mold cast as an original.

PIECE MOLD. Also used for multiple repro-

duction. A much finer cast is made with this process than one gets from the pliable mold.

Piece Molds are usually made from waste mold cast originals.

ARCHITECTURAL MODEL MAKING, ARCHITECTURAL SCULPTURE. There are many processes used for architectural sculpture and many technicians specialize in individual ones.

All these fine craftsmen work only in their own specialty and rarely venture into other techniques.

In the bronze foundry there are even more varieties to the craftsmen since every step in bronze casting requires expert facility and years of practice. The same is true of the stone craftsmen and all the other processes of sculpture.

And because of this tremendous labyrinth of technical processes some sculptors often shy away from the essential mechanics of converting their sculpture concepts into permanent material, and depend entirely on the technicians to give their work permanence. Or, in an effort to carry their work through all its stages to its final material, other sculptors become so involved in this materialistic labyrinth, their work is stunted and they can express their sculptural ideas only in a few limited materials.

This first group are not sculptors. They are merely clay modelers. Nor can the materialistically concerned second group, the stone chewers or wood choppers, be considered fully developed sculptors.

A mature sculptor should be a thoroughly rounded individual who understands, even if he (because of the limitation of his life span) cannot execute, every process of his sculpture —so that he can handle all the methods of sculptural expression. Consequently, if he must call in the various technical experts to assist him in carrying out his work, he will know the principles of the processes and material limitations of the mediums, and will be equipped to supervise and direct the conversion of his sculptural ideas into all permanent materials.

5.

Plaster—an Intermediate Material

CAST plaster is an intermediate material. It should not be considered as a final medium since no matter how much effort (polishing, carving, scratching, color, etc.) is devoted to a finished sculpture in plaster, it still remains a lifeless piece lacking the luster, warmth, durability, or any other qualities one looks for in a fine sculpture material.

In spite of that, every sculptor must know how to cast plaster, and the majority of all sculpture pieces sometime during their development must be rendered in plaster. For plaster is the step between the clay model and your final bronze cast. Plaster is the step between your clay sketch and your stone or wood carving. And it serves as the step between many mediums and many processes through all sculpture procedures.

The principle of all plaster casting process is the same. A negative mold is made around or on the model. The negative mold is prepared with some separator. A creamy mixture of plaster and water is poured (or laid) into the negative mold. The creamy mixture hardens. The negative mold is removed and you have a dead white plaster reproduction of your model.

The simplest and most commonly used process is the Waste Mold. Although in this process

A B C D E

Fig. 79. A. Model. B. Model with mold. C. Mold removed. D. Mold prepared and sealed. E. Cast of Model.

the negative plaster mold is made on the clay and usually destroyed, and the clay model is usually broken up, to achieve just one cast of your sculpture, the work must go through this process to be carried any further. Multiple casts from Gelatine, Glue, Rubber, or Piece Molds are best made from a plaster cast.

CASTING A LIFE-SIZE
HEAD AND NECK
WASTE MOLD

Here's how you go about making a waste mold plaster cast of a life-size head and neck. The first of your materials, of course, is casting plaster. Fine casting plaster is sold and delivered in hundred-pound bags by the plaster manufacturers. Smaller quantities are available at house painting supply stores, or ask your local dentist where he gets his plaster. Dental plaster is usually very fine stuff. You will need about 35 to 40 pounds of plaster to cast this head and neck.

Listing the materials, then:

35 or 40 pounds of plaster

a bottle or cube of wash bluing (available at any grocery store)

a bottle of liquid green soap (available at any drugstore); get about 16 ounces

a shaving brush

a small soft brush

a few tablespoons of olive oil or salad oil

a blunt chisel

a hammer or mallet

a metal spatula or you may use your broad-blade wooden modeling tool

two or three 12- or 14-inch-wide porcelain pans

a half of a child's rubber ball

a few lengths of old iron pipe

a few 6-inch by 6-inch strips of loose mesh burlap cut from an old potato bag.

There are some professional plaster casting tools pictured in *Fig. 80.* They will be helpful if you get some of them but they are not absolutely necessary for your first cast.

Check over that list and you will find that all you need is 35 or 40 pounds of plaster and some liquid green soap (every normal household is equipped with all the other ingredients or materials I mention—no home is complete without some old iron pipe) and with these materials alone you can make a passable, professional plaster cast of the life size portrait you have modeled of your favorite uncle.

MIXING PLASTER

But before we begin, let us talk a little about mixing plaster.

Plaster is simply sprinkled into a pan of clear water. There is no absolute law on the proportion of how much plaster is used with how much water. The method for mixing plaster used by the best professional casters is as follows: Having decided how much mixed plaster they intend to use, they choose an adequate-sized pan, usually fill their pan two-thirds full, and then they dig out handfuls of plaster from the plaster bag. They let the plaster sift through their fingers into the water. Their fingers keep working through these handfuls of plaster as it sifts through. This is to discover and discard any coarse or foreign material in the plaster and to break up the lumps of dry plaster. They keep sifting plaster into the pan until a small mound of plaster appears above the water's surface. Then a few more handfuls are sifted around the edge of the pan and the plaster mix is left to rest a moment or two.

Air bubbles usually rise to the surface of the plaster mix. When all the plaster on the

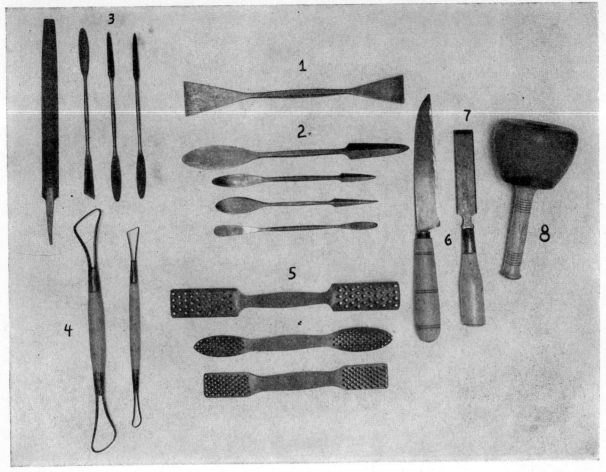

Fig. 80

1. Plaster chisel used for carving (not chipping) plaster and building plaster.
2. Plaster spatulas should be pliable.
3. Plaster files for finishing—can be used for wood and stone. Keep them clean with a wire brush.
4. Heavy wire end modeling tool can be used for plaster carving and finishing.
5. Coarse graters for working the surface of plaster.
6. Heavy plaster knife.
7. Dull-edged chisel for chipping plaster.
8. Mallet also used for wood and stone.

All these tools should be kept clean and oiled. Plaster rusts tools very quickly. The spatulas become pockmarked, the chisels lose their edge. Clean all these tools with a wire brush and keep them oiled.

surface has absorbed its fill of water the good caster mixes his plaster with a large ladle or metal spatula, or, lacking either, with his hand. He stirs quickly and regularly at the bottom of the pan (do not whip your plaster—it is not cream, and you do not want to stir any air into your plaster). When the plaster is mixed for a little while, it is left to rest again. Air

bubbles that have been stirred into the mix rise to the surface. If a lot of air has been whipped into the plaster mix, it forms a scum of froth on the surface. It is best to skim this froth away before using the plaster.

What proportion of plaster do you use to water? How long shall you mix? That depends entirely on the amount of plaster used, what kind of plaster it is, weather conditions (I am serious about that—dry or humid weather has an amazing effect on plaster), and a hundred other factors. There is no set rule—only this: the longer you mix your plaster, the faster it will set and become unworkable; the less you mix it, the slower it will set. One minute to two is the usual time for mixing.

Before going on to a quick synopsis of the method used for making the waste mold cast pictured in the following pages, here are a few precautions you must take if you plan to try it out.

Work in a room or place where you have *plenty of water available*. If your water is tapped from an ordinary sink, *guard your drain*. A piece of window wire screen placed over the drain will save you a lot of trouble. Plaster crumbs and plaster refuse can work havoc with your plumbing.

Work on a box or low table that permits you to get around your clay model quickly. Stumbling over objects with a dripping pan of plaster in your hand is disastrous and rather disconcerting.

Spread sheets of newspaper over everything, your work table, floor, around and under your plaster bag—even thumbtack sheets of newspaper to the wall, if you must work too near some wall. Liquid plaster splashes, drips, and slops over. Professional plaster casters use newspaper this way. Spent plaster is dirty stuff —white dirt, I grant, but very white dirty indeed. Newspapers save a lot of cleaning up later on.

Give the inner surfaces of your plaster pans a quick smear of oil. Use very little oil and begin casting.

Place your clay head on the newspaper-covered box or table. Arrange your tools, ingredients, and materials neatly within easy reach.

STEPS TO WASTE MOLD CASTING

The Seam. A well placed seam is the first and most important step in your mold making. Draw a line on your clay head as indicated in this sketch.

Fig. 81

That is your seam line. We are going to make a two-piece waste mold, and we will make a separation of those two halves of our mold with a clay wall. There are other methods for making a separating wall which I shall take up later. A negative mold is made fore and aft; the back section of the head is cast first.

The mold is strengthened with iron pipe.

The clay wall is removed, the plaster seam oiled.

The second half (the front) of the mold is made, and also strengthened with iron pipe.

The plaster well set, the two halves of the mold are gently pried apart at the seam.

The two halves of the mold are cleaned and prepared with green soap and then lightly smeared with oil.

The mold is put together again. The seam is sealed with another mixture of plaster.

Now all the plaster is set. Clean up your pans and fill them both with a new mixture of plaster.

The hollow sealed mold is up-ended and a new batch of plaster is poured into the mold. The mold is rolled so that the plaster spreads evenly on the inner surface of the mold. The plaster is poured out, then again poured in, then out, repeating the rolling motion. When the mold has been lined with about an inch of this fresh plaster, it is allowed to rest and set.

The plaster set and hardened, the mold is chipped off carefully and reveals your finished plaster cast.

This pouring in and rolling and pouring out is to make sure all the crevices are filled with plaster and to insure a hollow cast with an even thickness of plaster throughout. A good caster always make a hollow cast, never a solid lump of plaster. The hollow cast is stronger, lighter, and dries out better than the clumsy solid lump. For some good scientific reason a crisp shell has more resistance than a dry chunk of the same material. So pour in, roll, and pour out, and make a good strong shell of plaster.

TEST FOR SET PLASTER

Plaster that is properly mixed is usually of a nice creamy consistency (no watery areas). As it begins to set it becomes like heavy sweet cream, then heavier like clabber (sour cream), then like moist crumbly fudge. Soon after this stage it begins to harden. The plaster becomes quite warm, then cools, becomes cold, and is as hard as it will ever get. The plaster is set. Set plaster retains water a number of days after it has set. Professional casters test their plaster to gauge if it is hard enough to chip with their fingernail. They press the nail of the thumb directly down into a set plaster surface. If the surface is crumbly and moist it is not yet set. If the plaster has a crisp resistance it is set and ready to be chipped.

Plaster that is called "dead plaster" is useless. This plaster has been exposed to moisture and is no use for casting or any other purpose. If there is any question in your mind about the plaster you intend to use for casting, mix a small batch and let it set on a piece of glass or something similar. If it is "dead plaster" it may never set, or if it does seem to set you will find it a crumbly chalky material.

The photographs and diagrams that follow explain this process in detail. Since every essential step for making a waste mold is pictured and described, there is no excuse for your not making a pretty good waste mold of the portrait head with your first try. It is as easy as baking a cake. Study the photographs and notes on the following pages, then go to it.

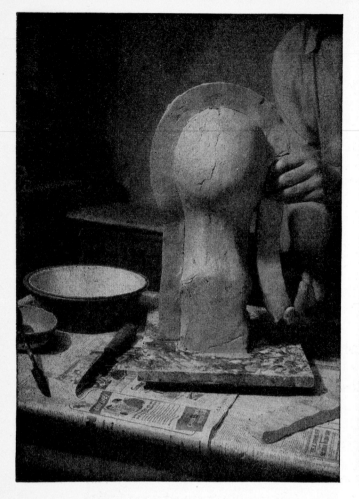

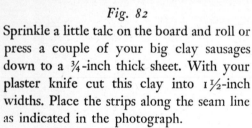

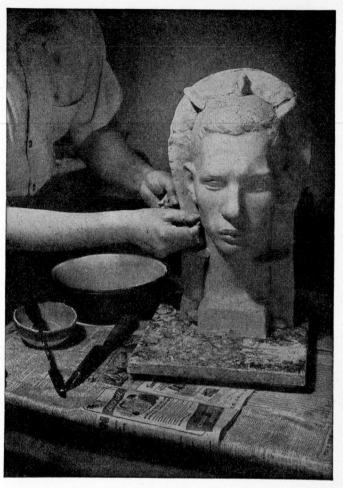

Fig. 82

Sprinkle a little talc on the board and roll or press a couple of your big clay sausages down to a ¾-inch thick sheet. With your plaster knife cut this clay into 1½-inch widths. Place the strips along the seam line as indicated in the photograph.

Fig. 83

Support the clay wall with loosely applied smallish sausages of clay along the front of the head. That is done to help the clay wall resist the pressure of the applied plaster.

Fig. 84

Fill your pan half full of water. Let your washing blue cube soak in the water for a moment or two until the water is quite blue. Or, if you have a bottle of bluing, pour a little liquid bluing into the water.

Sift your plaster into the water like a good plaster caster. Mix it properly. Let the plaster rest a moment. Then, as I demonstrate in the photograph, pick up handfuls of plaster and throw and dribble it on the clay. Keep that pan under your plaster hand to catch the drip. Cover all the clay on this side of the wall with about ¼-inch (or a little more) coating of blue plaster.

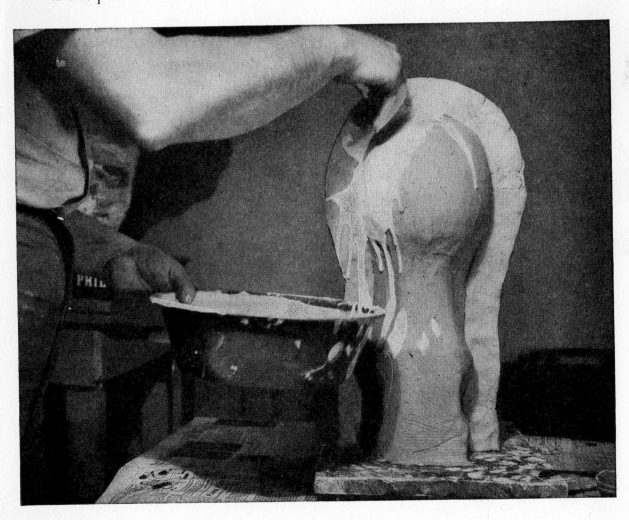

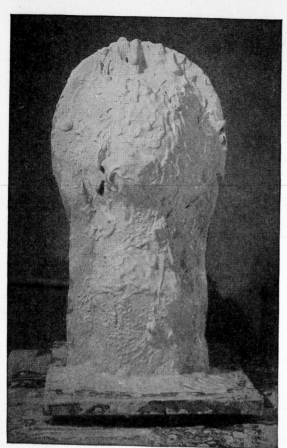

Fig. 85
The blue plaster coat has been spattered on the back of the head. Note it is purposely left lumpy so that the plaster added to complete this half of the mold will catch on these lumps. The object of this first blue coat is to serve as a warning, when chipping the completed and filled mold, that I have chipped down to the surface of my cast. If you do not understand that yet, don't worry. You will later.

Fig. 86
Now, in a clean pan mix another batch of *white plaster*. No bluing used. And the way to clean a plaster pan is to let the plaster set (harden), then soak the pan in water a moment. The set plaster will flake out easily.

In this mixture (if you are using the same size pan I am) fill the pan about two-thirds full of water and sift your plaster in. Mix, rest, and wait until your plaster is about the consistency of heavy *sour cream*. Then build up your mold with your spatula, wood tool, or your hand. Build it up evenly to a ¾-inch or 1-inch thickness.

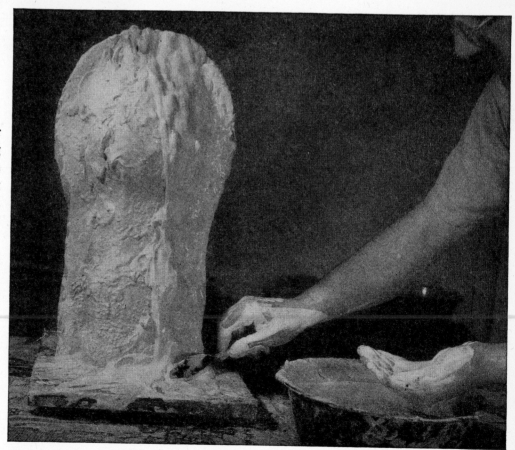

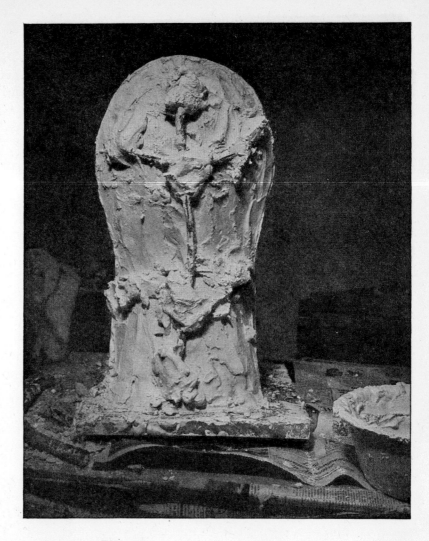

Fig. 87

Now I have attached the old iron pipes. This half of the mold is ready. The old iron pipes have been bent and stuck on the mold with blobs of plaster. Note the iron pipes are placed across and up and down the mold to give maximum support to the plaster where it is needed most.

This step in the process is easy if you plan your moves carefully. Here is how you bend your pipe. If you have a vise it is obvious. Bend your pipes. If you haven't, find some solid hole in the masonry of a brick wall or in the ground. Place one end of the pipe you want to bend in the hole and slip a larger, longer pipe over the other end. Bend your pipe. If you do it right, it is easy. If not, it is just one of those unpleasant things that must be done.

Mix a quick batch of plaster in the half of the rubber ball. Place your bent, standing iron pipe. With a little finagling it will stand snug and upright against the plaster mold. When the new mixture of plaster has set to the consistency of heavy sour cream, throw three or four large blobs of plaster across the pipe. Place the cross pieces of pipe to hold it in place and throw on your blobs of plaster. Hold that pipe until the plaster is well set, or the pipe will break loose and you will have to do this job over again.

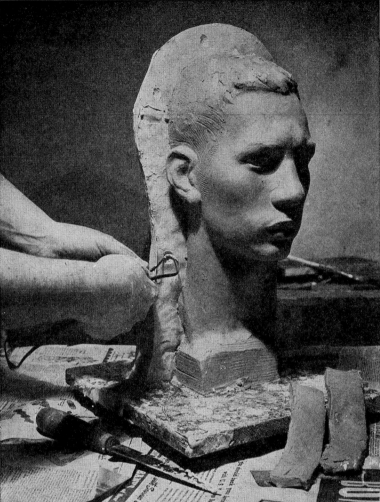

Fig. 88
The back mold being complete we begin the front half of the mold. The clay wall is removed. Quickly scoop a few depressions in the set plaster (I am using a heavy wire tool for it). These scooped depressions will act as keys when you put the front and back pieces of your mold together.

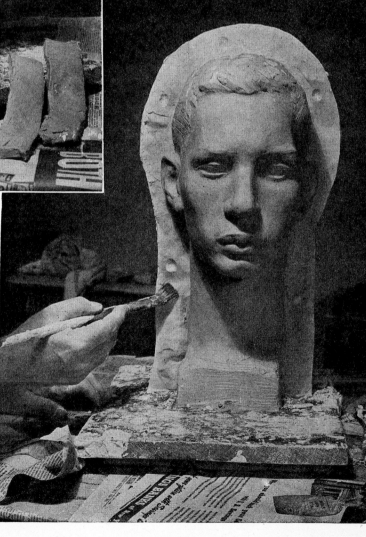

Fig. 89
Oil the seam and the key depressions well. Spread some oil along the edge of the back mold.

Now repeat the same process and make the front of the mold: blue plaster, regular plaster, irons, etc. Then go out to lunch, or wait an hour or two before you touch this work again.

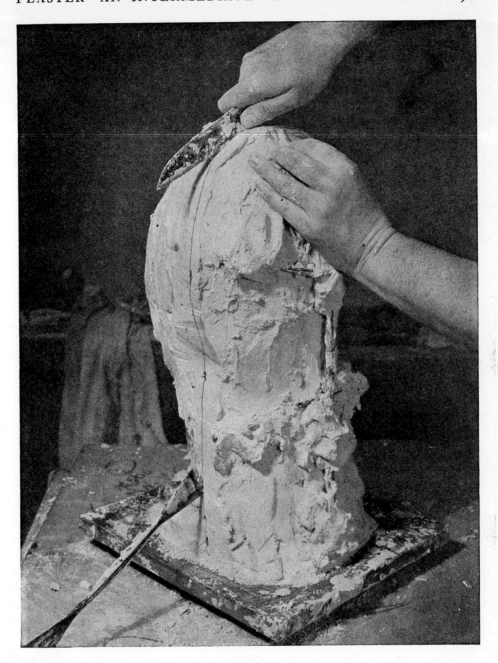

Fig. 90

Both halves of the mold are complete. With your plaster knife carve down the excess plaster at your seam until you clearly see the line of separation between the front and back molds. Then, with your chisel and a knife (using them the way I do in the photograph), pry gently into the seam. A little water slowly poured along the seam line will help open it up. Take off your back mold. If it seems to stick a little, tapping on the wood baseboard of your model with a hammer might loosen things up.

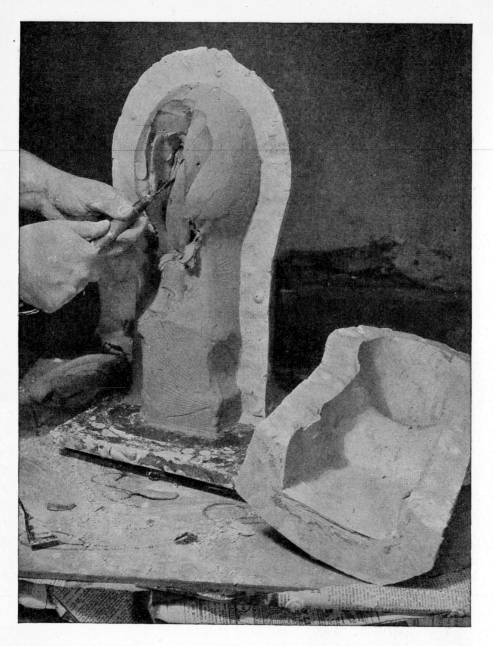

Fig. 91

The back mold is off safely (thank goodness)—no cracks, no chips. Dig out your clay model from the front of the mold. Do not try to save that clay model—it won't work. Use the heavy wire to dig out the clay. Be careful as you get deeper into the clay that you do not scrape the plaster mold with your wire tool.

Both front and back of the mold are out and clear. This mold came out clean. If some clay sticks to the

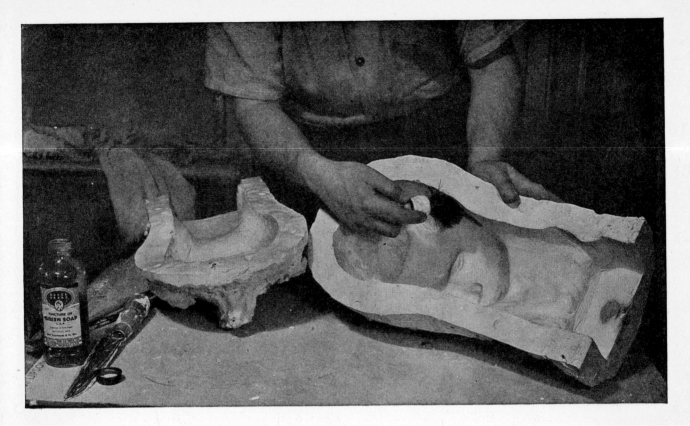

Fig. 92

plaster, pick out as much as you can with wads of clay squeezed down on the clay fragment stuck to the plaster. If that does not work, wash the mold out with a soft sponge and water. Then let the mold dry before going any further.

Now this mold is being soaped.

Keep a clean pan of clear water handy. Be sure there are no plaster chips or crumbs—used plaster will ruin your soaping. Here's how to soap. It is important you learn to do it properly:

Pour a little liquid green soap into your clean mold. Then, with a shaving brush just dipped in water (and I mean just dipped, not wringing wet) work up a healthy lather in the mold. Carefully lather every part and piece of your mold, neglecting no crevices. The object of this soaping is to create a slightly fatty surface and seal the pores of the plaster mold, so that the plaster case will not stick. After you have worked up a creamy lather in your mold for a few minutes, with a shaving brush dip up the suds and squeeze your brush clean in some basin. Throw this used soap away. Then begin again and give your mold another soaping.

If the soap suds dry up in the mold as you work, wash the dry soap out of the mold with a little water and a clean sponge and soap it up again.

Your mold has been soaped enough when its inner surface has a fatty glitter (see it in the photograph, in the mold I'm working). Now quickly pass over the surface of the mold with a soft brush dipped—just dipped—in oil. Too much oil will stain and spoil your plaster, so use it sparingly.

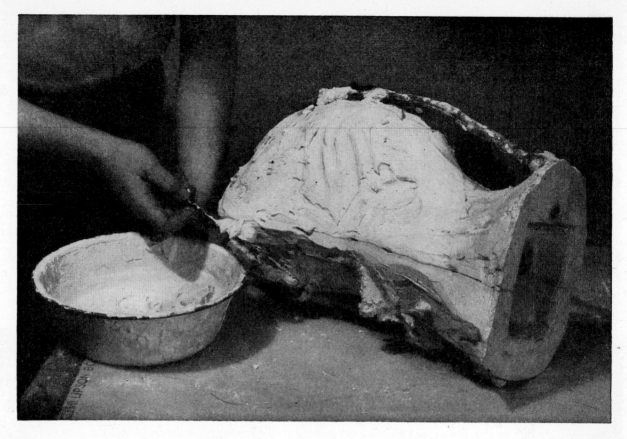

Fig. 93. Sealing Mold

The soaped, oiled, clean mold is put together. The keys that we
scooped into the back mold were very helpful for the front mold,
just snapped into place on the back mold because of them. Now
mix a batch of plaster again. Let it set to a heavy sour cream.

Seal the seams with blobs of plaster. Careful now—don't leave
any holes. Pile the plaster on ¾ of an inch deep or better all along
the seam. Then throw a few blobs across the seam (as indicated
in *Fig. 94*) just for good measure.

Look into the empty mold—do you see any pinpoints of light?
That is a hole. Blob the plaster on. After this plaster is set, to be
doubly sure the mold will hold together when the cast is poured,
tie a few wires around it as in *Fig. 94*.

Fig. 94

Here's how: Clean your pan, clean your table. Mix a full pan of plaster carefully, sift it well, mix it properly, let it rest. Skim off any air bubbles or any scum. Now rest your mold bottoms up in a box or propped up against your table, or if you can do it, hold it as I did for this picture and pour.

Pour your plaster in slowly. Be sure the plaster you pour is not too thin and definitely not too thick—just the consistency of heavy (unwatered) sweet cream this time.

Empty your pan into your mold. The liquid plaster won't half fill it. All right, let's go on.

Fig. 95

Pick up your mold and roll it gently so that the liquid plaster coats the whole interior of the mold. Roll it a few times. Then gently pour the liquid plaster back into the pan. Keep rolling the mold as you pour so that the liquid keeps adding plaster coat on coat on the inside of the mold.

Repeat operation. Rest your mold bottoms up, and pour and roll and roll and pour your plaster out to the pan again. About now you will find the plaster getting thick (getting to the sour cream stage). Be careful the heavy-cream plaster does not pull the coating of plaster away from the mold. It might be sensible to mix another pan of fresh plaster. Pour and roll.

When you have coated the inner mold with about ¾ of an inch or 1 inch of plaster, you have done about enough.

Rest your mold (bottoms up), dip the burlap strips in whatever plaster you have left in your pan (or if that plaster is set, mix a small fresh batch). Spread the dipped burlap strips and place them in the neck of your cast plaster head. Keep the strips flat. They will help strengthen the neck.

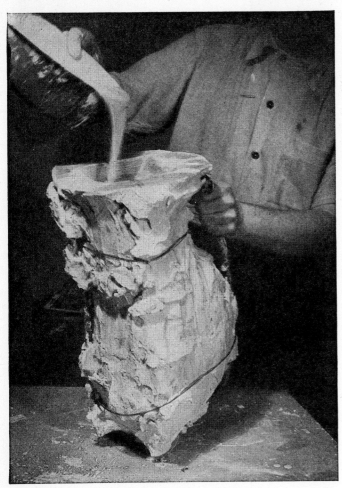

Fig. 94. Cast Being Poured

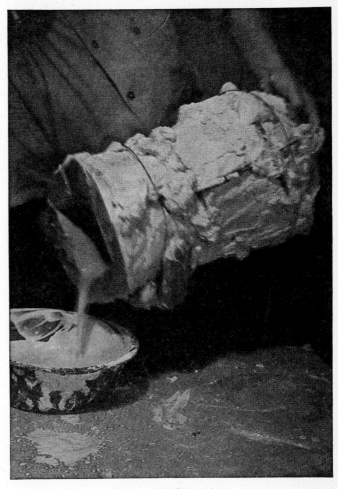

Fig. 95. Rolling Cast

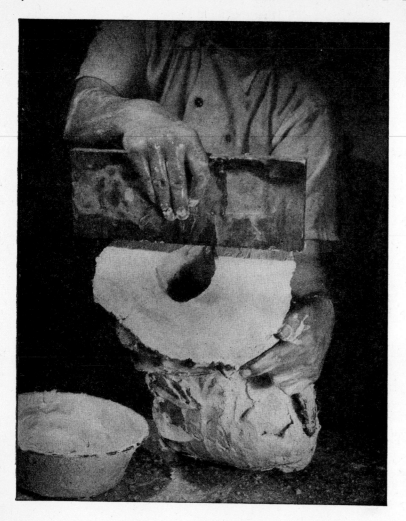

Fig. 96

Now if you have worked quickly the plaster might be soft enough to do this: Get a flat stick or board and just scrape it over the filled bottom of the mold. It will give your cast a professional look. And when (or if) you chip out your head, you will have a nice flat base for your cast to rest on.

Time out again. Let everything rest (the mold, bottoms up). Clean up your studio workshop. Wait about two hours before you start to chip out your head.

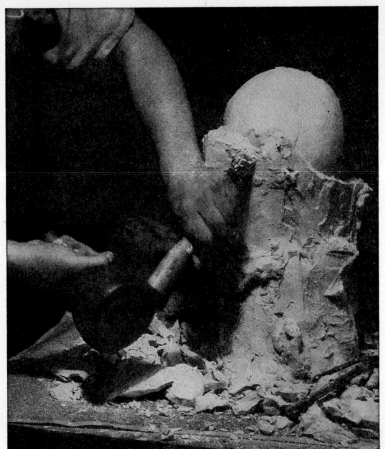

Fig. 97

Now chip, using the blunt chisel, and tap the head with a mallet or hammer. Knock off your bent iron supports first. Chip away (beginning chipping at the back of the head first) until you see blue plaster. *Take it easy.* You are coming to the surface of your cast. You will be happy about that blue coat of plaster as you carve into your mold, wondering nervously if you are clipping off a bit of the nose, or the ears. When you see blue plaster you are coming to the surface. *Take it easy.*

Note the angle at which the chisel is held in this picture.

Don't (an important don't) try to chip too big a piece off your mold. A large chunk of mold might break off and carry along some of your surface detail.

Fig. 98

This head is almost out—not bad, not bad. All I have to worry about is that left ear. The rest will be easy.

Chip gently. Usually three strokes, two mild strokes, then one sharp clips off a crisp piece of mold. This mold was properly prepared, well soaped, and oiled, so this cast was easy chipping. If any steps in the process had been slighted it would not have been so easy.

But don't lose heart if your mold sticks a bit. Have patience and chip smaller pieces. Try not to sink your chisel into the cast head, but do not go to pieces if you do chip it occasionally. Plaster can be repaired. Even if you clip off a piece of ear or nose, save the piece—it can be fixed. In the section called "Finishing and Repairing Plaster" I will tell you how.

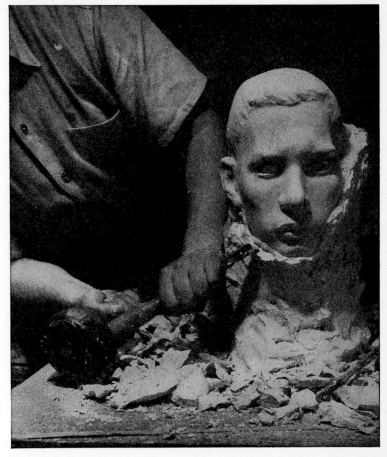

CASTING WITH BRASS SHIMS
WASTE MOLDS OF FIGURE
AND COMPOSITION

Professional waste mold casters waste no time. They do not have the time to cast one section of the mold and wait for the plaster to set, as one must in using a clay wall separation. They usually make their seams with shim brass or the "pulled string" method. And they make all the pieces of the waste mold usually at the same time.

Here is the shim brass method. (I shall tell of the "pulled string" later on.)

Go to the biggest, most elaborate, and best equipped hardware store in your town and buy a few feet of thin brass (38-gauge) sheeting. Ordinary hardware stores do not usually stock it. This brass sheeting is rather expensive (sold by the inch) and comes usually in rolls 6 inches wide. It is difficult stuff to get but is grand for plaster casting. When properly handled it can be used over and over again for years. I have been told that auto accessory stores sometimes

Fig. 99

Insert shim brass along the seam line. One piece of brass overlaps its neighbor. Push the brass into the clay or plasteline model about ¼ of an inch or a little more.

Note the shim brass wall under reclining arm and bent leg of the *Lazy Man.* Smaller pieces of brass were cut up and these holes were completely blocked. In large figures the shim brass used in the hole shapes is handled the same as anywhere else on the clay model.

These two compositions are in plasteline.

The *Cow* is being cast with a plasteline wall of separation.

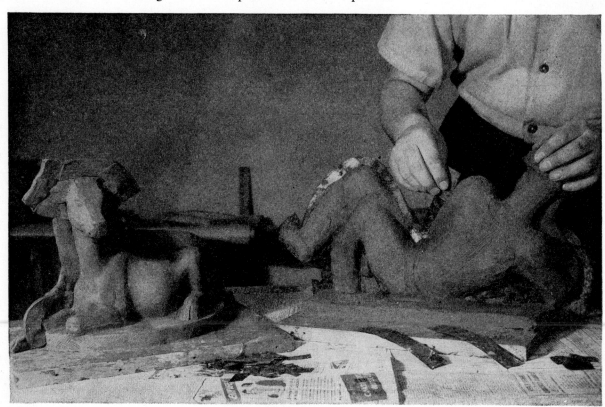

stock this brass sheeting. It is used for gaskets, or something.

Granting then you went to some trouble and bought (or acquired) some brass sheeting for shims. Cut it across with a heavy scissors (it cuts like strong paper) into 1-inch and ¾-inch strips. Just cut half a dozen strips at first so that you become accustomed to the stuff.

Now I'll run over the process quickly and then do it with pictures.

Draw your seam line on your clay (or plasteline) model. Cut the strips of shim brass into 1½-inch lengths and insert the shims along the seam line.

When your wall of separation is complete, proceed with plaster same as casting the head with clay wall. The only difference being (and it's a grand difference as a time saver) that you can make all the pieces of your mold at once. Were you planning three, four, five, or a dozen pieces to your mold, with shim brass separating walls you can make all these pieces at once.

You cover your clay model with the plaster mold. Then when your plaster is set, trim your seams and either draw out your shim brass with a pair of pliers or separate it as you did the "waste mold for head" with a chisel, knife, and a little water.

From then on, the procedure for casting a figure or composition is the same with only the variations indicated in the following pictures.

Fig. 100

Blue plaster is thrown on.

Note that plaster is thrown on both halves of the model of the *Lazy Man*—him with his time-saving shim wall.

The *Cow* with a plasteline wall separation gets plaster on only one half of the mold.

The blue plaster must cover everything.

Note that the brush dipped in blue plaster pushes plaster into deep crevices. Handle brush lightly. Do not let it touch the clay model. Keep it well coated with liquid plaster. Keep a pan of clear water handy, and dip your brush into the water to keep it clean.

Fig. 101

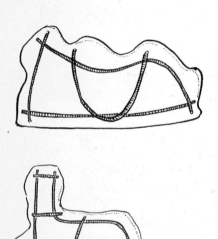

Fig. 102

Do not let irons interfere with seam.

Mold is being separated.

White plaster has been added and the mold completed.

Lazy Man with his shim wall of course got white plaster on both sides of the mold at once. *Cow* with her clay wall separation got plaster on one mold. Then the back mold was built up the same as the procedure for casting head.

Note the iron supports on both models; these are smaller irons and heavy wire. Planning their placing is very important since a model like this needs support. Try to crisscross your irons so that they follow the plaster shape and support each other, as indicated in sketch.

Fig. 103

Molds have been cleaned, soaped, and oiled.

The loose heads, legs, and arms, etc., on both these compositions need inner support.

Before molds are sealed, cut some pieces of galvanized wire. Bend these pieces of wire so they will fit in the molds as an armature would.

After the mold has been cleaned, soaped, and oiled and just before you are ready to seal your mold, mix a small batch of plaster. Drop a few blobs of plaster in your still open mold. When the plaster is almost set, rest bent wires on plaster blobs. Be sure wires do not touch the *surface of the mold*.

Now seal molds. Then go ahead and mix your good plaster, fill your molds, and proceed same as "Cast for Head." Chip carefully.

CASTING A FREE STANDING FIGURE—WASTE MOLD

Casting a free standing figure, say one modeled with an armature and a back iron, is a complicated job and not to be tried by the novice until he has had quite a bit of experience with plaster. A work of this sort can seldom be cast with a two piece mold, and attempting to make such a cast with a clay wall separation is a tedious, lengthy process since you have to isolate four or five pieces (at least) with clay wall separation. Use shim brass only in this type of cast. Almost any other method might result in disaster for your statue.

Here is a series of drawings showing how such a cast is made. I just indicate the possible shim brass separations, possible iron supports on the negative mold, possible inner iron supports in the cast.

In taking off the pieces of a mold like this from the clay, piece No. 1 should be pried off the arm first. Then the big front piece No. 2 should come off. The clay should be dug out of the back of the mold. Piece No. 3 on the back of the hanging arm comes off easy. Pieces No. 4 and No. 5 ought to be clear of clay before they are moved away from the armature. Assemble all pieces on piece No. 2 (after they

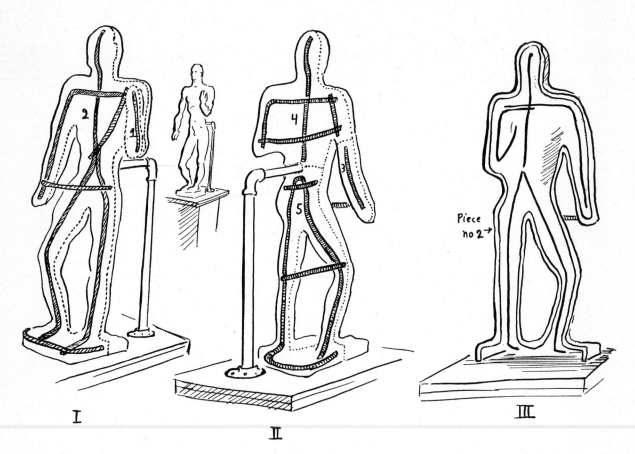

Fig. 104

Dotted line indicates seams. Heavy black lines are iron pipe supports. III represents finished and cleaned piece of mold No. 2. Thin black line in III is galvanized wire inner supports laid in mold.

are all properly cleaned, soaped, and oiled) before the mold is to be sealed for filling.

If you do not already know all the processes leading up to these steps and the intermediate and final steps to complete this cast, you have no business attempting such a cast and wasting good material. Read over again (and practice) the preceding section of this book devoted to simple two piece "Waste Mold casting."

"PULLED STRING" WASTE MOLD CASTING

The thin first coating of blue plaster is splashed all over the clay model. This plaster is allowed to set. Then a strong thin string is dipped in water and laid on the set plaster. The wet string clings to the plaster and establishes a seam line. A new batch of white plaster is mixed, allowed to become heavy cream, then this plaster is built on top of the string. The heavy cream plaster is built up into a ridge about 1 inch thick and 2 inches wide. The string is about the center. At the proper instant when this new plaster is just about completely set, the string, which has been allowed to dangle over the clay baseboard, is pulled out and through the setting plaster. Thus a separation is made.

Then the plaster caster builds up the rest of his molds, being careful to get no plaster on his established separation. He "iron supports" it, then lets everything set. When the plaster has hardened he places a chisel or two into the seam separation made by his "pulled string," taps his chisel sharply, and the first thin crust of plaster that he has cast on the clay cracks through. The separation is complete.

From then on it is the same as any other waste mold casting.

This is a smart process and should be attempted only by smart (and well practiced) plaster casters. The "pulled string" method is not as prevalent here as it is in Europe. There I have seen expert craftsmen make multiple piece molds with this method.

They laid a veritable network of wet strings on their models and built their plaster ridges, pulled their strings with a beautiful professional flip, and made wondrous plaster casts. This method requires an expert knowledge of plaster, an exact sense of timing, and a lot of courage. Try it if you dare—yes, try it on some simple sculpture unit which you do not care too much about. For if you pull your string at the wrong moment, either the string will break because you pulled it too late and the plaster is already set, or (and this is more apt to happen) you will pull your string too soon. And the squishy plaster, resentful at being disturbed by the passage of the string, oozes together again and the mold will have no separation.

On occasion I have used this process for simple casts, but I do not make a practice of it. The nervous strain of worrying "will I or will I not" pull the string at exactly the right moment is too much for me. I stick to shim brass and clay walls.

WORKING IN PLASTER RETOUCHING, REPAIRING, FINISHING PLASTER

One of the best professional waste mold casters I ever knew (a good friend of mine who shall remain nameless) once said to me that the best plaster casters are those who can best imitate in plaster the style and surface texture of the work of the sculptors who employ them. Obviously what my friend meant is that top-ranking waste molders are as human and as apt

to err as we common mortals, the sculptors. That they, too, occasionally sink their expert chisels into a fresh cast as they chip. They, too, occasionally clip off an ear or crush a nose and surreptitiously do a bit of plastic surgery on a bashed-up sculptured figure.

So take heart, novices, if, after you have chewed the mold off your cast, you find ruinous gashes and nicks ripped into your plaster sculpture, or if, because of "blow holes" pockmarking the surface, it has a rather leprous appearance.

It can be fixed. Do not throw your sculpture away yet!

"Blow holes" (little or large pockmarks on the surface) are caused by air bubbles in your liquid plaster which were poured into your mold. That might have happened when you mixed the plaster and whipped air into it.

REPAIRING BLOW HOLES

Twirl your spatula into the blow hole (as indicated in *Fig. 105*) and enlarge the hole. The cast air bubble might be a lot bigger than it appears on the surface. Open it up. Now mix a small batch of plaster into the rubber ball.

If you repair your plaster surface right after you have chipped the mold away, a normal mixture of plaster with just a little more water added before you stir the mixture is about right. Do not stir the mixture very long, and let it set to a "sour cream" consistency before using it. While your plaster is thickening, wet the "blow hole" by dabbing it well with a soft brush dipped and redipped in clean water. Wet the blow hole and all the surfaces around it. Wet it well. Then when your plaster mix has

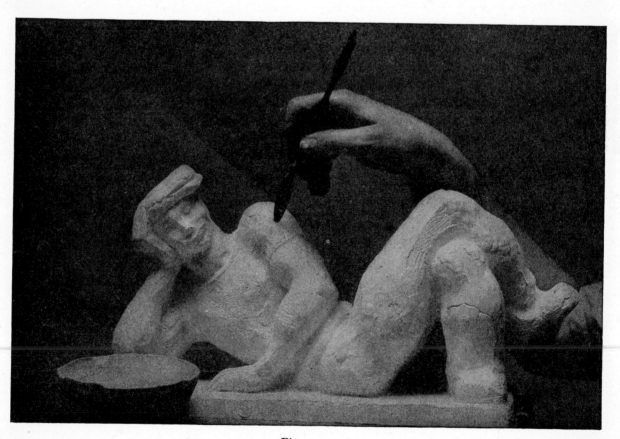

Fig. 105

become thick cream, pick up a blob of it on the tip of your spatula and fill the blow holes full of plaster. Press the new plaster in well. Dab more water on the new plaster and around it. The old set plaster of the cast tends to absorb water from any new plaster added. If you do not feed the surface surrounding the new plaster with water, it will absorb the water from your applied plaster and you will find a hard dark lump fills that blow hole.

If you repair plaster long after the cast is made and dried out, use more water in your plaster mix, and wet your old plaster even more before applying new plaster.

Some casters prefer to fill "blow holes" with "killed" plaster or "dead plaster." "Killed" or "dead" plaster is a mixture which when set becomes a crumbly white chalk that has no strength. I would rather not use it. There are many ways of "killing" plaster in the mix. The simplest way is to use one part plaster to about two parts water. Stir this mixture for a minute or two. Let it set. When it has become quite thick, stir it again for a number of minutes. Let it set again. That will "kill" any plaster, and it should be very "dead" indeed.

Chips and cuts in your plaster surface are filled the same as "blow holes" but you needn't twirl your spatula in the chip or cut. Just wet it and lay on your creamy plaster.

REPAIRING AND JOINING PLASTER PIECES

When an essential piece has been knocked off your sculpture it can be stuck on thus.

It is best to stick a piece back on as soon as

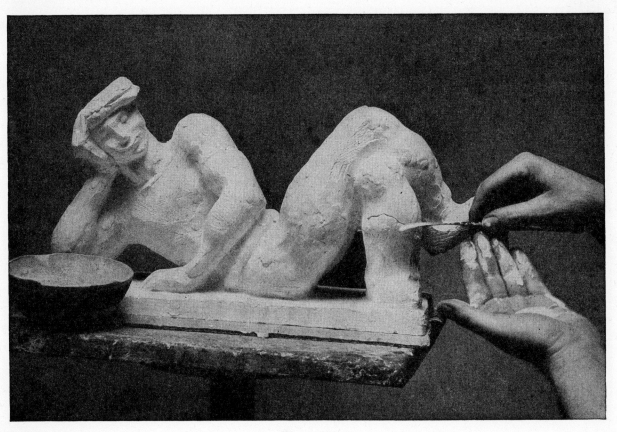

Fig. 106

possible after your mold is chipped away. Twirl your spatula in the center of the broken area of your cast until you have a deepish hole. Twirl a hole into the piece which has been broken off. Try to place these holes so that when the piece is put back on the cast, the holes will meet. Wet both broken pieces and broken section of cast well.

Mix a normal batch of plaster in your rubber ball. When the new plaster has become creamy, drop a blob of the creamed plaster into the cast hole, fill the hole in the broken piece, and squeeze the broken piece back on the cast. Hold it there until the plaster is set. You can scrape away any new plaster that has oozed from the cracks of the broken area afterwards. Dab it with water after it sets.

When you want to join a largish piece back on your cast (such as an arm or a head or a jutting out part of the composition), dig your holes deep into your cast and into your broken-off piece. Cut a piece of galvanized wire; it must be no longer than the depth of both holes. Mix a normal batch of plaster. When it is creamy, drop a dab of plaster into the cast. Insert your piece of galvanized wire into the hole in the cast. Fill the hole in the broken-off piece and fit it back on the cast.

If you want to repair a plaster statue that is completely dried out, get a tube of Duco cement. You can get that at almost any hardware store. Instructions are on the tube.

CARVING AND FINISHING PLASTER

Fresh cast plaster can be scraped and carved with strong steel wire modeling tools or with chisels. When the plaster is dried out it is best worked with chisels and files. Better wet your plaster if it is set and dried out before carving.

Sandpapered plaster is pretty at first glance. But after a while it looks pretty awful. Use sandpaper if you must but use it sparingly.

MODELING DIRECTLY IN PLASTER

Surface shapes can be directly built up in plaster by building up and spreading small dabs of thick cream plaster on the wetted surface. And complete sculpture units can be built up on improvised armatures swathed in plaster-dipped burlap. Also, plaster units can be built using plaster-dipped paper as a core.

Use a thin mixture of plaster for building shapes on the cast plaster but let the mixture set to a "sour cream" consistency. Before applying any fresh plaster to the cast dig heavy scratches (crisscross) into that surface of the cast where you want to add plaster. Wet the cast well. The "sour cream" plaster is laid on the cast where you want it directly—leave it where you lay it. Do not play or fuss with your new plaster after it has been laid on and has begun to set. Work crisp and add new plaster. In carving over the surface of newly applied plaster, work carefully. This plaster will tend to flake off.

MULTIPLE PLASTER CASTS GELATINE OR GLUE MOLD

Multiple plaster casts are made from pliable molds supported by and enclosed in a plaster casing called a shell.

The pliable molds may be made of a gelatine (derived mainly from fish skeleton). These gelatine molds are called glue molds by professional sculptors and casters. Another material used for pliable molds is agar, derived from a gelatine made from oriental seaweed. Another

material is rubber or latex. Since gelatine or glue is the cheapest and most easily available of these materials it is the material generally used for pliable molds in sculpture studios.

A glue mold is usually made on a shellacked plaster cast which has previously been made by the waste mold casting process. A glue mold may be made from a plasteline or a clay shape, but for reasons that follow it is not practical for beginners.

Fig. 107

Let's make a glue mold of this Cast Horse. This shape will permit us to solve some typical problems that arise in all glue mold casts.

MATERIALS

Along with the regular plaster equipment mentioned in the section on a Waste Mold Cast of a Head, we shall need a couple of pans that fit one into the other, or a double boiler, to cook the glue. We shall also need:

a sheet of tin about 10 by 10 inches square
alum crystals or powder (a small quantity available at any drugstore)
some ordinary talcum powder
a pint of shellac (bought in a paint store)
a yard of burlap (or cut up an old potato sack)
10 lbs. of dry glue flakes (bought at a house painter's supply store).

MAKING THE SHELL AND COOKING THE GLUE

Since it takes some time for the dry glue flakes to become liquid enough to pour, we usually put the glue flakes on to cook and make the shell at the same time.

Soak the glue flakes in enough water to cover and let it stand. When the glue flakes are pliable melt them in the top section of the double boiler. Keep the lower pan supplied with boiling water and the upper pan covered. Occasionally stir the glue with a stick while it melts down. And while the glue is cooking prepare the Cast Horse thus.

Gouge five or six depressions about an inch deep into the solid plaster bottom of the Cast Horse.

Then, on a board a lot wider and longer than the base of the Cast Horse, drive five or six nails placed so they will fit into the base when the cast rests on the board (a nail for each plaster hole). Allow these nails to project out about ¾ of an inch.

Fig. 108

Now mix a small batch of plaster. Wait until it becomes creamy, drop a generous blob on each of the nails, and fill the depressions gouged into the plaster base. Ease the Cast Horse down on the nail. If it has been done right, the plaster-covered nails will fit exactly into the plaster-filled holes, and when the plaster is set the Cast Horse should be firmly fixed to the board.

With a little plaster, neatly plug up any openings that happen between the Cast Horse and the wood board.

Now then, shellac the base of the Cast Horse with two or three coats of shellac. Shellac the board too.

On another board or table sprinkled well with talcum powder, roll out a few sheets of not too moist (and not too stiff) clay. Those sheets of clay should be evenly rolled (sprinkle the clay generously with talc) just about 1 inch (or ¾ of an inch) thick.

Give the Cast Horse a brush of oil, cover him snugly with a sheet of wet newspaper. Then cut up sections of the clay sheets so that they will fit around the shellacked, oiled newspaper-covered Cast Horse like this.

Fig. 109

This clay cover should cover the whole Cast Horse with an even thickness.

Incidentally, do not forget to watch your glue. Stir it with a stick. If it is all melted down, turn the light low and keep it covered.

Now build a clay separation wall along the natural seam line for a two piece plaster mold (the shell) of this clay-covered Cast Horse.

Mix a batch of plaster. Cut two pieces of burlap big enough to cover each side of the clay-covered Horse. When the plaster mix has become creamy, build about a ½-inch thickness of plaster on one side of the covered cast. Then dip one of the cut burlap pieces into the plaster bowl and fish it out juicy with plaster. Fit it on the one side of this shell you are making. Build on some more plaster until you have a shell about 1 inch thick.

Now remove the clay wall and, as you did in making "A Waste Mold of a Head," gouge out a number of keys into the edge of the plaster shell.

Mix soft clay into a little water until you have a liquid mud. Paint this mud thickly on the edge of the shell and into the keys. This will act as a separator. Now make the second half of the shell. With both sides of the shell made and set, trim it off nicely with your plaster knife so that it looks neat. Then *mark the outline* of the base of the shell with an *indelible pencil* on the board on which it rests. (I shall explain why later.) Now pry open your shell. It should come apart very easily.

Take off the clay covering from the Cast Horse and clean away any clay that might have clung to the cast.

Gouge into the inner surfaces of both halves of the shell, and make a number of keys. These keys will help hold the glue in place. At certain points in the shell carve holes right straight through as is indicated in this drawing.

Fig. 110

Fig. 112

Now mix another small batch of plaster and cut as many small pieces of burlap as you have nails. Dip the burlap and drop the pieces juicy with plaster on the nails and attach to the shell and board on all sides. With more plaster seal the base of the shell to the baseboard. Now with more pieces of burlap dipped in the plaster, drop those plaster-dipped burlaps across the shell of the seam thus.

Drill these holes into both sides of the shell. The large hole at the top of the cast at the seam line is the one through which glue will be poured. The small ones will act as vents.

Remember to watch your glue.

Oil the inside of the shell, brush a little talc into it and brush it out again, and brush a little talc over the Cast Horse.

Fit both sides of the shell around the Cast Horse along the lines you marked with indelible pencil on the baseboards. That mark should guarantee the shell is back where it was when the clay sheet filled the space between the inside of the shell and the Cast Horse.

Drive a few small nails along the board at the base of the shell thus.

Fig. 111

All right now, wrap a couple of wires carefully around the shell (same as the mold in "Waste Mold of Head"). If there are any openings along the seam line better seal them with a little plaster.

Now, one last look at the glue; it is going to be used soon. Is it smooth? Are there any lumps when you lift your mixing stick out of it? It should run off the stick like a very heavy syrup.

Make a funnel with the sheet of tin which will fit into the large hole on the top of the shell. Just roll the tin up and hold it together with wire or something. Fit it into that top hole and prop it up and seal it around with clay. Oil the inside of the tin funnel.

Prepare a number of balls of clay as big as your fist and set them conveniently near each hole you dug through the shell. (See *Fig. 113*.)

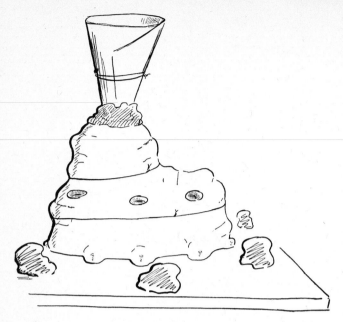

Fig. 113

bottom, so keep some extra clay around to plug any escaping glue. When the glue has cooled a little, rest a good-sized ball of clay on the glue in the funnel; this will provide a little more pressure.

Let the glue rest overnight.

PREPARING THE GLUE MOLD FOR THE CAST

In the morning take the plaster shell off the glue mold. Undo the wire twisted around the shell, and chip off the burlap that held the half of the shell together at the seam with a chisel and hammer. Loosen the gobs of plaster around the nails at the base of the shell, cut away any glue that had poured through the holes on the shell, and just lift the halves of the shell away from the cold glue.

Now then, if the glue is all ready and proper, we shall pour. The glue is ready when it is lumpless, smooth, and neither too hot nor cold. It is best when it is a little warmer than blood heat (normal blood, that is). Wet your finger and try the temperature of the glue.

Glue ready? Shell ready? Now pour the glue into the funnel. Pour it slowly, yet not too slowly. As you pour, the glue will fill the empty space between the Cast Horse and the shell. Watch the holes drilled through the cast shell as the glue rises in the shell. The glue will flow out of these holes. Let it flow a little to get rid of any air, then clean away the glue (not too clean) from the holes and plug them well with the nearest balls of clay you have prepared.

When the glue has flowed from all the holes (which you plugged with big wads of clay) keep pouring glue until it has filled your funnel. Now for all the precaution we have taken to prevent this, warm glue might force its way out of the seams of the shell or from the

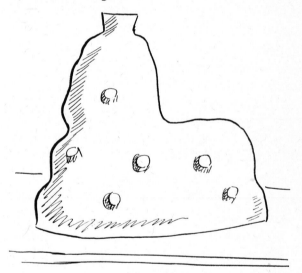

Fig. 114

The uncut glue mold should look something like this. The gobs of glue jutting out were formed by the keys and by the glue which flowed into the holes cut through the shell.

Now, with a sharp strong knife trim off the big lump of glue that had been left in the fun-

nel. And then with your sharp knife begin cutting at the tail end of the Cast Horse and cut the glue along the seam line into two halves—the same seam line as in the shell.

Cut carefully and keep separating the pliable glue mold with your fingers as you cut it into two halves. When you have cut along the seam line until you have separated the glue in two halves you will find the glue holds together in the hole shape under the Cast Horse's foreleg. Separate the glue carefully; then cut through that lump of glue until you have completely separated the halves of the glue mold.

With the well made glue mold and shell finished there is not much more to this job. Let's do the rest of it quickly.

Clean the glue mold of any chips of plaster that might have stuck. Then dissolve a couple of teaspoonfuls of alum in a quart of water. Dissolve the alum crystals completely. Then, with a clean brush paint on a generous wash of this alum solution on the inside of the glue mold and put it away to dry. This alum wash is to harden and preserve the surface of the glue. When the glue mold is completely dry, brush oil over the inside surface of the glue, then dust a generous amount of talcum into the inside and over the outside of the glue mold and brush it out again.

After brushing some talc on the inside of both halves of the shell, slap the glue molds into their place in the shell. The keys will hold the glue molds in their halves of the shell. Fit the whole business (the shell halves, each holding its glue mold) together. Tie the shells together with a twist of wire. Check on the inside of the glue mold with your fingers (lightly) to be sure the glue molds have not shifted in the shell. Just feel along the glue seam line with your fingertips and push the glue into place if it has moved.

Now mix a batch of good plaster. When it

Fig. 115

has rested a moment and become thin cream, pour it into the up-ended glue mold in its shell and roll and pour it once or twice (same as rolling Waste Mold Cast of Head). Then strengthen the head and the leg of this pouring of the new Cast Horse by inserting a piece or two of galvanized wire in their proper places. You can reach the head and leg easily from the bottom of the filled mold.

Let the plaster set and untie the wires that hold the shell together. Take off the shell, peel off the glue mold (gently, please—you don't want to tear the glue or break off a piece of plaster statuary), and now you have your first cast made with a glue mold.

This procedure is common to all glue molds. There is little variation to any problems that might come up in this process. It is simple, but it should be obvious now that because of the time it takes (it is always a two-day job) sculptors usually give out work of this type to be done by the technicians (the glue mold casters).

Here are a few things to watch while you cast with this process. Be careful that the heat of the setting plaster does not melt the surface of the glue mold. Get the shell off and the plaster cast out of the glue at the earliest moment you can, even while the plaster is still a little warm.

Almost any one can get about eight or nine plaster casts from a good glue mold that is properly washed with alum and properly oiled and talc'd. An expert glue molder may get a dozen or more good casts out, but after a while his glue also begins to go.

Apply the alum wash after every second or third cast to keep the glue surface. Too much alum will curl up the glue. Oil and brush with talc before each cast. Try to get all your casts done on the day the glue mold is cut. Glue tends to dry up, and if it is left overnight, be sure to tie it up in its shell as if you plan to pour plaster. Let it rest up-ended and cover its bottom with layers of cloth. Do not leave it overnight in a very cold room; that would either freeze the glue or dry it up quickly. Casting in hot weather with glue also has its dangers—the heat tends to melt the glue. So ice water is used in mixing the plaster.

The reason should be obvious now why a glue mold is rarely poured on a plasteline or clay model. The heat of the poured glue would melt up the plasteline or dry the clay surface so that it sticks to the glue molds. But experts (they are wonderful people) can cast glue on plasteline or clay. The secret of the method is to paint with a soft camel's hair brush many thin coats of shellac on the plasteline or clay model, allowing each coat to dry thoroughly, until they have built up a hard crust of shellac on the plasteline or clay. After oiling these models they protect them from the clay sheets by wet newspapers on the shellacked plasteline or clay model. Then they make their shell. Here is another trick. They let the glue cool before pouring until it is just lukewarm, and they get it out of the shell as soon as it can be safely handled. Since glue pours sluggishly in this cooler state, it is difficult for a novice to judge at what moment to pour.

This is a pretty smart process. I have on occasion cast glue directly on plasteline and clay, but I prefer the more certain method of casting on a good plaster cast.

COLORING PLASTER

Although, as I have said again and again, plaster is an intermediate material and nothing can be done to finish plaster to give it the feeling of permanence good sculpture material should have, sculptors are always tempted to try and overcome and cheer up the dreary look of dead white plaster. And too, we sometimes try to imitate in color the material for which we plan the final sculpture. This is called by some "patining plaster." That of course, is ridiculous since it is merely a process of painting and faking the natural patine of good material such as bronze and other metals, stones, terra cotta, wood, etc.

As a rule sculptors never do anything to a plaster cast until it is thoroughly dried out (and do not try to dry it out with heat—that weakens the plaster). But I have occasionally taken the curse off a still wet plaster cast by brushing on a very thin coat of orange shellac. The shellac affected by the chemical activity of the setting plaster has a rather interesting color effect. This method is unpredictable since the shellac may peel when the plaster is completely dried out. I do not guarantee the results. Any coat of shellac or paint applied to a still moist plaster cast may peel or develop a fuzzy mold as the plaster dries out. This mold filters through the surface coating for weeks. It is best to work on bone-dry plaster.

Here are some perfectly safe recipes for coloring plaster to imitate stone—Limestone, Sandstone—and for Terra Cotta—Grays, Buffs, Browns, Reds, Pinks.

Get a chip or sample of the material you plan to imitate, if you can. When the cast is thoroughly dry give it a few coats of thinned shellac. If you are planning a light color, use white shellac; if it is a dark color, orange shellac may be used. Let each coat of shellac dry thoroughly before applying the next. Then, on the dried shellacked surface paint a coat of Casein paint. Prepared Casein paint (a milk derivative) can be bought at any paint store. I find it more practical to buy the dry Casein flakes, melt them in hot water and then mix this gluey liquid with dry colors which are also bought at the paint store.

Nevertheless, however you get the paint, here is the usual procedure for its use. Merely paint it on to your shellacked plaster. One coat of paint that is neither too thin or thickly mixed will cover your surfaces. When the Casein is completely dry, a dusting of talc mixed with a little dry color applied with a wad of cotton wool will get rid of the painty look. Rubbing gently with a soft flannel cloth will give the sculpture a little polish. Do not polish too much because the limestones, sandstones, or terra cottas which can be imitated with this process do not usually take a polish.

Imitations of the lustrous marbles, granites, alabasters, or other stones which take a high polish and have interesting markings and crystals usually turn out pretty awful no matter what process is used. Even those done by the technicians who specialize in what they call patining plaster.

This is the method they use. On a shellacked plaster they paint the body color of the stone they plan to imitate. The body color is the main color of the stone. They use a mat paint (a non-glossy wall paint), or they mix dry color with turpentine and a little linseed oil. When the applied paint is thoroughly dry, they mix small quantities of paint the colors of the crystals that spot the stone. This paint is a thin mixture. Then they dip the tip of a dry brush into the paint and spatter it on the body-colored cast. The trick in this method is to hold your dipped brush with the bristles upright so that the paint splatters on the cast in tiny globs.

Some plaster patinières also try to imitate the streaks and stratas that happen in stone. That is called "marbleizing." The results are always horrible.

Here is a pretty safe way of imitating bronze casts.

Get some dry analine dye, such as is used for dyeing silks and cloths. Decide what bronze color you will try to imitate, say for a pretty good brown and gold yellow bronze, and proceed thus. Mix a strong yellow dye (just use water). Paint it on to a dry *unshellacked* plaster cast. Wait until this coat has thoroughly sunk in and dried in the plaster; that should take at least two hours. Then mix a sepia brown dye. Brush this dye on the yellowed plaster quickly, allowing the yellow to show through occasionally in the crevices and sometimes on the main shapes. When this coat is completely dry, soften some ordinary floor wax in the warmth of your hand until it becomes creamy, and lightly paint it over the surface. Or you can let a little wax melt up in your hands and rub your waxed palms lightly over the colored plaster. When the wax is dry, give it a gentle rub with a soft flannel cloth and you might have a pretty good (ferric acid) patine imitation. If it does not look metallic enough, a finger dipped in a little gold bronze powder (the stuff used for picture frames and available in any paint store) and touched up on the edges of the shape will make it look more metallic. Do not use too much bronze powder. It cheapens the effect.

Various combinations and bronze effects

are possible with this analine dye method. Always paint on the lighter color first, then brush over with the darker tone. For example, a green bronze effect could be made with a first coat of bright green dye followed by a quick wash of blue leaving a lot of green areas; then a third color, a jet black dye or a sepia brown, allowing the green and blue to show through in the crevices and on the main shapes. Then the wax.

Here is a combination for a handsome purplish-bronze patine which the French are fond of: an underneath coat of brilliant red analine dye followed by a coat of jet black washed over it as a second effect, and then the wax.

I have used the same combination for wood imitation (red mahogany and the harder, darker woods) by using thin washes of brown, jet black over the rich red body color, then a lot of wax, and polish.

The lighter yellow and golden-colored woods can be simulated with a yellow body and a thin wash of sepia and black.

There are two more methods used for imitating bronzes. One is to paint on a body color with oil paint thinned with turpentine and, just before this paint is dry and while it is still tacky, brush on dry colors into the crevices and over the main shape. When it is all thoroughly dry, pounce on some talc and give it a gentle rub with a soft cloth. The second system is to stipple, with a long bristle brush, wax and combinations of dry color on a shellacked plaster and then polish. These two methods tend to pile on too much crusty paint to suit me.

Here is one last method, used by professional plaster patinières, which I do not like. It is a business of painting thin lacquers of varicolored bronze and gold paint, and finishing up with a wash of varnish or lacquer mixed with sienna or umber. The darker bronze paints are painted on first, then the lighter ones, and finally the color. But as I said before, bronze paint looks pretty cheap and flecks off plaster sooner than the other methods already mentioned.

Aluminum is easy to imitate.

Paint a rich red analine dye as a body color. Apply a few coats of shellac, followed by ordinary aluminum paint (the same aluminum paint which is used on radiators and roofs). When the aluminum paint dries, apply a wash of dry color (black or umber) using a little oil and turps as a medium. Rub it down with a soft dry cloth leaving some of the black and umber in the crevices and on the surfaces. It will be difficult to tell this imitation from the true aluminum if it is done right.

PLASTER SCULPTURE PAINTED FOR OUTDOORS

Incidentally, that same aluminum paint mentioned above, Casein, and regular house paint are the only paints which will preserve cast plaster if the sculpture must be exhibited outdoors for a short period. All the other paint or dye combinations will wash off with the first sprinkle of rain. But even these good paints (aluminum, etc.) cannot prevent the plaster from rotting if it is out in the weather more than two or three weeks.

Finally, color can be applied to plaster casts not as an imitation of other materials but just for fun and to cheer up the looks of it in the same manner that the Eskimos painted their totem poles—bright cheerful strips or areas of color. But using color like that requires a lot of sculpture wisdom and a well-developed esthetic taste, so be wary if you attempt to use color in this manner.

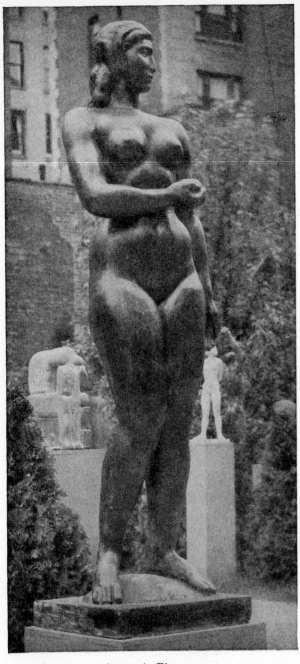

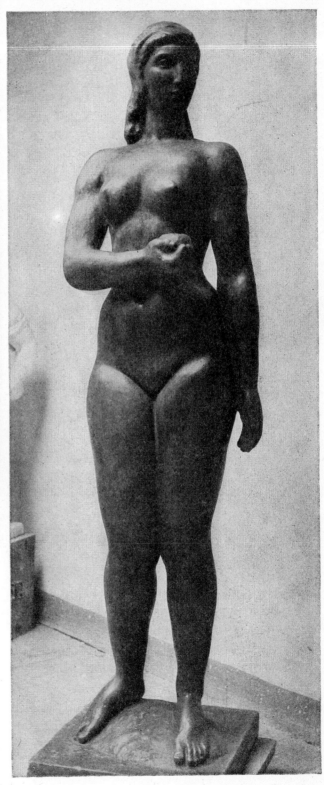

(BELOW) *Fig. 116. Shulamith*. LOUIS SLOBODKIN.
This 7-foot plaster figure was patined with a red and jet-black analine dye. Then it was given a rub of wax. It made a pretty good simulated bronze. The process has been discussed in the text.

(ABOVE) *Fig. 117*

The *Shulamith* figure was exhibited at the first Sculptors' Guild Outdoor Exhibition. I gave her a number of coats of Spar varnish to protect her from the weather. Spar varnish is used to weatherproof wood railing aboard ships. In spite of this powerful varnish, after a few rainy weeks areas of the plaster surface were pock-marked and rotted from exposure. This photograph was made after the figure was out in the open just two weeks. The legs and base already show the scars of weathered plaster.

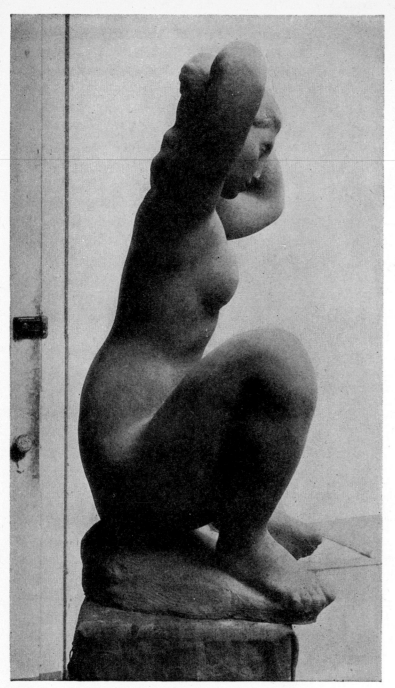

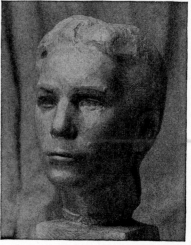

Fig. 118. *Bathsheba*. LOUIS SLOBODKIN. Simulated terra cotta. This life-sized version of the statue was given a coat of Casein and dry color and then a little rub with talc. It has been exhibited around the country but has never been shown outdoors. I do not think it would weather very well unless it had a few more coats of Casein. This process has been described in the text.

Fig. 119. *Head*. LOUIS SLOBODKIN. Head of simulated aluminum. This process is described in the text.

6.

Composition in Sculpture

THE time has come, now that we go deeper into the permanent materials of sculpture, to consider composition. Because if you do create sculpture in some permanent form, it would be best to live with a well organized stone carving, wood sculpture, terra cotta, or bronze as a permanent record of your achievement.

Every time a sculptor creates a piece of sculpture he not only executes it, he composes. Even though in an over-all shape he may be restricted by the limitations of material or other conditions, he accepts these restrictions and composes and executes within these imposed limitations.

A musician may never have composed one bar of music. Such a musician, instrumental or vocal, is an Artist Virtuoso. The music he interprets may have been composed by Beethoven, Schubert, or Palestrina. In turn these great composing (artist) musicians may have been unable to render an account of their own music, for all I know, on any instrument. Definitely they could not sing their music as well as a top rank vocal artist. A dancer (an artist)

may never compose her own dance movements. The choreographer is the dance composer. The same thing holds true of an actor who speaks, moves, and gestures according to the planned composition of a playwright and a stage director. And there are many other art forms wherein there are at least two creative artists (the composer and the virtuoso) essential for the execution and composition of one esthetic expression.

But in the plastic and graphic arts—sculpture, painting, drawing, and sometimes architecture—this condition does not exist. And that is particularly true of sculpture. For the composition and execution of sculpture are completely interwoven and interlocking forms.

A simple head created by a sculptor is a composition in itself or it is nothing. The placing of the units of the shapes of the head and neck, the momentous decision on how the smaller shapes of the mask are to be arranged, what is to be emphasized and what subdued, the choice of movement of the related and counteracting planes to the fullnesses—all that

is the sculptor's responsibility. That is composing and executing an esthetic expression at one and the same time by one artist. And too, that procedure is true in all phases of sculpture.

When I suggest now and then that the novice compose or arrange shapes in relation to the material or problems of sculpture, I assume his natural sense of composition will adjust and arrange shape to shape within the main unit in the same sense that he would place pieces of furniture and rugs around his living room or objects on a desk.

These units of furniture or other objects within the room or on the desk must be placed so that they will relate to each other in size and function, and satisfy the individual taste of the arranger. Crowding all your large pieces of furniture in one corner of your room and leaving the rest of the room sparse (unless this arrangement has some good logical reason) is ridiculous. Any placing or emphasis of the large shapes of a sculpture piece which would tend to unbalance and weaken the main over-all unit—that way lies madness too. That is a simple principle—not a law.

Rules on composition, like all other esthetic rules and laws, are made to be broken. But there are some general principles that seem to be evident in all great sculpture. Now and then comes a new, strong, sculptural voice (a fresh contemporary or rediscovered ancient) who appears to shout down these principles. And when the newness of that great sculptural voice wears off and becomes a familiar sound, we find he too is shouting the same primary principles of all good sculpture composition.

I believe that sculpture should be strong—that it be balanced—that its shapes be varied —that the main motive grow within its main shape—that it be composed organically of interlocking, flowing, complementary and contrasting geometric shapes within a main unit —that the material with which it is executed be not misunderstood and crippled into a shape that is foreign to the healthy natural desire of that particular material to retain its own character. . . . And there are hundreds of other ideas (more and better) about what makes good sculpture composition.

A sculpture composition cannot depend upon its quality for subject matter alone. The greatest, kindest, noblest, handsomest hero that ever walked the earth is no better a subject for sculpture than the humblest, dumbest little calf that ever lived. This colossal hero subject may have no importance at all if it is badly handled, while the dumb little calf may become a priceless jewel preserved affectionately for thousands of years because the few shapes that make him in stone were dealt with so well.

And that is true of the highest emotions known to man—motherhood, love, sacrifice, sympathy. Expressed poorly in sculpture these emotions may become weightless, mawkish sentimentalities. And yet a grinning little man twirling a fan, interpreted in sculpture by some Chinese master, may have tons of meaning.

A sculpture composition cannot depend on a tricky line. In fact, the less you think of line as you compose sculpture the better your sculpture should be. It is the shapes and arrangements of shapes that make sculpture and not lines. I remember some talk by drapers and fashion designers, that the "S" line is the line of beauty! It may be with them but has nothing to do with beauty in sculpture. I have heard comment that this or that piece of sculpture is not too good (etc., etc.) but it has beautiful linear composition. That means lines again—lovely, flowing, bobbing and weaving, interlocking, going and coming, sweeping

lines! How does that sound in Granite?

Tricky lines, tricky shapes, tricky materials, tricky subject matter, tricky execution—all tricks have nothing to do with sculpture or the composition of sculpture. They are just tricks.

"Sculpture composition should be simple—it should be strong . . ." there is that familiar refrain again. And by simple strength and so on I do not mean mere clumsy weight. That is not strength. It is either incompetence or vulgarity.

I should like to make a suggestion which I believe might help a student develop his own individual ideas on composition in sculpture. Draw sculpture shapes; they need not be shapes of any definite object or subject—just shapes. Try constructing shapes that have an abstract meaning. Create strong shapes, tragic shapes, happy shapes, embracing shapes, gentle shapes, and fool around a little and see how you would express any of those ideas or anything else you might think of with shapes that you never saw before.

Look around you at growing living shape. The Good Lord (or Mother Nature) is a master designer. Study the balance and growth of tree shapes, plants, hills, people, rocks, shells, or whatever you are looking at.

Don't be taken in by any schemes presented to you as shortcuts and guaranteed results on how to compose like a master in a dozen easy lessons. There are no such lessons.

There are no short cuts, no guaranteed methods, no promises in anything I have written so far as to what I believe a student must do to develop his sense of sculpture composition. All I said is that it is my conviction that "sculpture must be strong, simple . . . balanced. . . ." There's that old record again. But that is what I believe.

7.

Carved Mediums of Sculpture

SOMEONE said (some nameless someone is always saying something) carving should be easier than modeling because whereas in modeling one starts from nothing and builds living shape, in carving the shape already exists in the stone or wood, and all a sculptor has to do is chop away his excess material.

Yes, all a sculptor has to do is to rid his block of stone (or wood) of the excess material and release the idea of shape he must already see in the block. That is not any easier nor is it more difficult than creating shape out of nothing. Although the mechanics of modeling at first glance (because of the malleability of clay) might seem to permit a quicker realization of sculpture shape than carving stone or wood, a second glance and we realize that the existence of the natural sculptural quality of any stone or lump of wood compensates for the plasticity of clay. That although we can build up quickly in clay (after we have learned the mechanics of modeling), it may be more difficult to achieve solidity, volume, unity, and all the other qualities of good sculpture in clay than in stone or wood, since both these mediums (stone and wood) in their natural state already have those qualities of good sculpture. In carving, one of our main concerns is to recognize those good elements in our material and to avoid as much as we can chopping out and destroying these contributing qualities with cold steel chisels.

Stone Carving

A STONE is carved with your head and a few other tools.

The procedure is simple. There are five main steps. The first is the most important.

1. Use your head. Study your stone, its grain and texture. Then decide and make a sketch of what you are going to carve.
2. Use your point chisel. Knock off largish chunks of stone until you have roughed the approximate shape of your sculptural idea.
3. Use your tooth chisel and clear up your shape further.

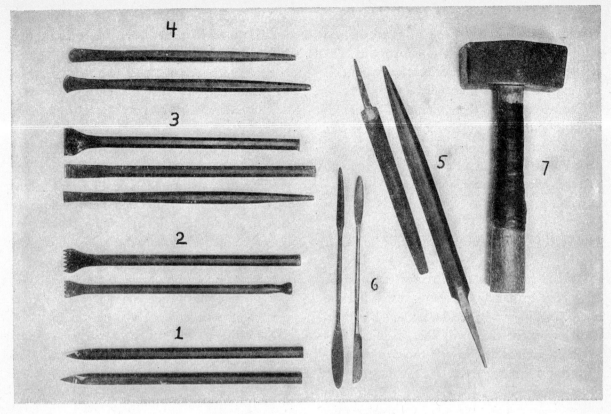

Fig. 120. Tools for Carving Stone

1. Point chisels used for roughing out.
2. Tooth chisels.
3. Flat chisels.
4. More flat chisels.
5. Large rasps.
6. Fine files.
7. Stone mallet.

When not in use these tools should be cleaned and wiped with a little oil.

4. Use your carving chisel and carry on.
5. Finish with chisels, files, and polish with abrasives or not.

PICKING YOUR FIRST STONE

For your first carving pick one of these stones: a piece of alabaster, lava ash, Colorado stone (a handsomely colored alabaster), soapstone.

These stones, or stones with similar texture, are available. They carve easily and let no one scoff at their durability. Thousands of years ago the Egyptians, Assyrians, Chinese, and many other master sculptors carved beautiful statues in these materials, and we can see their exquisite sculpture carved from these soft stones in our great museums today.

Try to get one of the stones I suggested. If you cannot, pick a chunk of building limestone (Indiana limestone) or one of the sandstones, or, if nothing else is available, a piece of one of the sugary marbles (Vermont marble) or something similar. Do not start your first carving in one of the harder or more

brittle marbles. And leave boulders, fieldstone, volcanic rock, or any form of granite alone until you know something about carving. For if you pick a difficult medium for your first carving I fear your first will be your last.

Choose a stone, the volume of which is roughly about one cubic foot or a little less. The objection to a larger stone is obvious (too much work). And too small a stone will present other discouraging features.

HOW TO GET YOUR FIRST STONE

A good stone, the size I recommend, is not very easy to get. Stone yards that sell large quantities either will not be bothered with so small a unit or they will charge you a fantastic price. It is best to visit the workshop of your local stone carver. He might sell (or give) you a piece of stone fit for your purpose. Or if you are related or friendly to a good-natured building contractor, he might give you a nubbin of stone some quarry has sent him as a sample. Or get the addresses of the stone quarrying companies, and write them a polite letter (with or without an offer to pay cash C.O.D.), and they might ship you a nubbin. Incidentally, a "nubbin" of stone might be a lump of stone varying in size from less than 1 cubic foot to 3 or 4 cubic feet. If you get a big piece, read the section on "How to split a stone" (*Fig. 134*).

My last (and perhaps most practical) suggestion on how to get a piece of stone is to poke around your neighborhood until you find some stone building being torn down. Get friendly with the boss wrecker and beg or borrow (or pay for) a likely piece of stone that you see in the rubble. You might get a piece of one of the sugary marbles or a block of limestone or sandstone.

No matter how you get your first stone (and I hope it comes hard for reasons that follow) you will have had, perhaps, your first contact with people who work with stone. That in itself is a good experience. If you visit the stone yards you may have seen huge blocks of stone piled like cordwood or immense slabs of marble being sawed (literally) or twenty-ton blocks being moved about. The building contractor (the friendly one) might have talked about stone and let you look at various handsome polished stone samples contractors usually have around their offices. At the workshop of your local stone carver or gravestone carver you might have seen them at work while you waited timidly to bleat your plea could you have a piece of stone.

Even the wreckers who are tearing down the stone building contribute something to your knowledge of stone, if you watch them working with your mind open.

Therefore, if you have had a rocky path on your way to acquiring your first stone and had to hike around, and spent some time talking to and watching the people who work with stone it is all to the good. If you are a novice (and I assume you are for you have no reason to read about stone carving in this book or any other if you are not), you have had your first taste of stone dust and your first feel of stone and are now ready to begin carving your first sculpture in stone.

Study your stone. What does the shape, color, grain suggest to you? Can you see a good idea for sculpture in its shape? Make some drawings of your sculpture idea, remembering always this idea must fit within your stone shape. Now build up a lump of clay that is about one half the size and shape of your stone. Quickly model the idea you intend to carve—just block in the masses. Will it look good in stone? Very well, then, carve away.

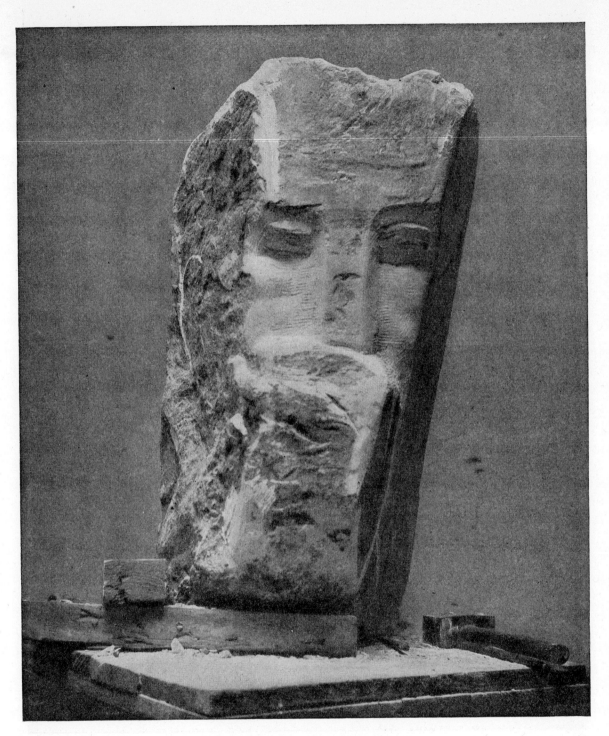

Fig. 121. Godhead. LOUIS SLOBODKIN.
Colorado stone. This 300-pound stone decided its own destiny.
The natural shape of the stone had such imposing dignity I could
see nothing less than a godhead in it.

Fig. 122. Bather. LOUIS SLOBODKIN.
French limestone. This 600-pound stone was purposely photographed in this harsh light to point
out a stone flaw that troubled me as I carved. When I got into the stone, a sand pocket was un-
covered that ran the whole length of it. The dark spot under the chin and those dark streaks
down the breast and arm and again on the inner thigh show its course. The stone was finished
and the hole left by the sand pocket was filled with a paste of Keene cement, dry color, and
water. The stone has been exhibited outdoors, and the patched surface is not too obvious.

Fig. 123. Stone Carving Photographic Demonstration
My half-sized clay model for *The Proprietor* is alongside my
stone. The possible placing of the shape planned is marked on the
face and sides of the stone. Draw on your stone with chalk,
greaseless crayon, or opaque water paint. I used opaque white
paint here. Do not use oil paint on stone. Oil sinks into and stains
the stone.

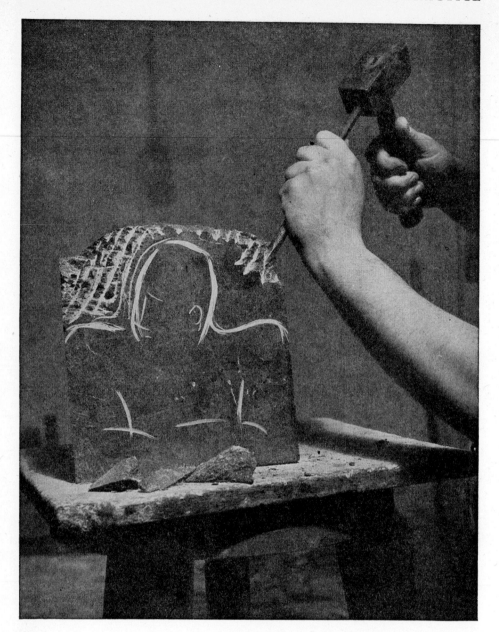

Fig. 124. Roughing Out with the Point Chisel
Note the angle of the chisel to the stone. Do not try to drive
your chisel into the middle of your stone—you will just break
your point and do no good. Swing your mallet free and steady.
Hold your chisel lightly so that the force of the blow from the
mallet follows through the chisel and is not stopped by the
restriction of your desperate (blister-making) grip. Rough away
working around your stone.

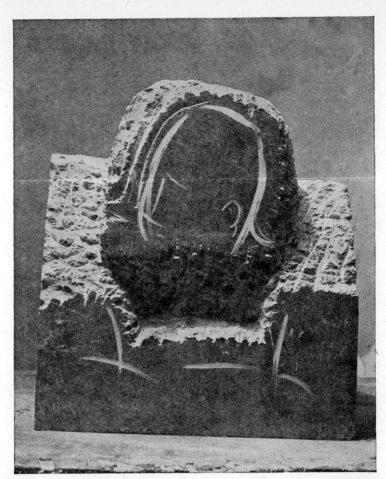

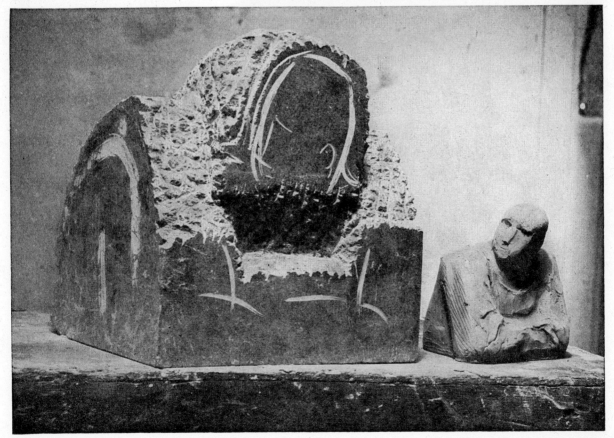

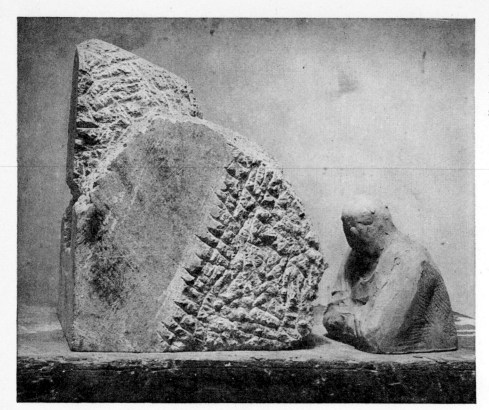

Fig. 127
Still another view of roughed
stone. Note that head shape in
the stone. The stone limitation
will force a change in my first
sculpture idea.

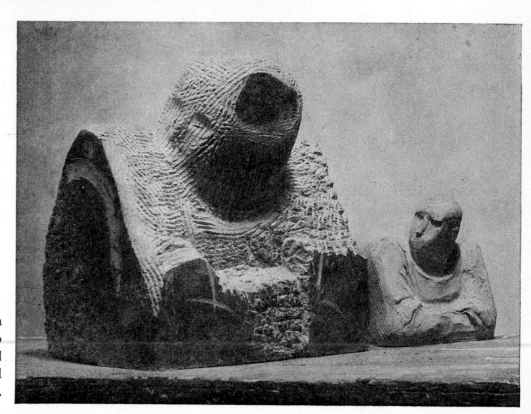

Fig. 128
Begin carving with
tooth chisel. Clear up
shape, work around
your stone. The original
surface is still with us.

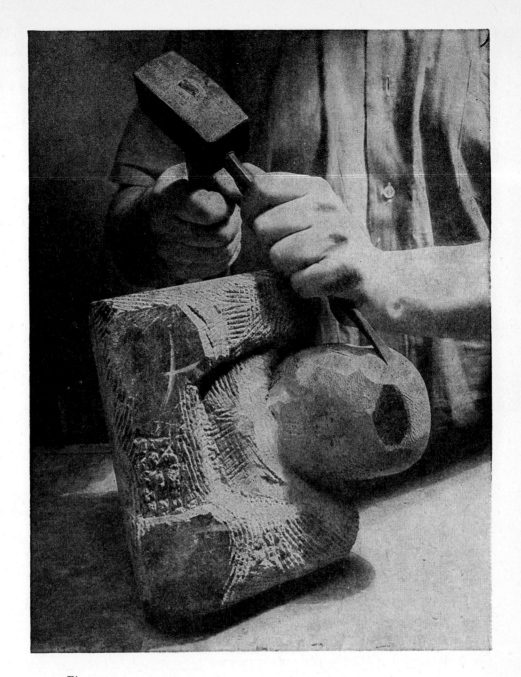

Fig. 129

The stone has been roughed and tooth-chiseled. Now begin working with flat carving chisel. Note the angle of the chisel to the stone. It is held almost parallel to the stone surface and cuts across.

Note the hand holding chisel grasps it lightly. The thumb helps direct the chisel.

FINISHING A STONE

A stone should be carried as far as possible with the carving chisels before any attempt is made to finish it by filing and polishing. In fact, a stone chisel-finished has more life and is pleasanter to the eye than a stone which has a polished surface forced on it before its shapes are properly carved.

Files such as are pictured in *Fig. 120* are used to grind and cut a stone surface down to a finish. The soft stones which I suggested (soapstone, alabaster, lava ash) can be finished with files, a rub with a pumice stone, various grades of sandpaper, and finally, whiting (putty powder).

Marbles are finished with files, then stones of varied coarseness, ranging from carborundum and various grades of sandstone to the soft pumice stone, are rubbed over the surface; then a hone and finally whiting. It takes a lot of time to polish a stone and plenty of elbow grease. Keep the stone wet as you polish.

CARVING MARBLE

The method described and illustrated in the preceding pages is used for all marbles, limestone, sandstone, as well as the softer stones. One variation is in the tempered hardness of the chisels used. Other variations from this described method will be effected by the grain and brittle qualities of some marbles.

Watch for flaws in all stones and marbles. Wet your marble all over and if you see a deep-grained dark streak which seems to go through it, be wary. Tap the block lightly with your iron mallet. Does it ring clear or does it give off a dull, cracked sound? You might find after you have advanced your carv-

ing that suddenly your marble splits away, along that ominous dark streak!

Two other pitfalls to be watched are:

1. The variation of texture in some beautifully marked marbles such as the handsome black and gold marble. The darker portions of this stone are softer in texture than its light gold-colored streaks. These fine golden streaks are as hard as iron—there might be iron in them that gives them their color. In carving this marble you will find because of the variety in its texture your chisel "jumps" and you will have an unwanted, varying shape.

2. Another variation—some hard marbles; for example, the glossy Belgium black marble is almost as brittle as glass. It tends to shatter away crisply as you carve. Watch the grain and be wary as you work.

Perhaps the most consistently textured of the harder marbles available in America is Tennessee marble. It is not as handsome as some other more difficult stones, but it is safer. And occasionally I have seen some very handsome blocks of Pink Tennessee.

GRANITE

Working granite is something else again. For granite is a hard and most difficult medium. And because of its formation (it is composed of crystals fused together by great heat and pressure instead of stratification like marbles and most other stones), you do not carve granite—you bruise it! By that I mean, whereas in carving marble or any other stone (other than granite) you carve across surface slicing off the stone, so to speak, granite crystals must be broken and bruised by pounding down directly with your heavy chisels and hammers.

Here is a quick resume of the process used for working granite.

If you begin to work on a largish granite block, it must first be bull-pointed as you rough it to the shape of your sculptural idea. Bull-pointing is usually a two-man job. One man holds a heavy hard-tempered steel chisel while the other swings the sledge hammer.

A small block (about a cubic foot) is first roughed with a heavy point chisel. Then the granite crystals are crushed further with a pick (a pickaxe-headed hand hammer). Then a brush hammer. That is, a heavy square-headed hammer with a waffled striking face.

Then after a few months (you beginners) which you spent crushing and mauling the surface of the granite down to what might be the shape you want, you carry it further with chunky flat-tipped chisels and mallet, until you are finished. Polished or not (with a car-borundum stone and other abrasives) and it is done. You have spent a lot of time which you could have used to develop a form sense by some much more sympathetic medium or studying the many other problems that confront sculptors.

After you are well matured in sculpture and plan to express your ideas in granite, you will have found out all I have written thus far on that medium and a lot more through the normal channels of development as a sculptor. This short bit on granite is not presented so much to inform the novice on how to work granite, but rather to warn him off. I have known many fledglings who have given up sculpture as a medium of expression because too early in their careers they ran afoul a piece of granite.

I do not approve of granite as a medium for beginners.

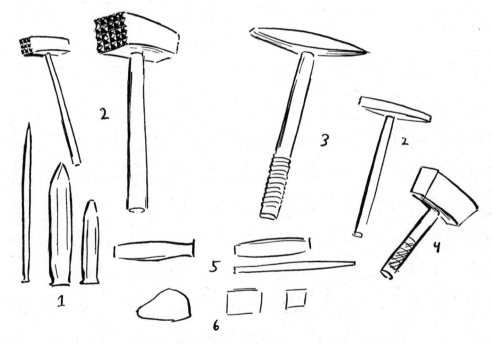

Fig. 130. Contemporary Granite Tools

1. Points (these are the heavy point chisels). 2. Bush hammers. 3. Pick. 4. Stone mallet.
5. Chisels. 6. Varied shape polishing stone.

Fig. 131. Egyptian Carving Tools
These chunks of rock were used the way our bush hammers and pick hammers are used to wear down and crush the stone. Courtesy of The Metropolitan Museum of Art.

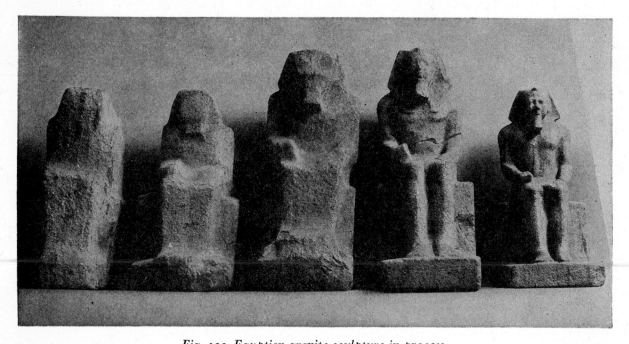

Fig. 132. Egyptian granite sculpture in process
This interesting collection shows pieces of granite sculpture which for some reason were discarded in process. It is obvious here that the methods of the Egyptians are similar to those we use in these days: roughing out, perfecting, and finally finishing. Museum of Fine Arts, Boston.

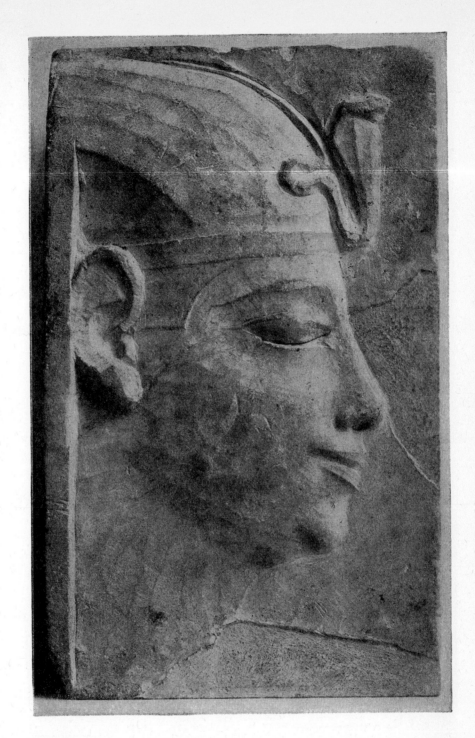

Fig. 133

A piece of unfinished Egyptian sculpture carved in limestone. The chisel marks are clearly evident. Courtesy of The Metropolitan Museum of Art.

HOW TO SPLIT A STONE

Find a strata marking along the grain around the stone. Carve a deep (about 2-inch) wedge-shaped groove with your point chisel along this strata marking. After the groove has been carved all around the stone, drive a strong, broad, flat chisel into the groove at points 3 or 4 inches apart. When the broad heavy chisel has been pounded into the stone at about four or five points the stone should split. If it is stubborn, carve your groove deeper and drive your chisel again. The stone will surely split.

The soft stones, and some marbles too, can be sawed with an ordinary carpenter's saw. This is a longer and more tedious process and not so good for the saw, but the stone can be cut exactly where you want it. In splitting a stone with chisels the stone usually splits roughly where it wants to split.

CLEANING A STONE

Deep-seated oil or grease stains cannot be removed from marble or any other stone. Surface grime and surface discoloration (such as rust, etc.) can be washed off a marble or limestone with a weak solution of oxalic acid, a stiff brush, and lots of water. When applying the oxalic acid wash it off quickly. It tends to eat into and rot your stone. Some stones can be cleaned with soap, water, and a good stiff brush.

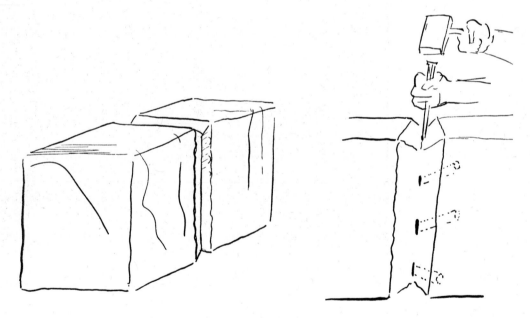

Fig. 134

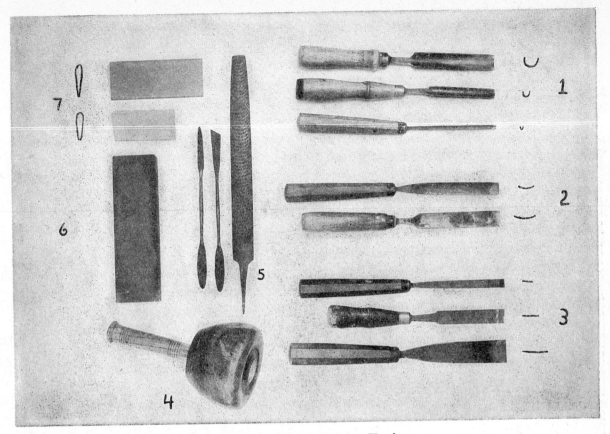

Fig. 135. Wood Carving Tools

1. Gouge chisels for roughing out and cutting across grain.
2. Curved chisels also useful for cutting across grain.
3. Flat chisels. 4. Wood mallet also used for wood and delicate stone carving.
5. Rasps and files. 6. Oilstone for sharpening flat chisels.
7. Arkansas stone slips, used for sharpening shaped chisels. These come in various shapes to fit the chisels. Lard oil or some light oil should be used when sharpening chisels. When not in use these tools should be cleaned and wiped with a little oil.

Wood Carving

TRY to get a block of mahogany for your first wood carving. Mahogany is so smooth-grained and consistent in texture it is a pleasure to carve. Lacking mahogany, get a block from one of the fruit trees (pear wood is good). Avoid the pines, cedars, firs, or any of the resinous woods.

Whatever you get, be sure the wood is well seasoned. That means that the block has been sawed a long time ago and has been thoroughly dried out. A block of wood from the beams of some old house or barn makes a fine piece for carving.

HOW TO GET A BLOCK OF WOOD

Visit a lumber yard. There might be a block of wood knocking about the yard that is just

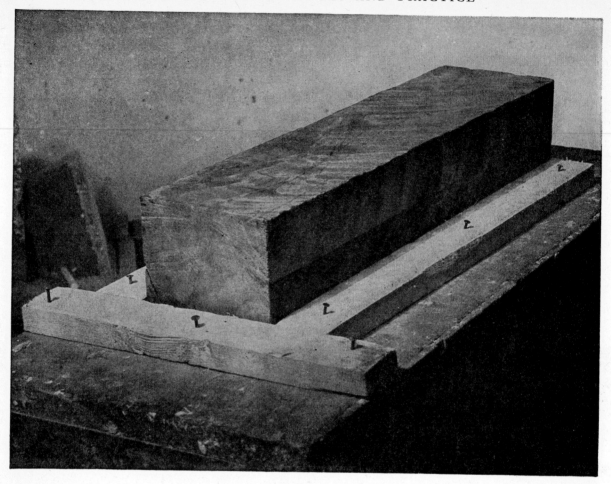

Fig. 136
If you have a strong work bench with a good wood vise, pay no attention to this illustration. If you do not, build yourself this simple jig to hold your block. As your carving advances use wood wedges to hold your block firmly in place.

what you need, or the lumber man might tell you where you can get one. Visit your local cabinet maker. He might sell you a block of wood or advise you where to get one. Or visit a wood-turning workshop. You might get a block there. As you visit various people who work with wood, try to get them to talk about wood and let your eyes wander around their shops.

Here again you sniff up some sawdust (the

same as you chewed stone dust when you were concerned with stone) and listen to talk about this new medium you aspire to tackle. In talking to the various craftsmen I suggest you contact before (and after and during) the time you study their craft, try to keep the conversation restricted to technique. Do not wander off into talk on art. The wood technician's ideas on art contribute nothing to your development any more than the stone cutter's

thoughts on beauty. But their knowledge of their craft is of inestimable value to you even though they believe the highest attainment in wood is carving jigsawed Swiss cuckoo clocks, and the zenith of stone carving is intricate marble whirligigs. Then close your ears to their art talk (and do not advance any esthetic theories of your own). Listen carefully and watch sharp for anything you can pick up on craft.

HOW TO CARVE
YOUR FIRST WOOD

Study your wood block. Draw your sculptural idea. Make a half-size clay model of the sculpture you intend to carve. It should be a compact solid unit of shape that moves with a consciousness of the wood grain.

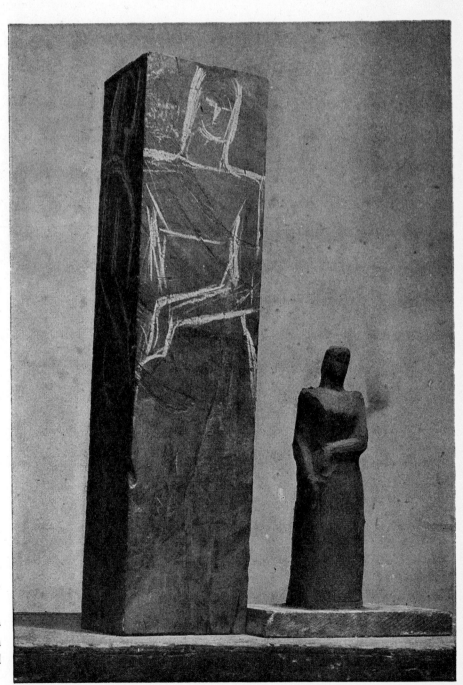

Fig. 137
Draw the potential placing of your composition on all sides of the wood block. Use chalk.

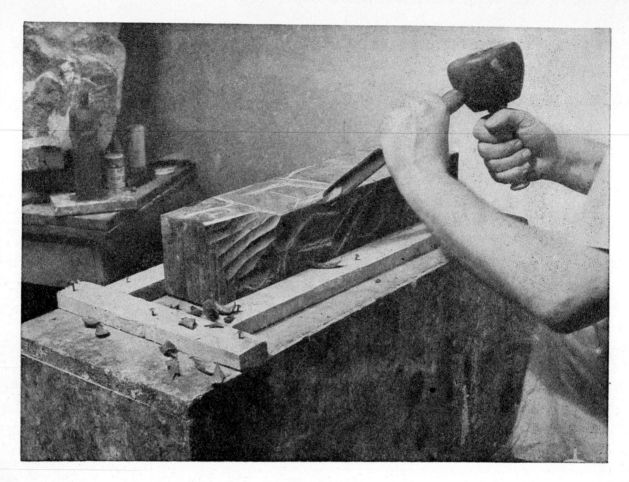

Fig. 138

With a deep gouge chisel begin roughing out the shape. Carve with the grain, not against it. This chisel bears the same relation to wood carving that the point chisel has to stone carving.

Note the angle at which the chisel is held.

Swing your mallet. Carve crisp. If the chisel sticks, do not wiggle it out of the wood. Pull it out straight or else you will break the edge off your chisel. Keep your chisel sharp.

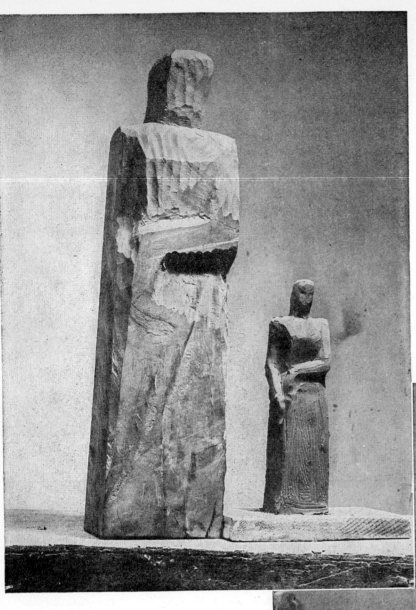

Fig. 139
The main shapes are almost roughed out with the gouge chisel.

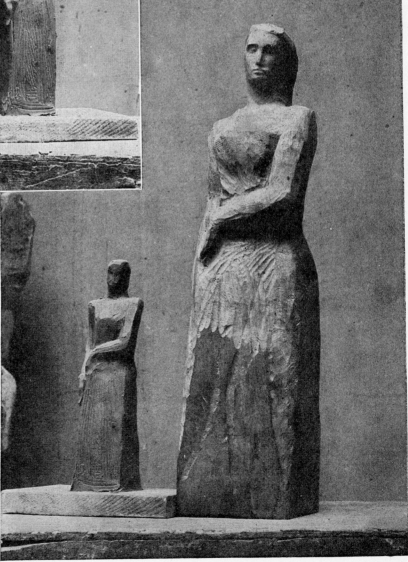

Fig. 140
Medium gouge chisels have been used. Flat chisels have advanced the head. Now *keep your chisels sharp.*

Yes, keep your chisels sharp and you will enjoy carving wood. Keep a razor's edge on them by constantly sharpening. Occasionally, take a batch of wood chisels to a professional chisel sharpener and have him renew their life with a good going-over. For unless you are a well-practiced tool sharpener, you will never get the beautiful nickless edge he can give your chisels.

FINISHING WOOD

A wood carving should be finished almost completely with chisels; then, if you must, rasp the surface and go over it with different grades of sandpaper. Finally, give it a rub with ordinary floor wax, a good polish, and it is done. It is best to paint on a thin coat of shellac before applying the wax.

No matter how well seasoned your wood is after you have carved it, you will often find that long cracks appear in the wood. These cracks are called checks. Checks tend to widen and grow longer as the work advances. Often they appear in a completed wood carving. One way to avoid checks while carving is to paint a thin coat of shellac over the section of wood you have carved after every spell of work. But this method will not guarantee the wood

against checking later on. If checks do appear, they can be repaired with a paste made from the scrapings and filings of the same wood mixed with a little melted carpenter's glue. Fill the check with this paste and hope for the best. If a check becomes really big, fill it with splinters and wedges cut from the same wood; then use the paste.

Another precaution to prevent checks in wood carving is to keep the wood at a cool, even temperature. A finished wood carving should not be kept in a steam-heated room.

Wood carving that has held together and lived through the centuries (though they too are often seriously checked) are in such good condition because the whole surface of the wood was covered with coats of paint: for example, the ancient Chinese and early Gothic carvings; or because the wood was laminated (sawed into smaller blocks and glued together before carving) or the log of wood was hollowed out at the core (by gouges or by being burnt out) before carving. But this is going into this subject in a big way. If you plan to stay with wood carving and leave all other forms of sculpture, we are leaving you here. Get going and find a job in a wood carving shop so you can learn the ten thousand things there are to be learned about the techniques of wood carving while we go on to the other permanent materials of sculpture.

8.

Terra Cotta

TERRA COTTA as a medium of sculpture is as old as the history of man.

This medium is merely fired clay. Yet it is more permanent than carved wood and about as long-lived as stone. There are a number of methods used for preparing terra cotta clay for firing. In the following pages I demonstrate the methods which incorporate the general procedures for preparing clay work for the firing kiln.

A kiln is the oven wherein the dried clay model is baked (fired) at a steady high temperature until the clay is as hard as a brick. In fact, it is a brick, since bricks are made that way. Be sure there are some working kilns not too far away from your workshop or studio. It would be senseless to prepare some clay models and then find, after your clay is dried and ready for kiln, that there is no kiln available. Look up your local potter and ask if he will accept your clay for firing. Perhaps there is a school with a ceramic department that will fire your piece. And my last suggestion: Perhaps a tile company or brick yard will make space for you in their kiln.

MATERIALS

Get a tub of terra cotta clay from one of the firms who deal in modeling clay or consult your local potter, school, tile works, or brick yard about clay. Clay and a handy kiln are all you need to make terra cotta sculpture.

The clay used for terra cotta is a water clay and is a little more expensive than the ordinary water modeling clay. It comes in a variety of colors and textures, and when it is fired its color varies from ivory to deep red. This clay has a fatty texture and is a wonderful plastic medium for modeling.

Occasionally coarse ingredients called grog are mixed into the clay before it is modeled. This clay fires to a very hard and interestingly textured terra cotta.

Working terra cotta clay has many features. What endears it to me particularly is that I can quickly register some sculpture idea (for stone, wood, bronze, or some other medium) in this clay, then set it aside and dry it out. At some later date I gather a batch of these clay sketches and have them fired. Thus with-

out the bother of casting I have a permanent record of my sculptural ideas.

Here follows the general procedure for three methods for preparing clay for terra cotta. All three have these procedures in common.

A statuette with no armature is built up on a clean board. The clay must be of even texture throughout (no lumps) and must be packed solid as it is built up, allowing no air holes. These air holes, if left in the clay, would explode when the piece is fired and not only bust up your sculpture, but they might injure the clay work packed into the kiln with your piece. Do not apply your clay sausages and pellets loosely when building up a model for terra cotta.

The clay is modeled, then allowed to dry up gradually. When it has dried away from its baseboard it is carefully picked up and placed on a sheet of clean paper. Then it is set aside in a dark, draftless corner of the studio. There it is allowed to dry out completely. There is an approximate shrinkage of one inch to the foot in clay prepared for terra cotta, so be sure to allow for this shrinkage in your planned sculpture. If you plan a piece about one foot high when you model your clay, make it thirteen inches high. The inch will shrink away.

After a few weeks, when the clay is *bone dry*, it is carted off to the kiln where it is fired, and you have a piece of solid sculpture good (if it is good) for a thousand years or more. Simple, isn't it?

Here is the first method.

DIRECT MODELING FOR TERRA COTTA

Note that the thickness of the walls of the gouged-out main shapes are about equal to the volume of the loose units of the arms, neck, etc. That is the secret of preparing all clay for firing. Since fired clay contracts, all volumes of the clay must be of an approximate equal thickness so that it will contract evenly all over. A thick mass of clay may pull at and break a thinner unit. Keep the clay even throughout.

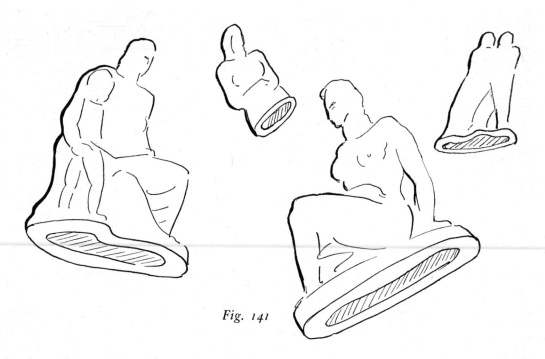

Fig. 141

Fig. 142
This is the sketch for *The Proprietor*. It is a quickly indicated idea planned for stone. The clay is solid. The surface may or may not be smoothed over.

Fig. 143 (BELOW)
The clay is still moist. But it has dried out enough to be handled safely. Gouge into the bottom leaving a shell of clay of an even thickness throughout. Place the clay model on a clean sheet of paper. Since the clay contracts as it dries out, this paper permits contraction. Now let it dry thoroughly in some darkened draftless corner of your studio until it is *bone dry*. Then have it fired. That's all!

This method can be used for all compact designs planned for terra cotta sculpture. Here is a typical group of ideas that will work in terra cotta prepared by this method.

SECOND METHOD
DIRECT MODELING
FOR TERRA COTTA

Design a solid unit of sculpture that has an
even volume through all its shape.

Here is an example.

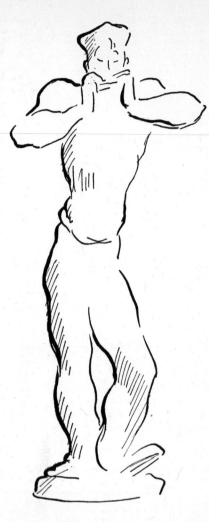

Fig. 145

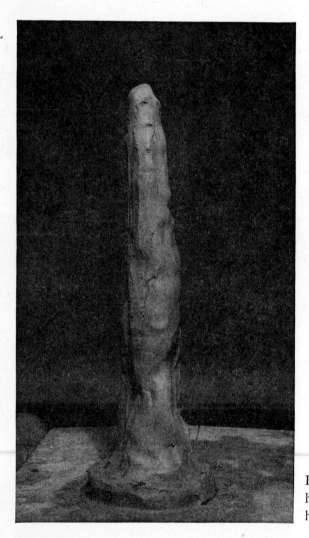

Fig. 144

Build up a solid lump of shape. As the clay
hardens, wet the surface and build the shape
higher.

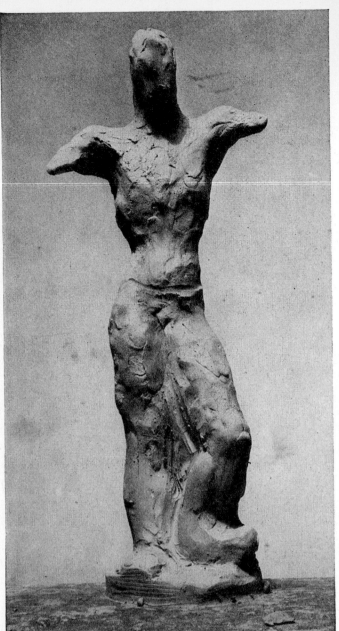

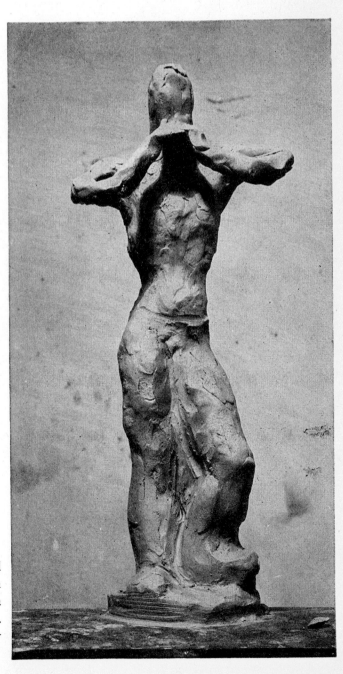

Fig. 146
Shape built up. Draw the head and the arm shapes out of the main clay lump. Build on clay and allow no air pockets in the clay shape. Let the clay solidify as it advances. Be careful in covering this clay overnight. Use very light, well wrung-out cheesecloths, or else the weight of the clay cloth will pull your clay shape awry.

Fig. 147
Arms indicated. These arms are attached to the clay the way handles are laid on cups or vases by potters. Look at a porcelain cup and you will get the idea. Let clay get stiff before going any further.

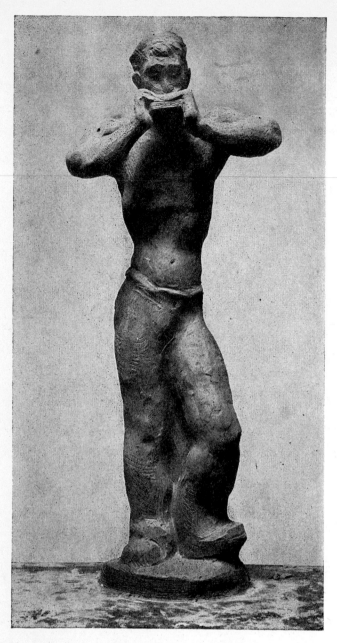

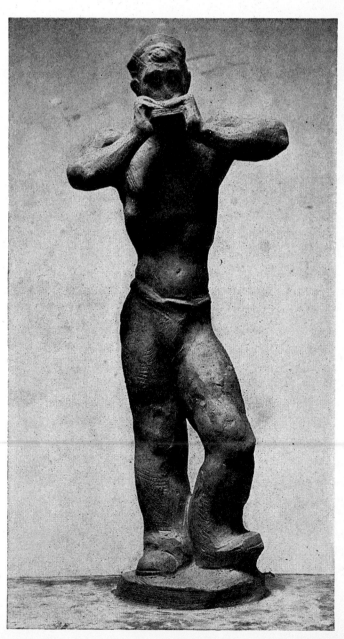

Fig. 148

The modeling advances. Wet the clay (surface only) before applying new clay. A piece like this can be worked on for quite a few days. When it has reached this stage, support the clay cloth (light cheesecloth) with which you wrap it up at night by standing sticks alongside your clay model. Keep the weight of the cloth off the clay as much as possible.

Fig. 149

Fig. 150

Fig. 151

On this page are a few of my figures that were modeled and fired with this method.

Fig. 149 (opposite page). Statuette completed. The clay was allowed to become quite stiff before that hole was dug out between the knees of the figure. Now the clay is allowed to dry. When the statuette is firm enough, it is transferred to a clean sheet of paper and allowed to become bone dry in a draftless cool corner of the studio. Then have it fired.

Fig. 152

THIRD METHOD
MULTIPLE REPRODUCTION.
CLAY SQUEEZES FROM
A PIECE MOLD

This method is more complicated than the preceding two. It requires a good working knowledge of plaster casting.

The process is simply this. A piece mold and retaining shell are made on the original clay (plasteline or plaster) model.

The piece mold is brushed with a little talc.

The terra cotta clay is squeezed into the prepared piece mold.

The mold is sealed and the clay is allowed to dry out three or four days.

The piece mold is carefully removed.

The clay production is touched up, seams removed, and the surface modeled. It is allowed to dry out completely, same as the pro-

cedure for the other two methods I have spoken of. Then it is fired.

You can make many clay reproductions from a good piece mold. Have them all fired —then get yourself a basket and sell your sculpture from door to door if you will. But you must have a good piece mold before you start this business. If you haven't had much experience with plaster you should not attempt this method alone. You should get a good professional plaster caster who can make a fine piece mold and shell for you (tell him it is for a clay squeeze). Then you can make your many clay squeezes, have them fired, get your basket, and still go into business.

Now then, for you plaster-wise novices, here is the process for a clay squeeze from a piece mold.

Design a shape which will not require too many pieces for the mold.

Use shim brass for the separation.

Follow through this process I have described, diagrammed, and pictured in the following pages.

Fig. 153
The seam lines are indicated on this figure. Insert shims and build up your plaster pieces.

Fig. 154

Pieces are all finished, carved, and assembled on the clay model. The plaster pieces are about 1 inch thick.

Each piece has had a small nail cast into its surface.

Note keys have been gouged into each plaster piece.

The outer surface of the assembled pieces has been well oiled, and a shell of plaster reinforced with burlap has been built around the front and back of the model.

Holes have been cut through the shell at the points where the nails have been cast into the pieces. Strong cords have been tied to these nails, and they have been pushed through the holes in the shells.

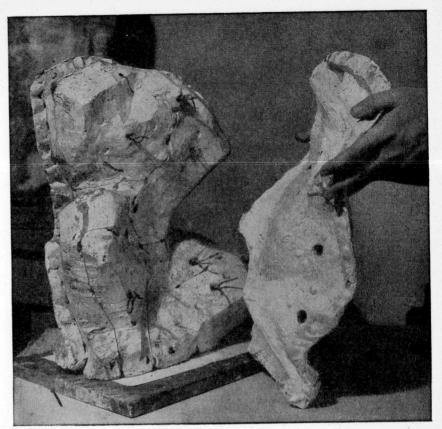

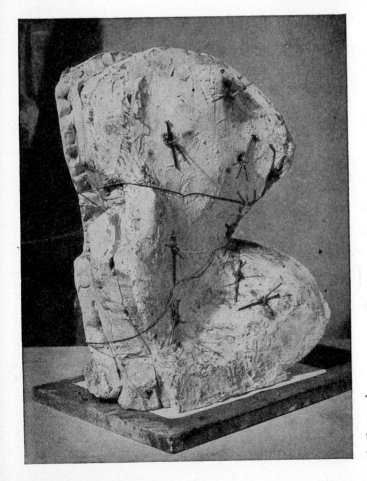

Fig. 155

The piece mold and shells finished and assembled.

Note the cords pushed through the holes in the shell are anchored temporarily by being tied to loose nails.

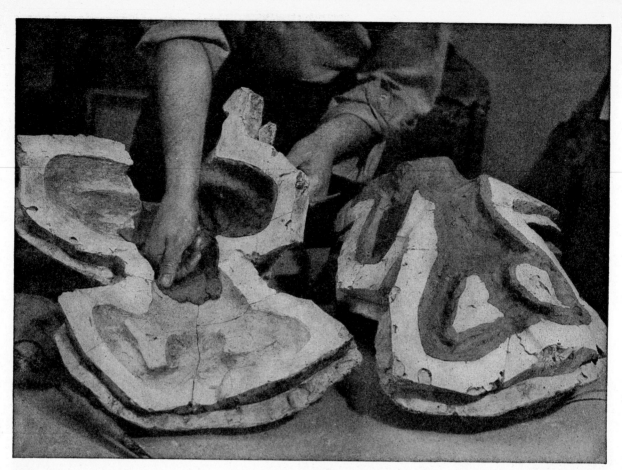

Fig. 156

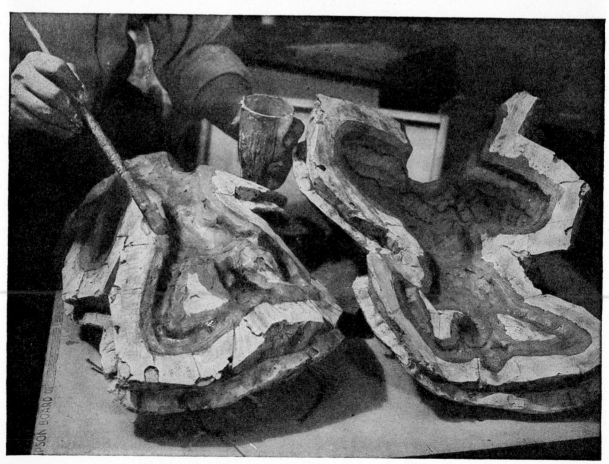

Fig. 157

Fig. 158

Fig. 156. Making the Squeeze. The open mold with all pieces tied and held in place with the cords through the shells has been brushed with talc.

Clay is pressed into the mold. One piece of clay overlaps the next as the pellets are squeezed. This clay need not be more than a half inch thick.

Fig. 157. The clay has been pressed into the piece mold. The two separating edges of the clay have been roughed and scratched with a modeling tool.

Now a heavy, creamy mixture of clay and water is painted on the separation.

Fig. 158. The two shells with their clay-squeezed pieces have been joined. Wires have been wrapped around the shell to hold it all tight.

Reach into the clay model with your fingers or a long modeling tool and patch up any areas along the main separations that have not joined.

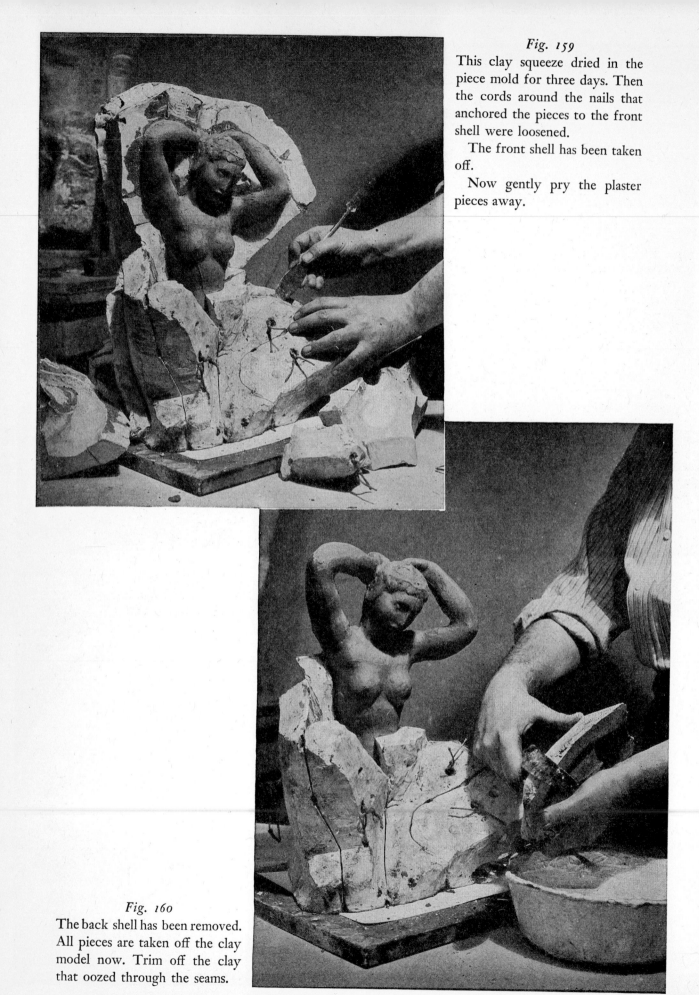

Fig. 159

This clay squeeze dried in the piece mold for three days. Then the cords around the nails that anchored the pieces to the front shell were loosened.

The front shell has been taken off.

Now gently pry the plaster pieces away.

Fig. 160

The back shell has been removed. All pieces are taken off the clay model now. Trim off the clay that oozed through the seams.

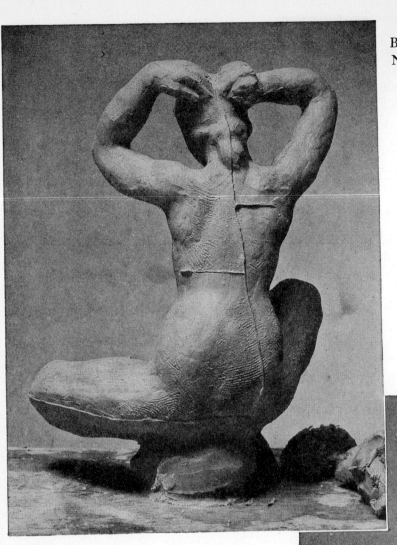

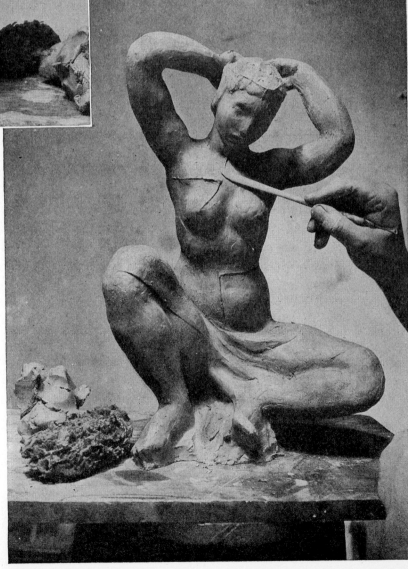

Fig. 161
Back of clay squeeze.
Note seam markings.

Fig. 162

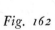

A wet modeling tool and a water-soaked sponge repair the clay squeeze. Model down or cut away seam markings.

Now put your clay away in some darkened draftless corner on a sheet of clean paper and let it dry out for a few weeks before you have it fired.

9.

Cast Stone

DISCUSSION ON THE DURABILITY
OF SCULPTURE AND PROS AND
CONS OF CEMENT CASTING

Cast stone is really cast cement. It is one of
the youngest materials used for sculpture. So
young, in fact, we can come to no conclusion
yet as to its permanence. Cast stone is as dur-
able as cast cement since that is what it is, and
it is composed of the same ingredients plus dry
color and a few handfuls of stone dust to give
it surface sparkle. Cement casters say that their
material will harden for seven years after it is
cast, and when it reaches its maximum hard-
ness will have all the qualities of a true stone.
That is what they say—accept it or not.

I have had sculpture pieces stone-cast which
after ten years are as good (or bad) as they
ever were. These pieces have been exhibited
indoors only and were never exposed to the
weather. They have not been tested by the
heat and cold, or wetness and dryness such as
exposure would impose on them. There are
cast stone pieces which I have seen used for
garden sculpture. After a few years of weath-

[154]

ering their color seems to have been washed
out a bit and their surfaces crumbled. But that
has happened to many marble pieces too. For
there are a number of fine marbles which, after
they are cut, lose color and quality with
weather exposure.

Sculpture was never meant to be kicked
around. It should receive the same respectful
handling accorded oil painting, pottery, or
other art forms created of less durable mate-
rial, and sculpture should receive the same af-
fectionate protection given to more fragile
mediums of plastic expression.

By questioning the permanence of cast
stone I do not mean mere durability. Rather,
I mean how well will this material preserve
the shape, color, and all the qualities of sculp-
ture the sculptor tries to get into the material
before he leaves it to go on with another work.
This quality in cast stone has not been tested.
Materials far less durable than cement have
been preserved through the ages. There are
beautiful figures modeled with mud (by the
Chinese masters) which exist intact even now
after four or five hundred years. This flimsy

material is merely built on an armature of straw or bamboo and then dried.

I believe these frail statuettes retain all the delicacy and spirit with which they were originally endowed. If they have lost qualities through the ages, how exquisite they must have been to lose and still retain so much!

It seems I have only presented the negative qualities of cast stone. Here are some of its positive qualities.

A sculpture idea prepared for cast stone can be reproduced as many times as any plaster cast. The surface of a cast stone can be chiseled and filed the same as real stone (sandstone, limestone). When used in an architectural setting which is (as I indicate in the chapter on architectural sculpture) the ultimate function of all sculpture, the weight of this material can be adjusted to the structural strength of the architectural scheme. By that I mean in an architectural design where you would like to use stone sculpture and are prevented because our modern walls are often just a veneer of material suspended on a metal frame. Therefore the weight of true stone would be impossible, but a light cast stone may be used.

CAST STONE

Here is the method for cast stone.

A sculpture shape is built up in clay (or plasteline). A plaster mold is made of the shape. For reasons that follow the mold is made heavier than for an ordinary plaster cast. The mold should be more than an inch thick and be well reinforced.

A mixture of cement, sand, color, stone dust, and water is poured or *pounded* (you see why the plaster mold must be strong) into the mold. If it is a hollow cast, iron supports are cemented into the cast, and often wide meshed-wire screening such as is used for chicken runs is cast into the cement. After a few days the plaster mold is chipped away. The cement cast (or stone cast) covered with straw and damp cloths, is allowed to cure slowly. After curing at least two weeks it may be surface-carved or filed and it is finished.

Here is the procedure for a solid cast stone. If you plan many reproductions in cast stone, make (or have made) a good piece mold cast and a strong shell, or else make a strong, well-supported waste mold. When the mold is thoroughly dry, paint the inner surface of the mold with a thin coat of shellac. When that coat is dry give it another coat of shellac. Repeat twice more. Give it at least four coatings of shellac, allowing each coat to dry out thoroughly. You can thin shellac with wood alcohol.

Now paint the dry shellacked surface of the mold with a mixture of stearine thinned out with kerosene. Make this mixture thin. It should look like a thin sugar syrup. Let the stearine mixture cool before applying it to the shellacked mold.

Assemble the mold, tie it firmly with wires, and begin mixing the cement.

Here is the regular mix for all stone cast:

1 part gray Portland cement
1 part white Keene cement
4 parts sand
1 part marble chips or fine crushed stone
dry color
water

The dry color I mention is available in any paint store. It is not expensive. Cement, sand, and marble dust can be bought at building supply companies.

Decide what stone you are trying to imitate in this cast stone mixture. Get a fragment of the stone if you can, and keep it around as a

model for its texture and color. The pinkish and reddish stones have been most successfully imitated in cast stone, and I have seen some black and gray cast stones that looked pretty good. The lighter-colored and buff-colored cast stones have generally been poor.

Here is a recipe for a mix for making a pinkish stone cast; a Tennessee marble or a pinkish sandstone might be your model.

On a large dry board mix dry your measure of one part gray cement, one part white cement, four parts fine sand, some marble dust (the measure of marble dust depends on how much glitter you want in your stone). Scatter a couple of tablespoons of Indian red dry color, a tablespoon of umber dry color, and a dab of yellow ochre dry color. Mix your pile of dry ingredients together with a trowel, and mix thoroughly. Do you think the color is about right? Correct it then with a little more dry color red, yellow, or umber.

Separate a handful of the mix from the main pile. Wet the handful until it is thickish mud. Use your trowel. Pick up the cement mud and make a pancake of it on a piece of glass (any old broken pane). Let the cement-mud pancake set for three or four days. Keep the main pile of the mix covered and dry during this time. Now that the sample pancake has set for three or four days (or longer) has it the color of the stone you want? Remember it is still full of water. It will dry out many tones lighter. Correct your color again in your main pile. Then go ahead and cast.

Dig a hollow into the center of your pile of dry ingredients and fill it with a pool of water. With your trowel mix it all into a nice big oozy mud pie. Add water as it is needed but add it slowly. Be careful the mix does not become too liquid. When it is properly mixed, pick it up by the trowelful and lay it into your prepared mold. Lay it in and pound it gently with a round-ended stick, padded well with a

cloth (or a little bag of sand), until your mold is filled. Scrape the filled bottom of the cast with a flat stick so that you have a decent base, and let the cast rest for three days before taking off the mold. Wet the filled cast at least once a day while it sets. Then cure it in an even temperature, covered by damp straw and burlap, about two weeks and it is finished.

A solid cast like this may need iron supports the same as a plaster cast. Because of the character of the material, it need not be supported as strongly as a hollow cast. A square iron rod or two pushed down through into a filled solid cast may be enough.

Hollow casts in stone may be made by laying and gently pounding (or tamping) a layer of cement about one inch thick into the mold. Then chicken wire is cut and laid into this cement crust, and it is supported by an armature of irons bent carefully to fit the inside of the cast.

A glue or gelatine mold and plaster shell is often used in making cement casts. There is some danger that because of the weight of the cement the malleable gelatine mold might give an inaccurate reproduction of the sculpture. Great care must be taken to prevent this from happening when making cement casts with a gelatine mold; the cement mix must be made more liquid so that it will pour into the mold and will not depend upon pounding to get a good reproduction.

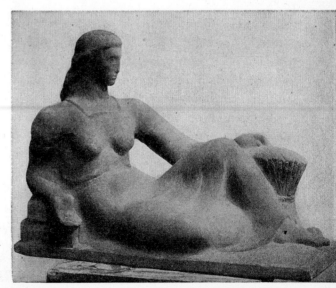

Fig. 163. Figure. LOUIS SLOBODKIN. A small shape cast in solid cement. For a life size head, cast with this method, see *Fig. 36.*

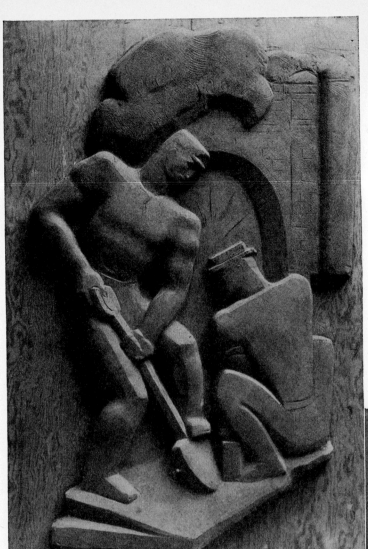

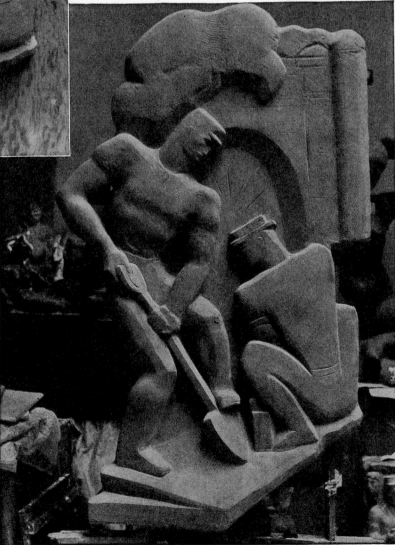

Fig. 164
Clay model for 5-foot cast stone panel. Maximum projection 3 inches.

Fig. 165. Tunnelmen. LOUIS SLO-BODKIN. Stone cast of *Fig. 164* finished and ready for installation.

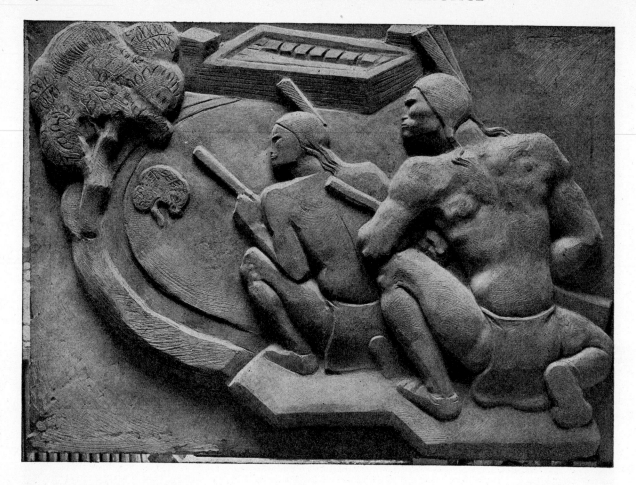

Fig. 166

This is the clay model for stone cast shown in *Fig. 168*. The over-all projection was about 3 inches on the 6-foot panel.

Fig. 167

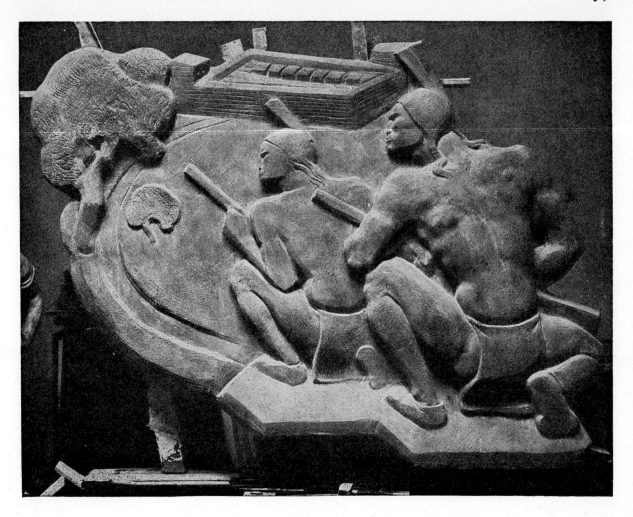

Fig. 168. Mohawks. LOUIS SLOBODKIN.

This cast stone relief sculpture is about 6 feet wide but the
cement is only 1 inch thick. It is supported by chicken wire
and a bent iron-rod armature (*Fig. 167*). It was cast light because
it was suspended on an interior hollow tile wall. It weighed
when finished about 150 pounds. Were this cast made solid it
might have weighed over 500 pounds, and it would have torn
down the wall. Had it been carved in stone it would have
weighed a lot more and might have ruined a lot more than that
wall in the building. The wood sticks are temporary supports to
facilitate handling in transportation. This cast is fresh out of the
mold. The small cracks on the surface often happen in a thin
stone cast. They can be repaired with a paste made of a mixture
of cement and dry color applied with a plaster spatula.

10.

Cast Metals

THE craft of casting metals requires so much equipment, technical experience, and knowledge that it would be ridiculous for a zealous novice (after reading this account) to attempt unassisted to convert his sculpture into metal. And each step in the process of metal casting is usually so exacting that technical experts develop in metal foundries who specialize in only one, rarely two, steps in this complicated procedure.

History has recorded very few sculptors who had the opportunity to cast their own bronzes. Benvenuto Cellini in his autobiography admits that on the occasion when he (assisted by a crew of technicians) cast his one major piece in bronze, the *Perseus*, he burned down his workshop! And he was more jeweler than sculptor, since he was trained and worked as a goldsmith, and a cornet player (he blew his own horn well), accustomed to casting and working metals. In his autobiography too, he speaks disparagingly of the "crude bronzes" cast in the studio of Donatello. I prefer the crude strength of Donatello's cast sculpture to the finicky Cellini bronzes.

There are a skinny handful of contemporary sculptors who experiment in bronze casting, but they evidently have the time, the money, the equipment, and the space to spare. However, aside from one or two sculptors who devote themselves entirely to working metals, as a rule their castings are not very good. All other mature contemporary sculptors give their work out to be cast in foundries by the men who have devoted their lives to this craft.

But all sculptors should understand the processes and prepare their sculpture models so that they will get the qualities they want in their cast metal sculpture.

Here is a quick resume of the procedures used in casting metals.

This much you should understand before you give your first piece to the metal casters, and if you would know more, follow your sculpture piece into the foundry and stand off in some quiet corner and watch the experts cast your work. They will let you in the foundry if you are polite and pass out cigars.

Bronze Casting

Aluminum, brass, silver, tin, white metal, and lead are also cast with this process.

THERE are a number of metals and metal alloys used for metal casting. The most honorable and ancient of these is the copper alloy called bronze. We do not know who (when or where) discovered that by melting together a mass of copper, some tin, and some other non-ferrous metals and pouring them into prepared molds, we could preserve for centuries the most intimate pressures of the very thumbprint of the sculptor. We do know bronze casts have been made during every important sculpture epoch in every part of the earth by almost every people for thousands of years.

Sculpture models for each metal or metal alloy should be designed and prepared with consideration for its final effect in the medium for which it is planned.

A work prepared for bronze may be freely designed with holes in the shapes, loose ends flying off into space, vibrating modeled surfaces, and all the other tricks and fun one might have with clay, but remember each of these holes in your shape, every loose end, and every lumpy ripple in your fascinating surface is going to cost you money. Since the foundry charges you for the time spent converting your work into bronze, and flyaway sculpture is often as bad in metal as it would be in any other material, be temperate in your design for bronze. Your sculpture need not be as compact as the shapes you design for stone or wood. Model your shape with the flow of bronze in mind, and consider every hole you

indicate in it. Control the wild desire you might have to flutter the shape out into space.

METHOD

There are two principal methods for casting bronze. One is called the Sand Mold process and the other the Lost Wax process (Cire Perdue). Both methods have their qualities and shortcomings. Consider the pros and cons of each before you decide whether a sand mold foundry or a lost wax foundry will cast your first piece.

SAND MOLD PROCESS

A good plaster cast of the sculpture is sent to the foundry. There, if the sculpture piece is a complicated design, this plaster cast is cast again in plaster in sections with prepared joints called Roman joints. (See *Fig. 170.*) If the original plaster is a simple unit no reproduction is made.

The plaster sculpture is molded in a finely ground French sand, a prepared mixture composed of silica, clay, and alumina. The dampened French sand is carefully (tenderly) piled and hammered around the plaster cast by the sand molder. Thus units of a sand piece mold are built around the plaster. Each piece of the sand mold is built so that it can easily be released from the plaster sculpture without marring its neighboring piece of sand mold. All pieces of the sand mold are held together in a containing iron frame called the flask.

The iron flasks are strongly constructed frames made in halves which fit perfectly together when they are closed and sealed together with clamps and bolts. These flasks act

in the same capacity as a shell does in ordinary piece mold plaster casting.

When all the pieces of the sand mold are completed and are nestled close in their iron flask, the plaster sculpture is taken away from its sand mold leaving every detail of its shape and surface firmly impressed (in the negative of course) in the French sand. A core is then built of armature and sand. This core is built inside the empty sand mold. It is shaped so that an air space is left between it and the sand mold. That space is the area the bronze will eventually occupy.

The two halves of the flask containing the sand piece mold and the core are sealed, clamped, and bolted together. The flask is put into an oven and the sand mold is completely dried out with a slow, even heat.

At last the dried-out sand mold is ready for the bronze. The bronze, which has been heated in a crucible to a bubbling liquid 1900 degrees Fahrenheit, is poured into the iron flask, and it fills the empty space between the sand mold and the core.

The iron flask and the sand mold are removed, the core is tapped and shaken out, and the bronze cast has been made. But it is not finished. It has very little resemblance to the fine-colored lustrous bronzes one sees in museums, galleries, or in the homes of those who can afford to buy sculpture. No, indeed, a bronze cast fresh out of the mold is a blotched dull piece of metal, colored like a bright penny in spots and a dirty black in others, with jagged seams and crude lumps of bronze that were never designed in the original sculpture.

Now the crude bronze is bathed in a solution of nitric acid and comes out of its bath with an all-over color of a bright cheap new penny. The chaser or chiseler takes over. Chasers are expert craftsmen who carve away the metal seams left from the sand mold pieces. They carve, file, or fuse on more bronze if the cast has developed any blow holes. They finish and try to hammer into the bronze any detail that might have been lost in the casting. These experts, although they work right alongside the sand molders, rarely develop the sand molders' craft any more than the sand molder usually develops any competence as a chiseler.

The chiseled, filed, carved, and (sometimes) buffed and burnished bronze is given to the patinière. The patinière is a specialist who can with various solutions of acids and applications of heat to the surface of raw bronze get almost any color of the spectrum, and often does if the sculptor does not stop him.

The sand mold bronze cast is done.

LOST WAX PROCESS (CIRE PERDUE)

Bronze foundries that cast with Sand Mold process almost never cast with the Lost Wax process and vice versa.

When the sculptor's plaster model is sent to a lost wax process foundry, a gelatine mold and plaster shell is made of the sculptor's model. A melted red wax is painted on the inner surface of the gelatine mold with a fine brush. Coat after coat of red wax is applied. Since this red wax will eventually be melted away and replaced by bronze, the thickness of the wax is governed by the size of the sculpture to be cast. In small one-foot statuettes the bronze is about ¼ inch thick or a little less. In larger work, say a life-sized figure, it is rarely more than ⅜ or ½ inch thick. That is about how thick the red wax on the inner surface of the gelatine mold will be painted.

The shell and gelatine mold is taken off the cold hardened wax and the sculptor is usually

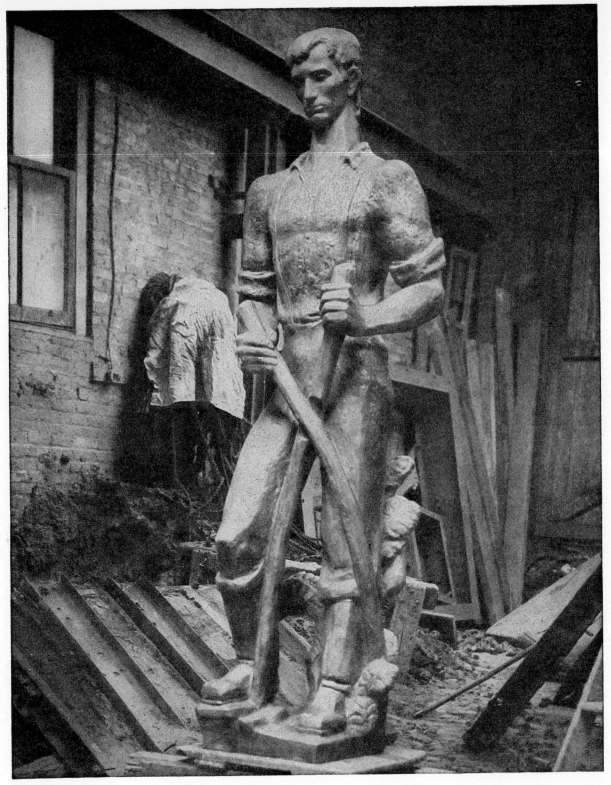

Fig. 169. Young Lincoln. LOUIS SLOBODKIN.
Interior of a sand mold bronze foundry. This eight-foot bronze figure was cast by the sand mold process. The iron frames in the background are the flasks. That pile of sand is the French sand we have mentioned.

called to the foundry to okay the wax replica of his work, or to work on it if he will. Conscientious sculptors usually touch up the red wax. The stuff can be modeled with heated metal tools, and detail can be sharpened or built up. Sculptors with less conscience about their work usually make sure that their signatures have been reproduced intact and let the foundry go on with the bronze casting.

Rods of red wax are now attached to the wax sculpture. They will act as vents and gates to allow the red wax to run off when the final mold is made. At last the final mold —a liquid mixture of plaster, silica, and some heat-resisting chemicals—is poured into the red wax as a core and built up and around the sculpture piece as a mold. When this mixture hardens, the mold containing the red wax sculpture is put into an oven and baked slowly until all the wax is melted away. It runs off through the gates and vents (the wax rods) that have been attached to the sculpture. Now with all the wax run off, leaving a space between the outer mold and the inner core, the mold is taken from the oven and packed in earth in a pit previously prepared in the foundry floor.

Hot liquid bronze is poured from crucibles into the empty gates of the mold. It fills the space left by the melted wax (cire perdue) and the lost wax bronze cast is made.

From then on the process is the same as a sand mold bronze cast. The silica mold is broken away from the bronze cast, the core is tapped out, the bronze is given its acid solution bath, and the chiselers carve away the seams and rods of crude bronze formed by the gates and vents. The patinière finishes the bronze and it is finally delivered to the sculptor's studio with a bill.

And that is a skimpy sketch of how bronze casts are made with the two time-honored methods, the sand mold and the lost wax processes.

It should be obvious now why sculptors in their own studios do not cast bronze, even if they have arranged to include training for this craft, in their too short life span. Definitely the crucibles, ovens, casting pits, frames, cranes, and other paraphernalia that make up a properly equipped foundry would crowd out the clay bins, carving and modeling stands, work benches, chisels, tools, and everything else that a sculptor uses to make the original sculpture models to be cast in metals and to feed work to the foundries.

So, novices, do not try to set up a foundry in the hall bedroom or attic where you do your sculpture. You might not have room. And too, you might set the house afire.

But there are certain steps in the making of his bronze cast in which the sculptor should take part. I have already mentioned retouching the red wax model in the lost wax process. Again the sculptor should supervise closely the chiseling away of the seams on the raw bronze. And too, he should carefully compare the bronze cast with his original plaster to be sure the bronze shape has not been altered or dimpled as sometimes happens. A faulty core or some fault in the mold might cause a falling in of your bronze surface. Bronze can be welded into these unwanted depressions in the surface. Or a good bronze finisher (if the piece is large enough) can hammer the shape out. The bronze chaser will (if he is not too crotchety a craftsman) permit the sculptor to borrow his stubby little chisels, hammers, and files, and let the sculptor scrape and bang away at his own bronze piece in the foundry. Some young sculptors I know order a crude bronze cast at commercial bronze foundries, then with a few tools of their own they carve away the seams, file down the surfaces, and finish

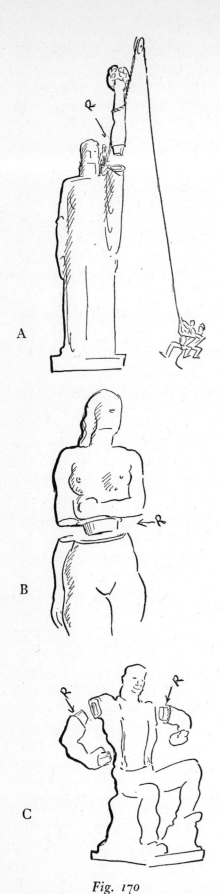

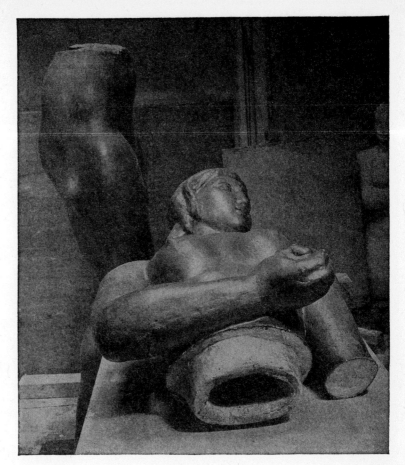

Fig. 171

Roman joints are used for bronze, stone, plaster, and many other materials for sculpture. They are sockets and units of shape cast or carved (by expert technicians) for smaller shapes joining the main sculpture mass.

A. This is an exaggerated stone idea. The huge arm with its carved Roman joint is being lowered into its socket. It will be cemented and metal-doweled into place. It is obvious that this impossible block of stone would have been bigger and more impossible if this arm were carved from the same block as the rest of the sculpture.

B. The photo and drawing show a seven-foot plaster figure with a Roman joint at the waist. This facilitates transportation and storage of this exhibit piece between exhibitions.

C. A small plaster figure prepared for bronze. R marks the Roman joints. Here they facilitate the bronze casting. These arms with their Roman joints will be cast separate from the main unit and then welded on.

A

B

C

Fig. 170

their own bronzes. A crude bronze cast is quite a bit cheaper than a finished cast. But it is best not to attempt too much on your first bronze. Work in the foundry as much as they will let you.

Another stage when the sculptor should interfere in the casting of his bronze is during the patining or finishing.

PATINING BRONZE

A patine applied to a bronze should have a number of essential qualities. First, this surface color should appear completely natural, as if the bronze had developed a bloom of color with its normal corrosion and the variety in its color tonality just happened.

The patine should be very thin and transparent, and should emphasize the metallic qualities of the medium.

An experienced patinière can get almost any color with the use of various acid solutions, applied heat, and timing. But bronze covered with an all-over thick color of violent light green, cobalt blue, chocolate brown, or glaring red is completely unnatural and looks like (as in reality it is) just heavy coats of paint. Bronzes that are patined with a simulated flesh tone for the skin and a darker color for the hair and drapery (on realistic sculpture) are garish and ridiculous.

Since bronze is an alloy of metal, the formulas of the alloy used have a great effect on the surface color, and the applied patine may be very temporary indeed if cheap metals are used. For example, the majority of bronzes cast these days are made up of an alloy of 90 per cent copper, 7 per cent tin, and 3 per cent zinc.

Other formulas that have been diagnosed from antique bronzes vary considerably. There are those among the Greek bronzes that are said to have a 62 per cent copper content, 22 per cent tin, and 6 per cent lead. Still others are 70 per cent copper, 22 per cent tin, 4.6 per cent lead, 2 per cent zinc. And still others have larger percentages of copper and smaller quantities of tin and traces of lead, tin, and silver in the alloy. I have seen bronzes in which some percentage of gold was used.

As I have indicated, an applied patine is at best just a temporary effect. The natural bloom of metals used in the alloy will eventually work through any temporary patine. All bronze tends to blacken with age. But those alloys which have a larger percentage of zinc will blacken quicker than any other. Precious metals such as gold or silver in the alloys of some beautiful old bronzes I have seen have come through and glittered up the darkened surfaces of those beauties.

METHOD FOR PATINING
HOT PATINE

The bronze foundry patinière should and always does consult with the sculptor on the color desired for his bronze.

A very watery solution of acid is mixed. The raw, finished bronze is set up on a metal-topped stand. The bronze is heated with a blow torch, and then with a long handled brush the patinière splashes a thin, quick wash of acid solution, followed by a quick wash of clean water. The effect is watched closely. Heat is again applied with a blow torch, again the thin wash of acid solution, water, etc. When the approximate effect is reached, the application of heat and acid solution stops. I say "approximate effect" because the acid solution will continue to work after the patinière stops applying heat and his coloring solutions.

Sometimes, because of that, a good patine becomes a bad one if the patinière has not stopped soon enough.

Occasionally the patinière gives the bronze (a small statue) a quick rub with his bare hands while the bronze is still pretty hot. They tell me that process gives something to the color—to me it just gives blisters.

On a large statue the procedure is to heat the bronze with blow torches; then a solution of acid mixed in hot water is splashed on the statue by the bucketful. This process is repeated until the desired effect is reached. But this quick method is not often satisfactory. When any bronze has been patined to the satisfaction of the patinière, sculptor, and everyone else involved, and when it has cooled, some wax is applied with the hands. Then a quick rub with brushes and chamois, and the patine is finished. Sometimes a thin coating of lacquer called French varnish is painted over the completed patine instead of the wax.

However, the hot patine is not often used on large bronzes. There is another process called cold patine. Obviously that is applying acid without the use of heat.

COLD PATINE

A cold patine takes time. After the raw bronze comes from its nitric acid bath and is washed down with clean water and dried, a solution of well-watered acid is splashed on the cold bronze. It is allowed to work for a day or so and again the acid solution is applied. This goes on for many days, sometimes weeks, until the desired effect is reached; then it is waxed or varnished.

Although there are various acids used in patining bronzes and, as I have indicated, the resulting color can have all the variety of the rainbow, it seems to me the best bronzes I have seen are simple in color. Just one or two acids or chemicals have been used. And in those antique bronzes which are made up of fine alloys, only time and the quality of the metal itself has given them their richness of surface color.

After a few sad experiences in some foundries, I find I prefer to patine my own bronzes. When the foundry sends back one of my bronze casts covered with their thick painty patine, I have on some occasions thrown the bronze into the furnace of my studio building and burned off the crusted, unpleasant color; then fished the bronze out of the furnace with an iron rod, and while the bronze was still hot have given it a quick wash of a thin solution of nitric acid, washed it down again with water, and given it another wash with a thin solution of ferric acid.

This is rather an unorthodox method of patining. But all patining is unorthodox in the sense that the most expert patinière will not guarantee the color effects on a bronze. At best he can only approach the effect desired, and sometimes the color qualities on a bronze go far beyond his intention. The method I described above has often proved successful. On occasion when the results were not too happy, I gave my bronze a quick clean bath of nitric acid and started the patine all over again.

Here are the acids I prefer using in doing my own patine.

Just a few crystals (teaspoonful) of ferric acid dissolved in about a pint of water. If this solution is applied to a clean, raw, hot bronze, you can get a color range from a warm rusty yellow to coppery red, deep red, deep reddish-brown. Wash on the solution, play your blow torch over the surface, again wash with clean water. Repeat.

You must work quickly and watch carefully for the variation and deepening of the color. Use a lot of water; keep brushing it on and drying it up with your blow torch. The color richens and acquires a deeper tonality with the application of heat. When the color is about right, let the bronze cool and rub a very little wax over your bronze with your hand; coddle it. Finally, give your bronze a polish with a chamois.

I have used a very thin solution of Liver of Sulphur, just a few crystals in about a quart of water. It is applied quickly with plenty of water washing it down over the hot bronze. The result has been a fine transparent yellowish patine with a nice variation of darker markings. If Liver of Sulphur is used indiscriminately you will get an unpleasant dead black patine. Use plenty of water.

Copper Sulphate applied the same way gives a pea-green patine to bronze; Uric Acid, a livid green. New bronzes are sometimes buried in the earth in sculptors' back yards, and natural uric acid is dribbled over the ground the bronze is buried in. The result is sometimes a nice varied green with dark-brown mottled spots. That is a rather haphazard method of patining. I have never treated a bronze that way, but I am told the best results can be obtained by building a small vault of flat stones, placing your bronze in the vault, and topping it with a flat stone. Pile earth on top of the stone. A daily wetting with uric acid for a number of weeks and you will have a fine bronze patine—so I am told.

It is possible, too, to burn gold leaf into the surface of a bronze and get some interesting effects. The bronze is darkened with heat and acid; gold is applied and melted into the surface. Darkened bronzes are sometimes covered with applied sheets of gold or silver, then shellacked with French varnish. I do not re-

spect either this gold or silver treatment. It is too precious.

Combinations of acids are used on bronze, one acid providing the main body color, and another solution touching it up in the crevices as a secondary. There are stunts that can be manipulated with cobalt blue on a darkened bronze. The methods used have already been indicated. All the chemicals and acids I mention are easily available. The bronze foundry can advise you where to get them or, since they are so cheap, they might give you a few crystals. Or if not, buy them at a chemical store or ask your local pharmacist.

There you have enough on the patining of bronze to start with. Good luck.

Aluminum, Tin, Brass, Silver, Gold, and White Metal (a cheap alloy) are cast with either the Sand Mold process or the Lost Wax. There is no sense in patining these metals. The precious metal casts usually have color enough. New cast Aluminum might be too glaring. Not much can be done about it. This metal will dull down in time. I have used a thin rub of wax and lamp black dry color over a freshly cast aluminum statue and got an effect that was not too bad.

Lead and Iron are best cast with the Sand Mold process. Design your shapes so that there are no undercuts and no finicky smaller units of shape to break off. These are both rather sluggish metals and surface detail is usually blurred in casting. Neither are very durable and loose small units of shape will surely break off. Cast Iron cannot be patined. It must be painted (with a base of Red Lead as a first coat) if it is exposed to the weather; else it will either rust and crumble away, or it might split. Lead exposed to the weather develops a beautiful bloom in a short time. It needs no artificial patine.

PROS AND CONS OF SAND MOLD AND LOST WAX BRONZE CASTING

A bronze made by the Lost Wax process is usually more porous than the Sand Mold cast. A Lost Wax bronze cast is said to take a better patine. And too, a Lost Wax is apt to have sharper intimate detail than a sand molded bronze although I have had Sand Mold casts with all the detail I wanted beautifully reproduced. Then again, Sand Mold bronzes may have a truer over-all shape than the Lost Wax cast. The very nature of the process, because the wax replica may warp just a little, accounts for that possibility. Finally, the qualities of both of these fine processes are pretty evenly balanced. Now that you have been told what to expect, have your work cast by either or both of these methods and hope for the best.

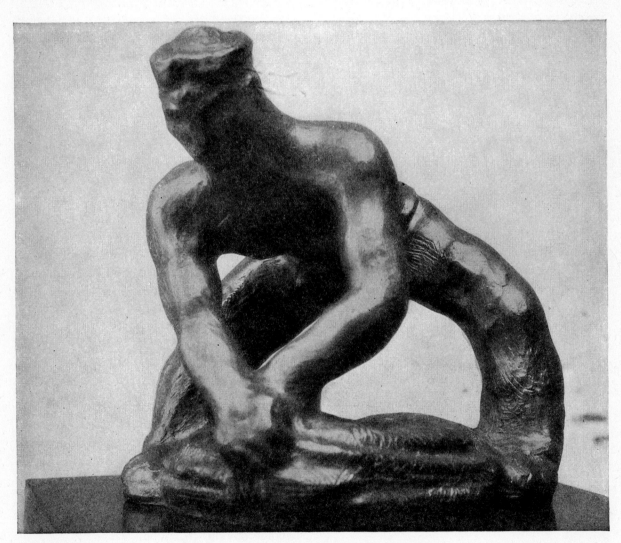

Fig. 172. Sailor Coiling Rope. LOUIS SLOBODKIN.
This bronze was cast in cire perdue (lost wax). I do not know if the surface will come through in the printing of this book. But the bronze shows intimate details on its surface, my very fingerprints.

Reliefs—High and Low

ALL sculpture panels attached to or carved into walls are generally listed under one heading—Reliefs. They range from Bas Reliefs (low reliefs), sculptured panels that have a very slight projection from their background, to Alto Reliefs (high reliefs) which have as much projection as a full free-standing sculptured shape but still must be considered reliefs since they are attached to and often composed on a wall or a panel limitation. All relief sculpture (except medallions, coins, etc.) whether high or low should be considered as features of architectural sculpture. Even portrait bas reliefs and plaques will eventually be hung on some wall since they cannot be exhibited properly any other way. They must be considered as wall sculpture, therefore architectural sculpture.

There are two main methods used for producing relief sculpture:

1. A built-up relief on an established background.

2. A carved relief from an established surface.

Both methods although they differ in pro-

cedure have the same esthetic objective. This is to create within a materially limited area the illusion of full-bodied shape. In other words, relief sculpture either high or low must have the same qualities as sculpture in the full round. There must be an over-all sense of unified shape no matter what material, medium, or method of execution is used to create any sculpture. And there is another element that a relief sculpture must have, which for lack of a better term let us call "relief quality." This relief quality will become evident as we develop this discussion on the method and procedure of indicating reliefs.

One common mistake a lot of novices and some fully matured sculptors make is to consider a relief a sliced-through section of a sculptural idea. And they either build or carve a fully rounded shape that dies off to a thin outline where it joins the background that makes up the panel. The fallacy of that should become obvious to anyone soon.

It seems to me I have seen an awful lot of this type of relief (carved in Carrara marble, no less!) installed in the dark rococo halls of

old medical colleges and in some dreary public buildings. If you have never been privileged to see one of these reliefs, here is a drawing of that type.

Fig. 173

This sliced head has no relief quality. It looks like (and is) a fully rounded head split at an accepted outline. The panel has no relation to the shape superimposed on it. This is neither relief sculpture nor sculpture in the round, nor is it any form of sculpture.

Here are some of the positive qualities relief sculpture should have. It must be designed with a consideration that the panel or background is part of the complete composition. The spacing and placing of the main elements of the composition must be incorporated into the design. The projections that make up the whole unit should be so indicated that it has a

general over-all tonality of color. By color in sculpture, of course, we mean the variations from light to dark we get by varying the angles and bevels of the planes we indicate to create our shapes and surface detail.

These drawings embody the main principles of relief sculpture. It is possible to get the approximate color effect of the full projection of Drawing A in a relief which is no more than a ripple on the surface of a very low bas relief (Drawing D). The bevels of the upper planes that catch the light are indicated to contrast with planned effect in relation to the lower shadowed planes. Sharply or subtly indicated planes, depending on how much color you

A B C D

Fig. 174

want, can suggest the staircase shape in almost any projection you plan. In fact, viewed from the front of a panel of a very low relief, this staircase can be suggested by merely a series of lines drawn into the surface.

Fig. 175

This plane may be indicated with the same projection as this plane.

The importance of these planes is obvious. They throw the side of the stairs back.

Fig. 176. Here is how that principle applies to a head.

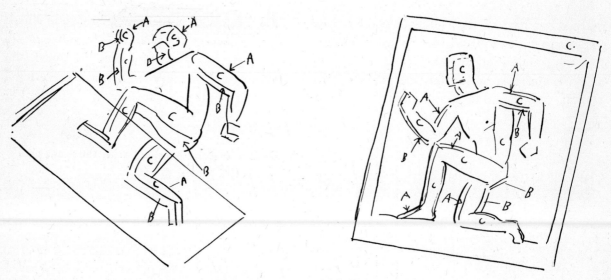

Fig. 177. The same principle applied to a figure.

These planes may be indicated with the same projection. It is the variation and contrast of the planes marked A and B to the surface plane C which will give the illusion of volume and placing in a relief.

Here is a simple bas relief that embodies the principles we have discussed so far in this book. This relief is cut into a sheet of clay squeezed on a board. The clay is ¾ of an inch thick.

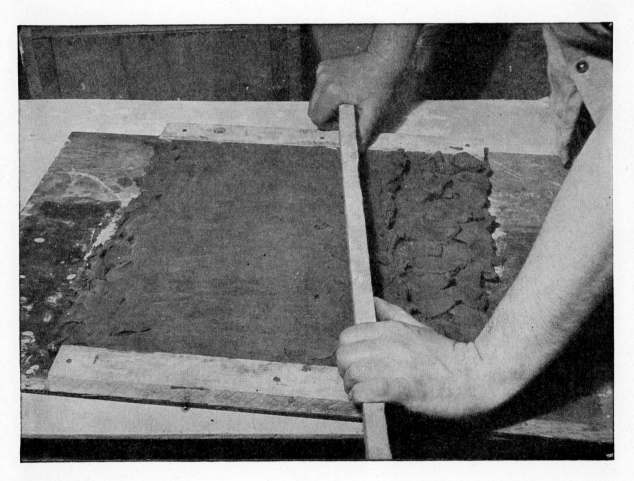

Fig. 178

A couple of strips of wood the approximate depth of the relief are nailed parallel on a shellacked board. Sausages of clay are squeezed on the board. With a straight-edged length of wood the clay is scraped until the surface is flat.

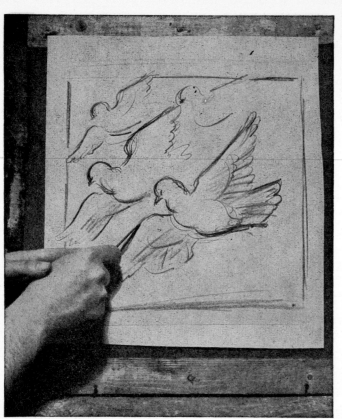

Fig. 179
The panel is fixed on a modeling stand or work table. The approximate design is drawn on a sheet of paper and traced through to the sheet of clay.

Fig. 180
The composition has been traced. If you plan to carve a panel in wood or stone, you should use one of the hundred and fifty methods everyone knows about for tracing on a hard surface. Carbon paper. Pinpointing your drawing and pouncing it on with some colored powder. Or why not draw it on by hand with chalk.

On a sheet of clay the pressure of a wood tool is enough for transferring your drawing.

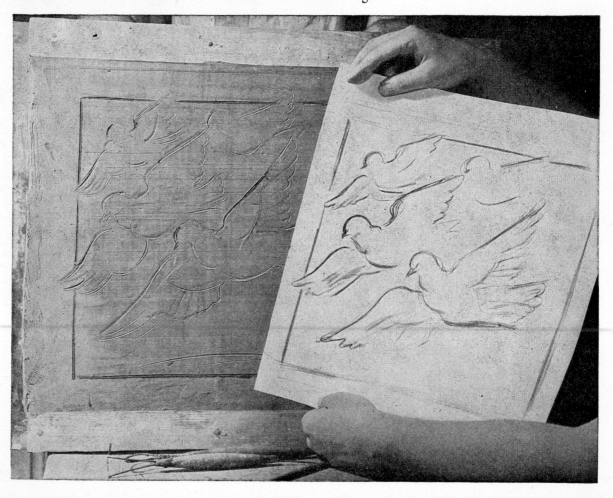

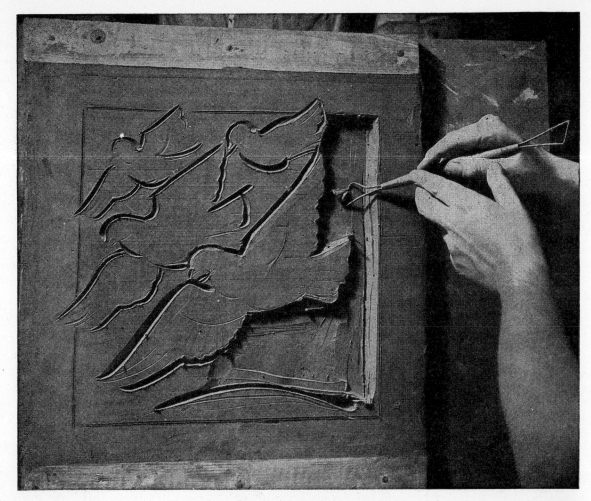

Fig. 181

Gouge away the clay to whatever depth
you decide. This relief I am cutting out
will have about a half inch projection
from background to surface. If it were
carved in stone, the background would
be roughed away with a point chisel. If
it were carved in wood, a gouge chisel
would be used. Leave all elements of the
composition outlined on the surface until
you have cleared away all the back-
ground.

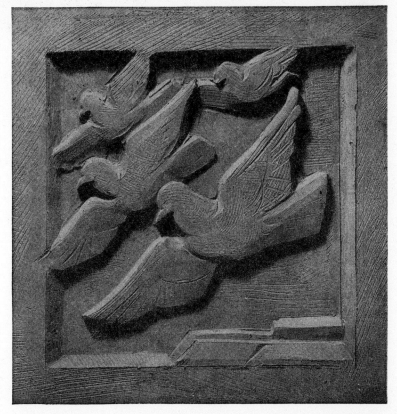

Fig. 182

Background is cleared now. Note that
the background in the hole shapes
formed by the interlocking patterns is
not carved down as far as the rest of the
background. These holes would have
become too dark.

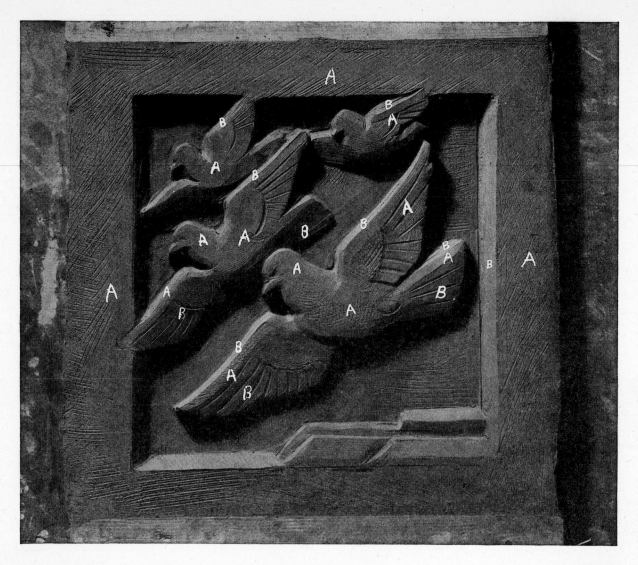

Fig. 183

Surface detail being developed. Note all shapes marked A are the original clay surface. Although all four birds appear to be on varied planes, in reality they are on the same plane projection from the background. The bevel of the contrasting planes A and B accounts for this appearance of variation as much as the reduced perspective of the small birds.

The possibilities and ways of handling a relief of this type are infinite. The method indicated here is the basic idea. In the following chapter, "A Practical Problem in Architectural Sculpture," I demonstrate how to do a built-up relief and present some ideas on casting reliefs.

12.

Architectural Sculpture

Sculpture, like any art form produced by man, should have a direct relation to communal life. The highest attainment in the field of sculpture is work that has some specific relation to the complete scheme of things—sculpture purposely created to occupy a definite place on earth and executed so that it fulfills a definite esthetic function.

It is my conviction that Architectural Sculpture is the ultimate function of all sculpture. Architectural Sculpture includes all the methods, procedures, and processes of sculpture we have considered so far. I mean the study and practice of modeling and carving all sculptural shapes and composition, and the execution of them in various mediums, has no end in itself. They are only a part of a functional whole and that all-inclusive unit can be termed Architectural Sculpture.

All sculpture until the comparatively recent easel sculpture which floats aimlessly from gallery to gallery was work commissioned to stand on some definite spot on this earth or to have a definite function (religious or historical) or to be anchored securely as an es-

thetic necessity to some building. Consider the great periods of sculpture—the early Gothics, Greeks, Egyptians, Hindus, Chinese, Mayans, Italian Renaissance, Assyrians—their magnificent sculpture creations were not flimsy stuff that floated around from Art Exhibit to Art Exhibit until they found a precarious perch in some Art Museum. No, indeed. There were no Art Galleries and no Art Museums. There were temples, churches, tombs, and public buildings for which their sculpture was designed, executed, and to which it was anchored. These masters all did Architectural Sculpture, not floating Easel Sculpture.

It is a general misconception that the eclectic ornamentation which has been strewn on our public and private buildings by commercial studios (aided, abetted, and commissioned by our misinformed architects) is the flowering of contemporary America's contribution to the great tradition of Architectural Sculpture. To repeat a colloquialism, current at the Art School where I studied when I was young, such stuff is only "cabbage modeling." That is what we called it and that is what it still is. Cabbage,

not Architectural Sculpture.

In olden times when Architectural Sculpture was architectural sculpture and not cabbage, when a temple, cathedral, or some public building was planned, the whole community was activized.

The plans were developed on the spot where the great building was to be erected. All during its construction, master builders and craftsmen were in constant attendance at the birth and growth of their magnificent building. The stonemasons, master stone carvers, wood carvers—all lived their lives (with their families of course since they were all bourgeois people and not at all long-haired) within sight of their life's work. Since these great buildings were built without the throw-them-up-quick short cuts used in modern buildings, many great artists and craftsmen lived and died on one important job and their sons born in the shadow of the growing masterpiece picked up their fathers' chisels and mallets and carried on.

It has been substantiated that in medieval times nomadic Guilds of craftsmen wandered from job to job over the face of Europe. The great cathedrals were built by these nomadic Guilds. It is said the Oriental designs of the sculpture on the Chartres Cathedral and the one at Rouen were carved by sculptors who may have come up from the Eastern Mediterranean.

In these days an architect may often start his plans for a tremendous building to be set on a distant spot on the earth which he may never see except in photographs. And the building may be completed and embellished with sculpture and murals within a year or two. The sculptor who is commissioned to embellish the building is given the architect's flat paper blueprints to work from, sometimes long before the very foundations for the building are begun. It is usually a great and often unpleasant surprise to the sculptor, architect, and anyone else concerned when the scaffolding is taken down from the façade of the new building and the carefully planned (planned from blueprints) architectural sculpture is revealed for the first time.

But in our modern accelerated way of life, that is the way work must be done. The sculptor, the plumber, the electric light fixture man (and all the others) make their units of shape from blueprints; then their work is assembled, screwed, bolted and welded together, and a building is done.

I believe it is possible to do good sculpture even under these conditions. Had our American architects the courage to commission the livelier creative artists available here instead of the stodgy old reliable dodos they usually employ to do old dodo sculpture for modern buildings, we still could have fine architectural sculpture even though it is built on blueprint paper foundations.

Some fault may be laid on the doorstep of the livelier sculptors too, because they neglected certain essential training in their development. I have often heard full-grown ablebodied sculptors timidly confess they were incapable of reading a scale ruler, and I have seen them go pale with fright when they unfolded a blueprint and faced its simple markings. Needless to say these sculptors were pure artists who did their work to be exhibited in the art galleries or museums. They had no training for architectural sculpture and had been chosen to execute some architectural sculpture commission because in some distant way they were related to the architect, or because some Art Authority pulled some political strings.

In spite of these peculiar circumstances the work was finished. Some competent Ghost

Sculptor thoroughly trained in all the branches of sculpture was hired to haunt the studio by the day. The well-trained Ghost Sculptor executed the commission and the pure art gallery exhibiting sculptor signed his name. Of course if you would be that kind of art sculptor you are wasting your time reading this section of this book. Devote yourself rather to a book on etiquette and develop the social graces so you will be commissioned to carry on Architectural Sculpture. You can always hire a Ghost.

But if you want a thorough development, get what you can of what follows, visit the museums, and study how sculpture was used on the architectural models there on display. Study photographs of ancient architectural sculpture in place, and finally, get a job in an architectural sculptor's studio—if you can!

ESSENTIAL TRAINING FOR ARCHITECTURAL SCULPTORS

Therefore, to start your development as an architectural sculptor let us consider first the new tools, materials, etc. Learn to read architectural blueprints. That is not very difficult. The placing of the proposed sculpture is usually clearly marked on an architect's blueprint. It is usually a head-on drawing of the mass and a side section indicating how the stone, metal-cast, cement, or wood sculpture will be anchored to the wall on which it is suspended or attached to the façade on which it is placed. The proportional scale is always indicated on the lower left or right corner of your blueprint sheet.

One quarter-inch equals one foot—one eighth-inch equals one foot, etc. That is obvious. It would be smart if you were to get the blueprint of the façade (the main face) of some stone building. Get friendly with some local architect and ask him for an old or discarded blueprint. If you explain the purpose of your request, and he is a decent human being (who incidentally happens to be an architect) he will help you out. He might even take a few minutes of his precious time to tell you something about blueprints. And if you are really gracious he might give you an architectural sculpture job to do, long before you are equipped to do it, just because you are nice. That has been known to happen!

Now, here is one more way to get an architectural blueprint. Contact your town, city, or state official architect and ask for (demand) blueprints of some planned public buildings. These blueprints are supplied to all accredited engineers, building contractors, plumbers, architectural sculptors, etc., for competitive bids.

Ask (as an accredited sculptor and taxpayer) for blueprints of any public buildings that are to be embellished with sculpture or ornamentation. Then buy a scale ruler. This wedge-shaped ruler is indispensable. On a stiff piece of cardboard you can draw the markings of a scale rule—but no matter how carefully you indicate the tiny ¼-inch ruler length or 1/16-inch length, it is bound to be inaccurate. Buy a scale ruler. And buy a small caliper or compass.

Since the majority of sculpture created for architecture is attached to some building, it would be best to attempt a practical problem in architectural sculpture. The usual procedure is this. The architect (sometimes in consultation with the sculptor) decides where the sculpture will go on the building; what material and what projection is then concluded. The subject is usually left to the sculptor's decision.

The sculptor studies the blueprint of the

building. He tries to visualize the building as it will appear when it is finally erected. How high will the sculpture be placed, what light will the sculpture be exposed to, how far away will it be seen, what distortions will happen to the shape because of these conditions. These and many other questions stir his mind.

He begins a number of small scale drawings of some sculptural ideas. What is a small scale drawing? It is one in which all the measurements are proportionately reduced. For example, a drawing for a 10-foot piece of sculpture made to the scale of 1 inch to 1 foot should be just 10 inches high. A 10-foot piece made to the scale of ½-inch = 1 foot would be 5 inches high. One quarter of an inch = 1 foot would be 2½ inches high. If you have bought a scale rule you will find that each end and all sides of the rule are marked off so that you can get true measurements of these reductions I have indicated, and many more.

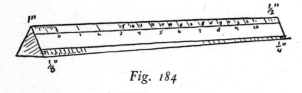

Fig. 184

These markings at each corner of the rule indicate a 12-inch foot rule in the reduced scale of many classifications. The tiny markings within the units of the reduced foot rule mark the proportionate reduction in inches. Is that clear? Study your scale rule a moment and you should catch on.

When the sculptor has penciled an idea which he hopes will work on the building, he usually builds a small scale model of the section of the building where his sculpture is to be placed. After measuring the exact dimensions of the space allocated to the sculpture on the blueprint and such architectural features as moldings and architectural setbacks, within

the immediate vicinity of the sculpture, he builds a plasteline model on a shellacked board. Or if it is a very complicated job and he is sure of his sculpture idea, he prepares a scale model of the architecture in plaster. All the architectural features of that section of the building are indicated in accurate scale. These models are built usually 1 inch or 1½ inches to the foot or a size large enough to allow the sculptor some freedom in modeling. If the architecture is embellished with molding, a templet for the molding is often made, the mold is run and applied (see *Fig. 185*).

Finally, with that section of the building ready, the sculptor indicates his sculpture as he hopes it will look on the completed building. This sketch model is okayed by the architect and anyone else who has any authority (the "anyone elses" might be the client who is paying for the work if it is a private building, or a committee of some sort if it is a public edifice). Then the sketch model is enlarged in clay to a working model and is cast in plaster from which the final sculpture will be made.

STONE SCULPTURE FOR ARCHITECTURE

A working model for sculpture planned for stone is rarely modeled full size. Since the final sculpture is usually carved on the building by stone carvers who mechanically measure (carefully, you hope) every feature and shape of the working model and carve it into the building, and since they work on scaffolds, it facilitates the work and permits easier handling if the working model is made either one half or one third the size of the final sculpture. These scaffolds are narrow, rickety structures and a large plaster model is cumbersome. Anyhow, since the stone carvers reproduce

the measurements with mechanical devices (either a pointing machine or large compasses —see *Fig. 187*), they can measure and carve just as easily and accurately from plaster models prepared one half to one third the size of the final sculpture.

Right about now I expect to hear a howl from the pure, pure art sculptors or those who aspire to create sculpture which is an exact transmission of their soul's yearnings unsullied by the grubby hands of strange and unknown mechanical stone carvers. Let me assure you all, you will howl yourself hoarse in vain. Modern architectural sculpture is not done any other way. Stone carvers who work on buildings are members of the building trade unions and the sculptor who has designed the work will be thrown off the scaffold if he so much as touches a chisel to correct some carving which butchered his sculptural interpretation. I know that from experience.

The sculptor may stand on a scaffold and criticize the work (not too harshly) and make suggestions about the interpretation of the sculpture into this final stage, but he must not carve even a little. That would appear to be a rather discouraging restriction but I believe it is just as well this restriction does exist. Modern buildings must be erected on schedule. They cannot wait for the dreamy conclusion of an esthete. The experienced union stone carver can and should make a good reproduction of the sculptor's work.

Modern architectural sculpture may be of such poor quality, not because of this condition but because many of our contemporary sculptors do not take this restriction into consideration when they prepare their architectural models. One might put a bit of the responsibility on the architects who commission sculptors whose forte is either sweet portraits and charming nudes or, at the other extreme,

distorted and deeply felt (by the sculptor, at least) abstractions. Both these extremists have not had time enough for the essential esthetic and craft development to properly design work for architecture. The latter's intellectualized shapes do not function any better than the decadent (gross or charming) nudes which too often spill their nudity out of the walls of many of our public buildings devoted to Justice, Statesmanship, or Legislation.

And it is a fallacy to look back at the golden days of architectural sculpture with the assumption that this condition (stone carvers reproducing sculpture from models) did not exist. On the contrary we have irrefutable evidence that in the greatest periods of architectural sculpture—the Egyptian, Greek, and many others—the master sculptor designed models and *directed* the designing of models from which apprentices and stone carvers worked.

Phidias, the Greek sculptor accredited with executing all the sculpture for the Parthenon, could not possibly have carved all the stone sculpture that enhances that magnificent temple. In fact, I question whether he could have designed all the models or drawings, or whatever they worked from, in his life span. No man could in an ordinary lifetime. There was too much of it. Phidias may have been the boss architectural sculptor, the directing intelligence who supervised the general scheme of the work. But the actual design and carving must have been executed by hundreds, perhaps thousands of lesser sculptors and stone carvers.

That, I believe, was true of all great architectural sculpture creations. There was a boss architectural sculptor who worked in close cooperation with the boss (or bossy) architects and the building with its sculptural and

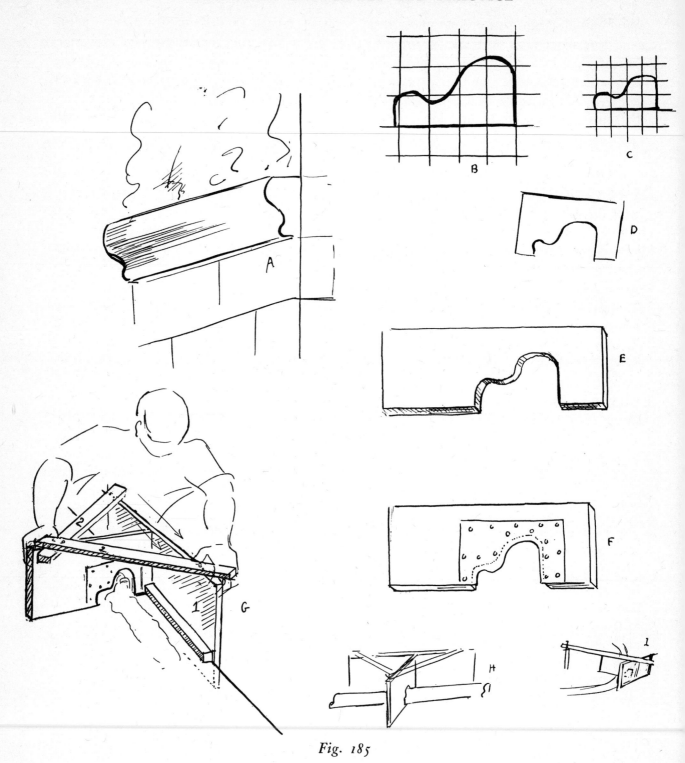

Fig. 185

mural embellishment was created under their immediate supervision by trained craftsmen.

Sometimes, as has happened in the Italian Renaissance, the boss sculptor and boss architect were one and the same person. The work of Donatello, Brunelleschi, and Michelangelo are proof of that.

A TEMPLET FOR ARCHITECTURAL MOLDINGS (*Fig. 185*)

A templet is a negative profile of an architectural molding cut in some rigid material and run (pushed) over soft clay or piled-up cream plaster until the positive shape of the mold is made in the clay or in the set plaster. If it is a small molding to be made in clay or plasteline and then attached to the clay or plasteline architectural sculpture model, the profile of the molding is traced from the architectural drawing on an ordinary sheet of paper. Then it is traced or pinpointed to a sheet of plaster cast about an inch thick or less. The negative profile is carved out with a sharp knife, the clay is spread on a board, the plaster templet is pushed over the clay, and the molding is made.

If it is a large molding in either clay or plaster, a rigid templet is cut out of a thin sheet of zinc. The drawings are traced on the zinc by tapping a nail at points along and through the line on the paper; a series of tiny depressions then appear on the sheet of zinc. The zinc profile is cut out with a metal scissors and finished with a file. Then a wood board is jigsawed crudely to the shape of the zinc templet. The zinc is nailed to the wood and the wood serves to back it up. Guideboards are then attached to the zinc and wood templet, and the clay or plaster molding is run.

A. The molding as it will appear on the finished job.

B. A tracing of the full size profile of the molding from the architectural blueprint. Since (we pretend) we plan a half-size model, we shall reduce this drawing one half by the square method.

C. Drawing of the molding profile we will use. These squares are one half the size of the squares in drawing B.

D. The drawing has been traced on this piece of zinc and cut out with a metal shears or heavy scissors. The inner edges have been filed and finished with emery paper.

E. The metal templet was traced on this woodboard and the molding profile jigsawed just a fraction of an inch larger than the metal profile of the molding.

F. The zinc templet is nailed to the wood templet.

G. The templet nailed together with guideboards (Nos. 1 and 2) and struts (No. 3). The templet is run along the edge of a marble-slab-topped table. If it is to be a clay molding it can be run on a good straight-edged wooden table.

In running a plaster molding a batch of plaster is mixed, allowed to set (to heavy cream), and dropped in a long pile along the track the templet will run. The templet is pushed along the table edge, more plaster is built up until the molding is the right shape, and the templet is run over a number of times with an even, steady pressure. If you keep your templet clean and work fast you might get a good section of molding. The finished molding is cut and trimmed and attached to the architectural model with nails or plaster-dipped burlap ties.

For really large moldings armature cores are built before the templet is run. A solid stick of wood may be enough for a clay molding. For plaster build up a core of roughly shaped clay, then use plaster-dipped burlap before piling on the plaster for the templet run.

BRONZE SCULPTURE
(OR ANY OF THE CAST METALS)
FOR BUILDINGS

All final working models for bronze cast for buildings are made actual size, or just a trifle larger to allow for bronze shrinkage. The processes in their earlier stages are the same as models prepared for stone sculpture. A primary sketch is made and approved, then usually a working model of about half to full size is modeled. This model may be enlarged with compasses and rulers and there is a mechanical device called an enlarging machine which is used too often. There are a number of machines conceived by mechanics (and some mechanical-minded sculptors) which have been used in the past few thousand years for enlarging, reducing, or reproducing in the same scale sculptural shape. If they are properly constructed without too many gadgets they usually work. Sculptors' working models are reproduced, enlarged, or reduced into cold, lifeless replicas with factual accuracy. But the best of these machines will never replace a competent sculptor. The most popular enlarging machine used in America is the Paine machine. This machine like all other enlargers works on the pantograph system in the third dimension (see *Fig. 186*). It is very successful on the colossal models for fair work —sculpture units from 12 feet to 36 feet high and beyond. There is a machine popular in France which is in my opinion a much finer instrument, but I question whether it can function on colossal sculpture.

Leonardo da Vinci invented in one of his spare moments, an enlarging machine full of trickily contrived strings and plumb bobs. The Egyptians used a simple proportionate square method of enlarging which is accurate and in use to this day. It is used mainly for enlarging relief sculpture and is also used by mural painters (see *Fig. 202*).

There is a three-point compass method, a slow but very accurate method for reproducing, enlarging, and reducing, that has been used for ages for work in both stone and clay, and it is still the best method that I know of (*Fig. 187*).

I prefer these last two procedures, the Egyptian squares for relief sculpture and the three-point compass method for any sculpture in the round. Though in the main I enlarge or reduce my own work only by means of a long rule and my one good eye. It seems to me that having once established the extreme limitation of the sculptural shape the eye is the best judge of the variations and proportions its smaller shapes must take. Since a change in the size of the main shape has a tremendous effect on the observer, the eye is the best judge. By that I mean while in a small piece of sculpture a design needs certain shapes emphasized to carry out its purpose, when the size of the whole design is altered (say enlarged), the importance or emphasis may shift, and the sculptor must meet the new size by controlling or rearranging the shapes within his composition to get the effect he achieved in his small reduction of the same design. This same principle holds true in either reduction or enlargement of sculpture shape.

If this idea is not clear mull over it a bit. It should clear up.

Here is a simple example of this idea. A nude, charming, plump, year-old baby enlarged in exact proportion to the size of a 6-foot man would seem a horrible monster as he stood alongside a properly proportioned full-grown man. And at the other extreme a handsome adult reduced in exact proportion to a tiny baby would appear a weak, puny

freak. I have seen colossal (realistic) babies carved in stone on the façade of the Louvre in Paris that had that horrible monstrous effect I mention. I have also seen colossal sculptured baby shapes on Eskimo carved totem poles, wherein the proportions were so juggled and manipulated the large baby still looked fine, full, and strong as they do in life (though there was no cuteness); and at the other extreme, fine adult figures in all proportions, from the tiny ivory carvings of the Chinese to the 40-foot stone Egyptians, had their proportions so well adjusted by the good sculptors of those days that living human beings alongside these fine works looked no more alive than the sculpture does.

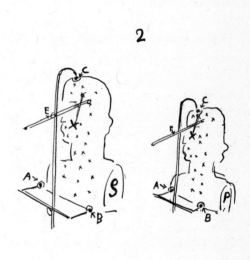

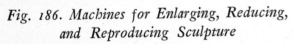

Fig. 186. Machines for Enlarging, Reducing, and Reproducing Sculpture

All machines used for enlarging, reducing, or reproducing sculpture have this common principle. From three fixed points (usually as on 2, A-B-C) the surface of the sculpture to be reproduced is traced by mechanical measurements.

1. This machine for reproducing in clay or plaster is indicated here without its wheels, pulleys, and doodads—just its main principles. A. The long arm of this machine which acts as an established surface.

B. and C. Assuming the large figure is to be twice the size of the smaller one, the sockets B and C are so placed on this long arm A that when the arm is swung up or down B will travel only half the distance C travels.

D. and E. Long needles or rods. E is allowed to jut out of its socket only half the distance of D. Thus, if the arm is swung and point X on the smaller figure is wanted on the larger one —needle E rests on point X on the smaller figure and needle D (only half E's length) touches air until the clay is built up to meet it on the large figure creating an X point there.

If a reduction were being made from the

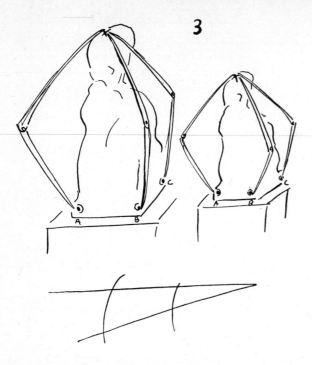

3

Fig. 187

larger figure to the smaller one, the process would be reversed.

2. Machine used for carving (reproducing, enlarging, or reducing). Three main points are established on the plaster piece (P) and on the stone piece (S).

These machines are light and easily moved. The points A-B-C on S (assuming this stone is being enlarged twice the size of P) are spaced twice the distance from each other. The ma-

chine hangs on point C and rests on A and B. An adjustable needle (D) juts out from arm E.

Point X found on P is placed on S by readjusting (shortening) needle to half its length in socket.

3. Three-point compass method for reproducing, enlarging, or reducing in modeling clays or carved materials.

This method works on the principle that by transcribing arcs from three fixed points any point in space can be established.

Two points A and B are fixed on both models, proportionately spaced if reduced or enlarged; then a rear point (C) known as the pull point is established with compasses from A and B. Compass arcs sprung from A and B establish a point on a flat plane. An intercepting arc from the pull point C pulls that point back or pushes it forward and places it exactly.

In reducing or enlarging with the three-point compass method the proportion of enlargement or reproduction is usually marked off on the floor of the studio. A measurement is taken for a point with each of the three compasses; then each compass is readjusted by arranging its spread to the change (reduced or enlarged) demanded according to the floor-marked measurements.

It is a long process but very exact.

All these processes depicted here are better left to the technicians.

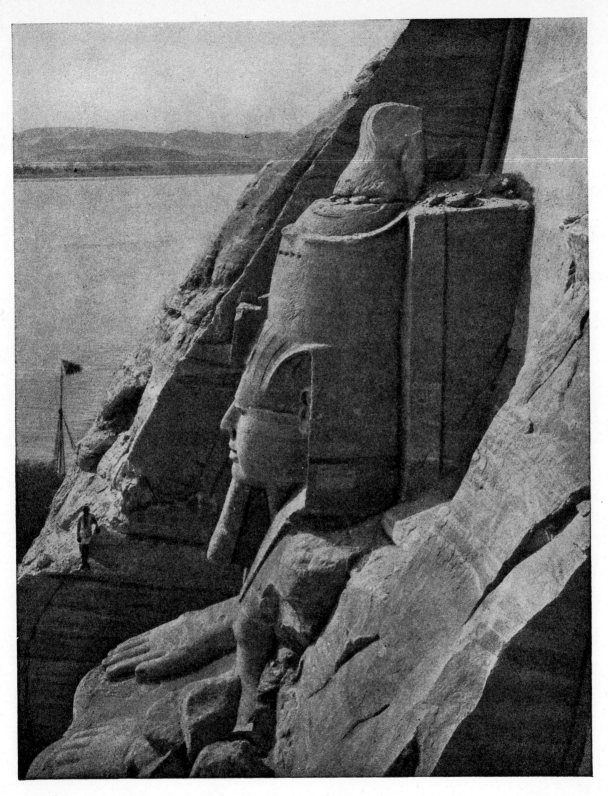

Fig. 188. Colossus of King Ramses. Carved into the temple at Abu Simbel, 1250 B.C.

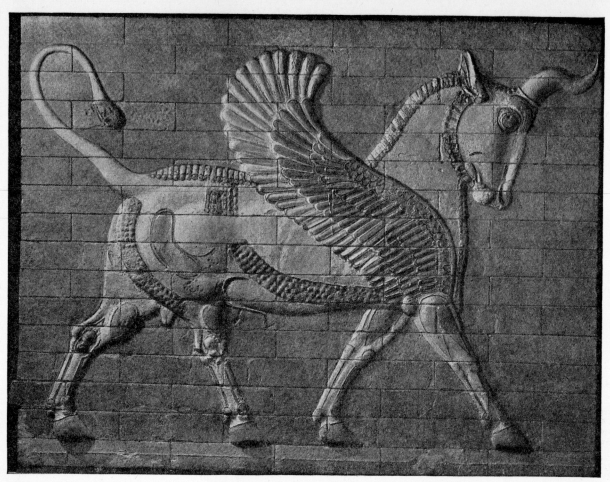

Fig. 189. Persian enameled brick sculpture built into walls of the Darius Palace about Fourth Century B.C.

Fig. 190. Detail of *Fig. 189.* Observe how carefully this sculpture is planned. There are no "feather-edges" to these bricks.

WOOD SCULPTURE
FOR BUILDINGS

Wood sculpture for Interior Panels (wood is not an outdoor material) may be carved in full size in the sculptor's own studio, after the primary sketches are studied and developed in drawing and clay, and then bolted to the walls for which they were designed. Wood is also carved from the sculptor's plaster models by expert wood carvers. Of course, these too are copied by mechanical means, but I see no sense in giving out work for wood to be carved. And that holds true of any carved materials that can be executed in the sculptor's studio and attached or bolted to buildings inside or outside.

TERRA COTTA SCULPTURE
FOR BUILDINGS

Terra cotta sculpture designed for panels or other architectural sculpture features is handled pretty much in its early stages as cast metal sculpture, which will be attached to the building. Although it is possible for the sculptor to prepare large clay models for firing in the studio, for practical reasons it is inadvisable. The clay must be dried and properly sectioned off so that it can be transported to the big kilns and fired. It is best to prepare a plaster model and have the terra cotta company that is commissioned to fire and cement the work to the building make a repeat cast. At times they prefer that the sculptor just ship them the molds. A clay squeeze is made in the terra cotta works, and the sculptor is usually called to retouch the clay before it is fired.

A large terra cotta is usually cut up into sections before the clay is fired. The planning of these sections must be done by an expert terra cotta man. He will know best how to prepare the work to provide for shrinkage and to guard against too much warping. Contemporary terra cotta sculpture for architecture is sometimes glazed.

The Persians about twenty-five hundred years ago built marvelous bas reliefs in glazed or enamel-fired clay bricks. Is there any question in your mind about the permanence of fired clay? Look at the Persians.

FREE STANDING
ARCHITECTURAL SCULPTURE

Until now we have been concerned mainly with relief sculpture or free units of sculpture which are well attached to buildings. But all architectural sculpture is not so definitely designed into a building's plans. Often free standing sculpture anchored to pedestals or placed in niches or incorporated in some way with a building is commissioned. And finally the big whopping monument (the aspiration of every sculptor) may be commissioned.

A monument must have the best qualities of great architectural sculpture or it is nothing more than a blot on the landscape or a dangerous traffic hazard. Good museum sculpture placed on an ill-considered base and set in some haphazard manner on a lawn, or plunked down with no consideration for its approaches or relation to the surrounding landscape, is a sorry sight indeed. The architectural qualities of a good monument must be present in every respect and detail of its conception.

Free standing sculpture incorporated into a building is also worked from blueprints the same as any other architectural sculpture. The processes are the same; sketches and enlargement are carried through. Naturally there is

a difference in the armatures built for these sculpture models, but the methods used for converting them into their final materials are similar to the processes we have already spoken of.

HOW TO GET A JOB IN AN ARCHITECTURAL SCULPTOR'S STUDIO

It is as foolish to believe anyone can become a full-fledged architectural sculptor from this book, or any other, as it is to hope to become an expert stone cutter, wood carver, clay modeler, or master of any other craft we have talked about thus far without the years (yes, years) of practical application these crafts require. If the argument I presented concerning the importance of architectural sculpture has convinced you, and you aspire to work in that grand tradition of sculpture, after you have spent a few years drawing, studying the nude, and have acquired some of the essential crafts and skills for sculpture, get a job in an architectural sculptor's studio. Sweep floors, mix clay, bang a typewriter, do anything you can to get yourself a job where architectural models are made, and keep your eyes open and your mouth shut. If you have any skills and show any talent for designing architectural sculpture, you may be given a chance to work on the big models which are being prepared.

Since there are many young sculptors eager to serve an apprenticeship in large architectural sculpture studios, in order to sharpen your chances for getting a job, here are a few things you should know.

First, you should know how to sweep a broad floor and do it quickly without too much dust (a sprinkle of water will hold down the dust). One architectural sculptor I knew used to place pennies in dark corners of the studio and then check up after the floors were swept to see if the brooms had even nudged them. The studio boys soon learned the penny trick and just gathered them up as an extra dividend to their far from magnanimous salary.

Know how to cover up large clay models well and quickly. Check back to the section in this book on "keeping clay moist." The procedure is the same, only on a bigger scale, for big clay models. Know how to use a wood saw and the proper way to swing a hammer. Do not choke the hammer handle; grip its end. There is an awful lot of rough carpentry in an architectural sculptor's studio. The armatures for the large clay models are generally constructed of wood frames with wood boards and slats building up the shapes of the model. These armatures are so constructed that the clay built on them is rarely more than 2 inches thick. That is not only true of free standing sculpture but of large relief panels (*Fig. 202*).

You can also better your chances for a job in an architectural sculptor's studio by practicing making actual scale model sketches from plans. Work up some monuments, panels, and free standing units of sculpture in true scale. Model them seriously and indicate the architectural features that relate to your sculpture.

Now then, if you have acquired some competence at designing scale model sketches, reading blueprints, some accuracy in enlarging scale models, an ability to saw a straight cut through a board and to whack a nail properly on its head with your hammer, you might never get a job in an Architectural Sculptor's studio as a floor-sweeping studio boy. You might be hired as an assistant sculptor!

A Practical Problem in Architectural Sculpture

Take a good grip and stretch your imagination. Imagine we are commissioned to execute a memorial commemorating a regiment of soldiers who fought on some Pacific Islands and suffered great casualties during the last war. This monument is to be carved in stone and set up in the quiet park of a small town. The only requirement insisted upon by the committee awarding the job is that an appropriate laudatory statement by the President of the United States and the name of every local soldier hero must be carved on the face of this monument.

There is a modest sum of money appropriated to pay for the work. The cost of stone, stone setting, stone carving, and all the other elements that must be considered in monumental sculpture vary so from year to year that it would be senseless to indicate a definite sum of money here. Let us grant that we have enough money to design and execute and pay the expense of this job and get a living wage for ourselves—and let's go to work.

We decide after trying many schemes that this idea will best express what we want to say in sculpture about these gallant soldiers and will fulfill the requirements of the committee and the limitations imposed upon us by the landscaping of the park in which the monument will be set.

We build up a unit of shape about 1 inch to the foot, perfect its proportion as well as we can, then consult with the architect (I forgot to say we are bossing this job and hiring the architect, so he must do pretty much as we say—let's just dream on). The architect takes measurements of the main shapes we have designed, discusses this and that, and goes off to

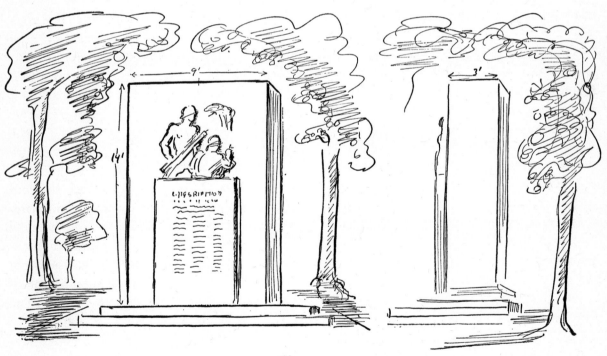

Fig. 191

make his drawings. Plans must be drawn for the foundation the monument will rest on, the approaches (paths leading up to the monument), and lots of other stuff.

We have decided since a block of stone 14 feet high by 9 feet wide by 3 feet thick would cost a mint of money—the transportation costs alone from the quarry to the site would be way beyond what we could afford, and then, too, we might not be able to get a block that size of any good stone, because they are seldom quarried in such huge blocks—okay, we shall build our monument with smaller blocks of stone.

The architect prepares drawings of the monument, indicates the way the stone may be set together, and sends us blueprints.

Roughly this might be the drawing of the stone before it is carved. Now we go to work on a small working model. Our main concern right now is with the area I have indicated within the jagged black line, the main sculp-ture—the two soldiers who will symbolize all the soldiers we want to commemorate will be carved into these stone blocks.

The sculpture shapes must consider the stone's limitations. We must pay some attention to the stone markings as we design—but that all comes later.

Here is the way we go about building up a relief which will be our first model for this monument. This work is to be modeled at the scale of 2 inches = 1 foot. It will be the upper width of the monument and just enough of the rest of it so we can make a good study of the sculpture relief.

On a shellacked board 18 inches wide (2 inches = 1 foot; nine 2 inches = 9 feet —simple, isn't it?) and 18 inches high, I squeeze just a skin of plasteline, flatten and scratch down a rather even surface. Keeping the 2-inch scale in mind the figures are drawn on the surface. Check their placing with a scale rule.

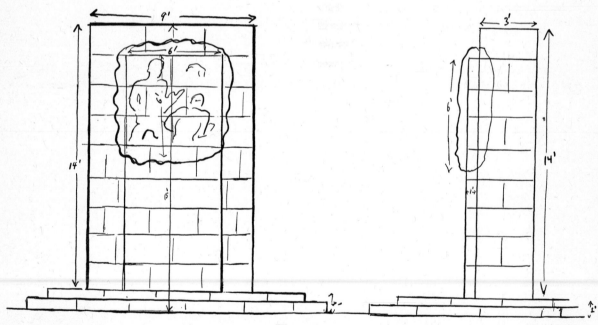

Fig. 192

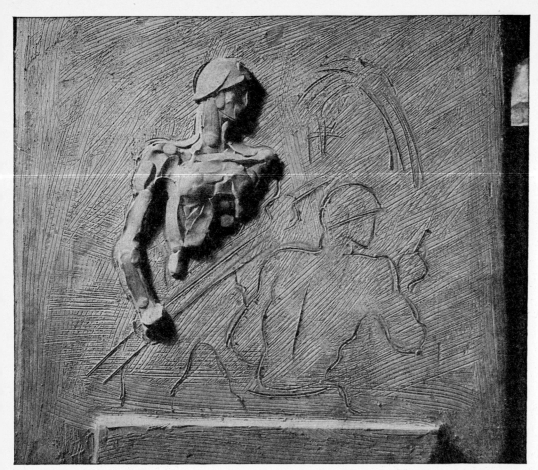

Fig. 193
The rough drawing of the main masses has been indicated. Clay is built on. Note the unit of clay built at the bottom of the panel indicates the block of stone. I do not plan to build beyond this surface which has a 1-inch projection (that is 6 inches high).

Clay is being built up on one figure.

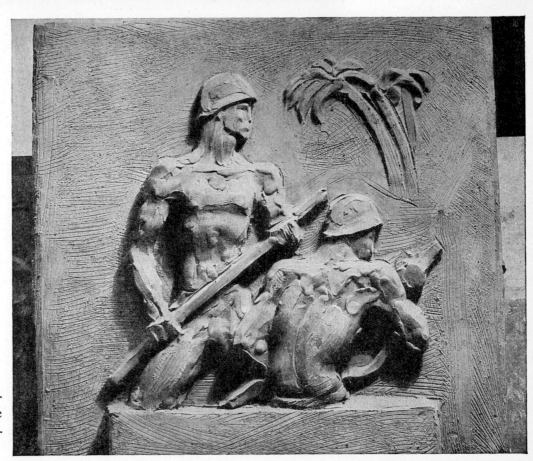

Fig. 194
Although this clay seems carelessly applied, every sausage and pellet has a definite purpose.

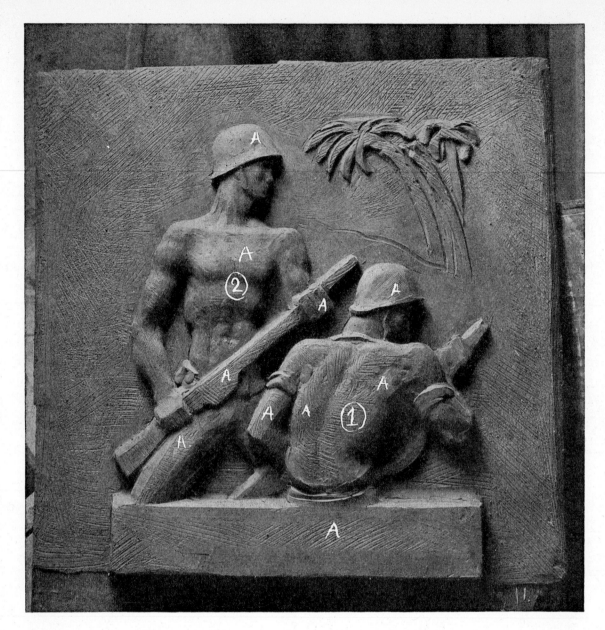

Fig. 195

Relief carried further. Now I have carried this work far enough so that we can talk about it. Note planes marked A are all built up to the full stone surface. Although soldier No. 1 gives the illusion of being in front of No. 2 and No. 1 seems to jut away from the background more than No. 2, it is only an illusion created by the break and bevel of the planes—and the resulting color.

Remember the "front and side and back of shape" theory we discussed in the chapter on Building a Head. That theory is of tantamount importance in modeling or carving relief sculpture. Since the sculptor must work on the front of all relief shapes he indicates, and cannot get his work done by merely slicing away at the outlines of his sculpture, if he will not consider some version of this "front and side of shape theory" he is lost. For though a thin form of sculpture can be created when working in the round by chewing away at the

thousands and thousands of outlines that make up a sculpture piece in the round, in relief sculpture there is only one outline of the main shapes—that's all. This outline may be corrected and redrawn over and over again, but no matter how much it is worked over and perfected it is still only one outline. And the relief will be merely a two-dimensional pattern drawn on a panel if the sculptor does not face the fact that in this form of sculpture as in all others there must be a consciousness of the front, side, and back to all shape.

After that digression on the same old cracked record "front, side, and back of shape" (incidentally that record idea is good; if some records were made that automatically repeated every half hour while you worked the essential truths about sculpture, such books as this would be totally unnecessary and a lot of schools and academies would go out of business), let's return to this job of doing a monument.

FEATHER-EDGED STONE AND STONE WASHES

Notice that in designing this relief I kept the outline of the shapes away from the stone markings. That was to prevent "feather-edging" the stone. When a model is designed for sculpture which must be carved into built-up blocks of stone, and the working model is so indicated that the stone joint markings are too close to the edges of the shapes, these thin slices of stone may break off. This is called a "featheredged" stone. For the stone in these areas may be so thin it will chip off in the carving or eventually split away when the stone has weathered a bit. It is best to arrange

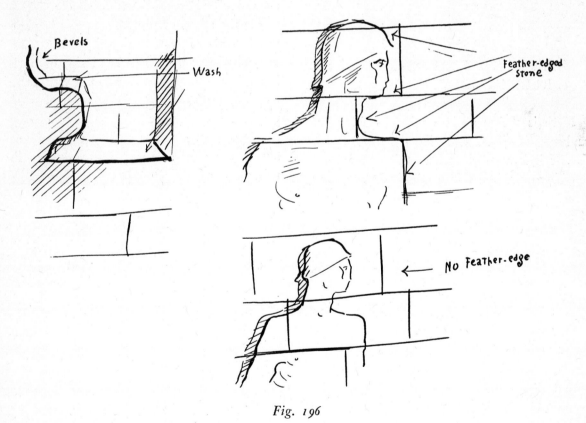

Fig. 196

the design so that the stone markings avoid the edges of shapes or run through the heaviest masses of the shapes.

There is another thing which must be remembered when designing a working model for stone which will be out in the weather.

Be sure and provide "washes" on the top of all the stone shapes. That means build the top planes of all the sculpture shapes at a bevel so that rain water will run off and not gather on your finished stone sculpture. The reason for that precaution is obvious. If these beveled top planes were not indicated, puddles of water would gather on your stone, eventually become lumps of ice, and damage the stone plenty. And too, pools of water gathered on the stone do wear it through.

Now then, let's grant everything has been taken care of. The sculpture relief in this stage is finished. We cast in plaster and get on with the job.

CASTING PROCESS FOR ALL RELIEF SCULPTURE

Here is the procedure whereby all relief sculpture is cast. Simply lay the panel down flat. If it is a panel such as this one we are working on, with no frame, build a temporary wood frame of firring strips (1-inch by 2-inch sticks of pine). Build the frame as I have indicated in this drawing.

Fig. 197

Mix the plaster, pour on the mold (that wood frame acts as a containing wall to keep the plaster from running off), rock the panel so that any bubbles which might have gathered as the plaster was being poured on the clay will come up to the surface. The plaster mold should be about 1 inch thick.

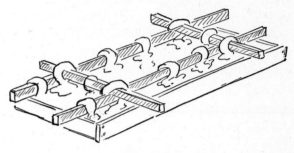

Fig. 198

Now strengthen the mold with pipes or crisscross sticks. These supports should extend a few inches beyond the wood frame.

Tie the sticks or pipes down to the plaster molds with strips of burlap dipped in plaster (called plaster ties). Dip the strips of burlap in a mix of strong plaster—do not wring them out. Let them be quite juicy with plaster as you fish them out of the plaster bowl. Then tie them across the sticks and to the mold and spread the ends of the plastered burlap like this.

Fig. 199

The plaster for plaster ties need not be mixed very much because dipping the ties into the plaster will tend to give it all the mixing it needs.

When the mold and ties are well set, knock

off the wood frame that retained your plaster (*do not* break up this frame—we will use it again later) and gently pry up the mold.

Now clean the mold, soap it well, and oil it sparingly. All three processes are the same as Waste Mold of Head.

Before filling the mold cut a strip of burlap (wide-meshed burlap if you can get it) a little larger than the width and height of the relief.

Nail the wood frame together and fit it around the mold again. Plug with clay any openings that might appear between the plaster and the clay. Oil the wood frame on the inside, the mold side.

Now mix a good batch of plaster and pour it into the mold. Rock the mold to shake up any bubbles that might have gathered as the plaster was poured. This plaster should make a sheet about ¾ of an inch or 1 inch thick. When the plaster begins to set mix a new batch, a small quantity. Rough up the surface of the back of your plaster cast; if you pick the right time you will find you can rough it up with your fingers. Then dip the burlap sheet (which was cut a little while back) into the new batch of plaster. Pick it out juicy and dripping wet with plaster and lay it on the scratched-up, almost set plaster cast. If this burlap, which is intended to strengthen the cast, has been cut a little larger than the cast, the overhanging edges of the plastered burlap can be folded back over itself on all four sides of the cast relief. It will thus strengthen those edges.

Cut more firring strips a few inches longer and wider than the relief, and lay them on the cast. Tie them down well to the cast with juicy, plaster-soaked burlap strips. Let everything set. Then carefully chip off your mold. Knock the wood frame loose and chip away the ties that hold the supports of the mold. If they are chipped away properly at the points where they catch on to the mold, the supports

will come away with them. Chip off the mold (not in big pieces, remember), and the waste mold plaster cast of this relief should come out all right.

This is the general system for casting all relief sculpture with a waste mold. The only variation—if it is a very low relief (or a small high relief) that is being cast and there are no undercuts or any small shapes that the mold plaster can cling to—is that this mold need not be chipped; it can be picked right off the cast. Then it is not a waste mold, and multiple casts can be made from this mold. And, too, a very low relief need not have the firring strip supports—just burlap and nothing else will be enough support for small reliefs. If it is a piece wider or longer than 1 foot (still a small relief), shellacked slender rods of metal or pipes can be laid into the back of the cast and tied on with thin strips of plaster-dipped burlap and gobs of plaster.

If it is a large high relief that is cast, the system varies only in the proportion and number of wood supports used. And the plaster ties must be longer to be attached to the deeper parts of the cast by twisting the burlap plaster ties as I indicated in this drawing. It might be wise too, in the case of large reliefs, to use one coat of blue plaster (refer to Waste Mold of Head).

Reliefs can be cast with gelatine molds. The

Fig. 200

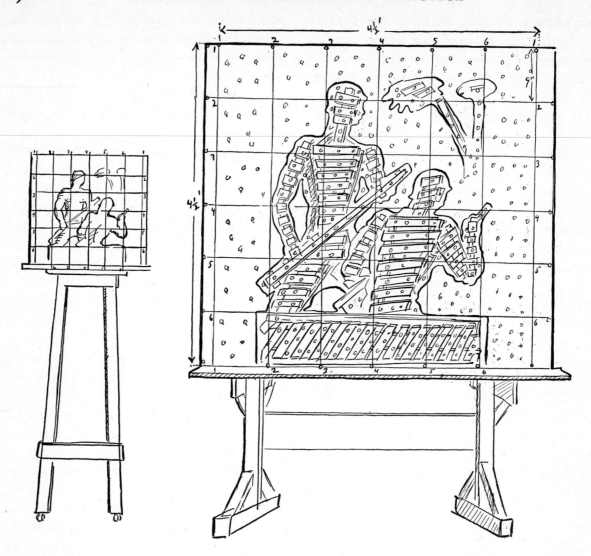

Fig. 201

Build a strong wood panel 4½ feet by 4½ feet and set it up on a temporary easel constructed as indicated in *Fig. 201*.

This drawing is made roughly to the scale of ¾ of an inch equals 1 foot. Check it with your scale ruler. Remember the small relief was 2 inches equals 1 foot. This large one is 6 inches

equals 1 foot (just three times the small one) so the squares I indicate are 3 inches on the small relief and 9 inches on the large. Proportionately smaller squares would be better on both models for more accurate enlargement, but they would be harder to see here in this demonstration.

procedure is the same as any other gelatine cast, except the gelatine need not be cut. It comes out of the mold in one big sheet and rests comfortably in one plaster shell as it is being filled.

With this cast of the first working model of our sculpture relief done, let us go on. Set up the plaster cast on a stand and begin enlarging.

We grant that the stone carvers will work from a half- or full-size working model. Here is how we enlarge this model. Remember this section in the full size will be 9 feet by 9 feet with a 6-inch projection (these measurements relate to the section we are working on now). Very well, this final working model will be 4½ ft. by 4½ ft. and have a 3-in. projection.

ARMATURE FOR ARCHITECTURAL SCULPTURE

Let us enlarge this quickly with the Egyptian method of proportionate squares and build up an armature for our half full-size working model. The outlines of the main masses are drawn on. The armature is carefully built up with wood strips and slats within the drawing. Flatheaded roofing nails (available at any hardware store) are hammered into the wood background and the wooden armature. These flatheaded roofing nails are allowed to project about half an inch from the wood. They are wonderful for holding clay on a big job.

All armatures for architectural sculpture including work in the round are built in this manner: wood structure with wood strips and slats and finally roofing nails. The wood structure is carefully placed so that the applied clay will be not more than 2 inches thick. If there has been a miscalculation and the wood

sticks out of the clay in some sections, the slats and smaller wood strips may be ripped or sawed off the main structure without redoing the whole job.

The armature is complete. Give it a few coats of shellac, or we might get the studio boy to do that (we hired one as soon as the first payment was made; that happened after the sketch for this job was completed and okayed).

Payment on sculpture jobs usually are arranged this way: First payment on completion and okay of sketch model; second payment on completion of final working model; third payment on completion of the sculpture and installation. Sometimes the payments are divided into four but this three payment method is more general (so remember that when you sign your next sculpture contract).

The shellac on the wood armature is dry and the studio boy has mixed and kneaded about a half ton of clay and rolled it into large sausages. Very well, slap on the clay. The only tools used so far are our hands and a chunk of wood with which we club the clay into place.

The model builds up quickly. Mark off those squares again. We drove nails into the edges of our big board to indicate where those squares were originally drawn before we covered the board with clay. All we have to do is to find the nails, place a long straight edge across our clay panel, and draw the across and up-and-down long lines that make the squares.

We need not again discuss the principles of relief sculpture, or the ideas on enlarging shape and the change of emphasis those shapes require, or the care we must take that the shapes we indicate will not interfere with our stone markings so that we force "featheredges" into the stone—all this is understood.

We finish this half size working model. Get

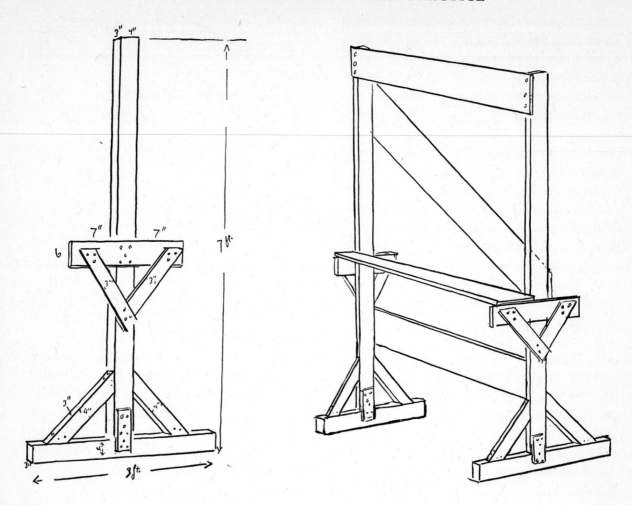

Fig. 202. A Practical Easel for Sculpture Relief

This is a practical sculptor's easel. Those two crossboards can be knocked off, and the two main elements (the standing uprights) can easily be stored in a corner of the studio when not in use. If a bigger or smaller job comes along, longer or shorter crossboards can be used, the supporting top shelf for the panel can be moved higher or lower, and we shall have another easel with the same main uprights. Another feature—those long skis on the floor make it a piece of equipment which can be slid around the studio if it must be moved for photography or some other reason.

This easel is made of good finished pine. The uprights, skids, and skid supports can be either 2 by 4 inches or 3 by 4 inches. The temporary shelf bracket can be made of 6 by 1 inch boards or 7 by 1 foot boards. The placing of those brackets depends upon the size of the job you are working on. For the half-size working model for this soldier's monument they were placed just about 2½ feet up from the floor. The same is true of the supporting cross pieces. They can be made of any width 1-inch board—8 inches is a good width.

it photographed. Have the committee okay it in the clay. By the time it is cast and has been worked over in the plaster and is ready to be shipped to the site to be carved, we might get our second payment for this job. We pay some bills (back rent, studio boy's wages, buy a new overcoat) and since the big relief was cast pretty much the way we cast the smaller sketch model, we ship it off to be carved.

Meanwhile, as we were carrying through this final model in our studio, the foundation of the monument has been laid, the stone has been quarried and set up at the site, and the architect has been busy too. Along with his other activities in relation to the monument, he has arranged to have a big drawing made of the lettering of all the names and the inscription which is to be carved into the face of the monument.

We (and he) had decided on the design of the spacing and placing of those letters. In fact, we have drawn up a typical line of letters, and he employs a good letter man (a technical expert) to carry on and draw on a large sheet the thousands of letters which make up the inscription and the list of names. A blueprint of this drawing will be given to a stone carver and he will carve it all on the face of the monument (carefully, we hope).

So I repeat, we ship the plaster working model off and hope for the best.

THE PROPER WAY TO CRATE AND SHIP SCULPTURE

This is the proper way to crate and ship sculpture so that it will arrive at its destination in good condition.

Since we are concerned with shipping off this plaster relief, let's tackle this problem first. Remember these sticks which jutted out a few

Fig. 203

inches beyond the plaster in the "Method for Casting Reliefs"—they were useful for supporting and handling the cast around the studio. Now they have an even more important use.

Nail together four sides of your box as indicated in drawing. Use finished pine for crating sculpture. The truckmen who will handle this box in transit will drop this precious sculpture crate with an awful crash if they get splinters in their dainty hands from a rough unfinished pine surface. Notice in this draw-

Fig. 204

ing the over-all dimensions of the box. I have assumed the depth of our cast including back supports is about 7 inches. We shall build this box 10 inches deep (inside dimension).

Note, too, the four-sided box is just about an inch larger than the plaster cast on all sides. The plaster relief is laid on the floor. Lower the nailed-together four sides of the box on the relief so that it rests on the wooden supports. Then the inside dimension of the box is marked on the relief's wood supports. Lift the box off again and saw through the plaster cast wood supports at the markings. If it has been done right the relief will fit snugly into the box and be held there by its wood supports. Drive nails into the outside of the box so that they will catch all those wood supports. Nail the bottom and top covering boards to the box, address it properly and call for the express man.

NOTE: There is no excelsior or packing used, yet this plaster relief will reach the stone man intact. The plaster relief is riding on its own wood supports and those supports have become part of the box. The only way that plaster relief can be broken (providing of course the plaster ties, wood supports, box, etc., are properly made) is to smash the box deliberately or wreck the train or truck it is riding on.

One precaution you must take. Be sure and send a letter to the stone man, or wherever the box is being shipped, warning him to pay attention to those nails that hold the plaster supports to the box, or else if they pry the box open carelessly—well, you might have to make your working model over again.

Almost all plaster models (architectural) can be shipped this way, because in the main they are designed for walls or attached in some way to architectural features—therefore, wood supports like these can be used.

Plaster models in the round are usually shipped in well-made boxes, packed in a tight bed of crumbled newspaper or excelsior. If it is a delicate plaster model in the round being shipped, pack it that way, but before it goes into its bed of paper or excelsior wrap it up in an all-over padding of cotton wool. Tie the wool on with string, wrap it in paper, and tie the paper on too before it is packed. Never pack cast plaster in a cardboard carton box.

Well, the job is shipped off. We shall now tear our hair until the model is properly carved. Finally it is done. We supervised and begged for good careful carving—maybe we got it.

The monument is finished. It has been unveiled—with speeches by people (some long-winded ones) who never had anything to do with making the monument or had any other relation to it—this job is done. Now let's go on to the next one and the hope that sometime we shall make good Architectural Sculpture.

One final remark on architectural sculpture.

There are other materials used for architectural sculpture besides those that have been considered here: Cast Glass, Cast Lead, Stucco (a very old material), Carved Brick, Plywood, Stainless Steel and various other alloys, and a variety of plastics and other materials. Since the procedures for working in the majority of these materials have a relation to those we have already considered I see no point in taking up their individual problems here.

New materials are being developed every day. Sometimes an adventurous architect comes along who believes that in commissioning a sculptor to work a modern material he is helping to create modern architectural sculpture. The fallacy of that idea is obvious. It is not the material (the new alloys or novel materials) that makes the sculpture—it's the sculptor.

Conclusion

Miscellaneous comments on sculpture. Now as I come to the conclusion of this book, there are odds and ends that I believe must be included. What of the sculpture principles I have not discussed? What of the practice? What of the materials? Here follows a miscellaneous assortment of comments and ideas that have not fitted into my earlier text.

UNCOMMON MATERIALS FOR HAMMERED OR CARVED SCULPTURE

Repoussé, Copper, Lead or Pewter, Crystal, Jade, Ivory, Bone, Brick, Plastics, Cast Plaster Blocks, Brass, Steel, Soap, Vegetables (potatoes, turnips, carrots, and such), Sponge, Toast, Butter, and Ice are also materials that have been used for carving or hammering out sculpture shape.

Repoussé Sculpture is the process of banging sculpture form out of metal sheets with round-headed hammers and metal punches. The forms are beaten into the sheets in reverse and then controlled and refined on the converse side. Copper has been worked and hammered hot and cold. Lead and pewter are hammered cold. A pitch bed or a bag of sand or wood shapes are used as a base to hammer against. It is an old process more popular in the past than it is today. Some of our good contemporary sculptors have used these processes and produced fine sculpture in repoussé copper and lead. Many of our gift shoppes display (and sell) hammered pewter ware and doodads made with this process. Wander back into some of their workshops if they will let you and watch them make ashtrays and butterballs. The same process is used for sculpture. Some people use pewter for repoussé sculpture.

Crystal, Jade, and Ivory were carved by Oriental craftsmen with a lot of patience, a lot of trick files, drills, cutting wheels, and rasps. And the Eskimos, medieval Europeans, Africans, prehistoric cave dwellers, and other primitive people have used ivory and bone and whittled these materials with tools of their own. If you have a lot of time settle down in an igloo (or a cave) and carve a piece of walrus tusk. If not, and you still want to try some of the unconventional materials I have listed above, here is comment on them.

Brick, Plastic Blocks, and such materials are

no better carving mediums (for novices) than brass or steel. They are different and, though they may take less time, I see no real value in carving these materials. Cast plaster blocks, soap, vegetables, sponge, toast, butter, and ice are easier to carve into but I see no more reason for using any of them except ice. That material carved by chefs into icy swan boats as containers for caviar is useful. Caviar tastes best when sprinkled with a bit of minced onion and eaten very cold.

UNCOMMON MATERIALS FOR BUILT-UP SCULPTURE

Modeled Cement, Papier-mâché, Lacquer, Mud, Forged, Fused and Wrought Metals, Cast Plastics, Cast Glass, Pipe Stem Cleaners, Wire, Sand, Dough, and Snow are other materials that have been and are being used for built-up sculpture shape.

Direct modeling in Cement. Cut chicken mesh wire is built up and held together by galvanized wire and attached to bent, shellacked iron rods as an armature nailed to a base. A mortar of Keane cement, mixed with slack lime and water and used as it thickens (like working directly in plaster), is spatulated onto the chicken wire armature; one begins building up from the base. It is not a very sympathetic material. One or two contemporary sculptors have used it successfully. But usually sculpture in modeled cement has a crackling existence. By that I mean the piece usually cracks every time a gentle breeze blows or whenever the work is moved.

Papier-mâché. Paper is soaked in water and glue and then laid layer on layer in a shellacked, greased plaster mold. The dried papier-mâché is taken from the mold, then shellacked and painted with gaudy colors. Sometimes paper pulp is cast into plaster molds. These processes are used by puppeteers and carnival maskmakers. They bear little relation to serious creations of sculpture.

Lacquer and Mud. Strange as it may seem, both of these mediums have been shaped into very beautiful sculpture by the ancient Chinese. Neither medium has been used much since. When I was much younger and visited the Metropolitan Museum almost daily I saw a few beautiful Chinese sculpture fragments time and again. One day I read the little gold-lettered sign at the bottom of the glass case they rested in. Two lovely Chinese fragments, a hand and an almost life-sized arm that I had admired and believed were made of fine green gold-flecked bronze, were made (so the inscription said) of lacquer! I studied the broken section of the sculpture carefully and I saw that a bamboo armature had been used and strips of wide-meshed cloth had been wrapped around and around until they approximated the bulk of the arm. Then it seems layers of lacquer were painted on, one on top of the other until a crust about ⅛ of an inch thick was built up. I do not know how they finished it off but the surface did show fragments of gold leaf. These Chinese pieces were as complete and as beautiful as any sculpture arms or hands I have ever seen.

There are Chinese mud figures on display too which are hundreds of years old. They are tender, gracious little figurines modeled in mud on straw or bamboo splinter armatures and sun-dried. There are delicate traces of paint on their draperies and heads. Since they are so fragile I am always amazed when I realize they have existed for hundreds of years.

Forged, fused, and wrought metal have been used by sculptors through the ages. Recently some of our contemporary sculptors have again used it as a medium. Those good sculptors who have had practical experience with welding torches and forges have created some

fresh sculpture shapes; others have gathered blisters.

Cast Glass and the Cast Plastics are not dissimilar in their final results. Cast colored or opaque Glass is not a new medium as any collector of bottles will assure us.

Pipe stem cleaners, Wire, Sand, Snow, and Dough are pipe stem cleaners, wire, sand, snow, and dough and not mediums for sculpture.

It seems to me before the novice sculptor wanders off to work in some unconventional (or esoteric) material he should consider what will this new material contribute to his development as a sculptor. Will working this strange material help develop his sense of shape or form? With no disrespect intended towards those good sculptors who have succeeded in creating good sculpture shape in esoteric mediums, it has always seemed to me that using a peculiar material for sculpture (unless it serves an esthetic need) is something like making music under self-inflicted handicaps. It is something like playing a violin posed on one leg high upon a tightrope. If playing a fiddle up near the top of a circus tent adds something to the acoustics, or standing on one leg does something for the fiddler's pizzicato, there is reason in such a performance. If it adds nothing to his musical accomplishment, I would rather watch (and listen to) the performing seals.

There are sculptors working with the novel materials, but in the main the living sculptor works in the traditional materials that have been used by sculptors for thousands of years. And then, too, those sculptors who now work in less popular mediums did begin their development by working in traditional materials. After years—many years—of working with clay and stone or wood they took off and began their work with a less popular medium. What I have already said about granite

carving—that it is not for novices—I repeat here. The unconventional materials are not for the serious novice.

OUR CONTEMPORARY AMERICAN SCULPTURE

There has been a healthy upsurge in our contemporary American Sculpture in the past thirty years. The majority of our Active American sculptors are grouped together in a few major art societies. In New York City the two main sculpture societies are the Sculptors' Guild and the National Sculpture Society. These are not local societies. Their membership is nationwide and all schools of contemporary sculptural thought are represented. Both societies hold large sculpture exhibitions and with regularity publish very completely illustrated catalogues.

If my reader is concerned (and he should be) with American contemporary sculpture, let him write to the Sculptors' Guild or the National Sculpture Society for their catalogues. The cost is nominal and the catalogues are well worth your attention.

Our major American museums also hold many large sculpture exhibitions. They, too, publish catalogues and these catalogues are also available. The novice sculptor should attend all the sculpture exhibitions he possibly can. That way he will not only know what is being done in contemporary American sculpture, but it will help his own development.

WHAT OF PERSONAL STYLE? WHAT OF PRESERVING YOUR INDIVIDUALITY?

Personal style is the individualistic voice, the quality of an artist's work that differentiates that work from any other. Even in the olden

days when the traditions of an art epoch dictated the limitation of an artist's personal expression by setting up a prescribed style—even then, within those rigid limits, the strong individualistic artist found a freedom of expression and asserted his personality through his work.

Great art has many facets. It is composed of countless esthetic truths. An artist's personal style develops when he realizes that there are certain art facets he sees and feels clearer than all others. His style is his own emphasis on those esthetic truths he feels most strongly and he uses his medium to shout or whisper his concern with those truths. If his interpretation is deeply and honestly felt, his art mirrors his strong individuality. And that is the main quality; that is the voice that differentiates him from the babble around him. A mature artist spends his life struggling to realize and develop this differentiation. His is a continuous battle to preserve and give out through his individuality those esthetic truths strongly felt.

But his preservation of the individuality of the artist, this struggle to realize and express the inner emotions is not the concern of the novice! Before he tries to use his voice to assert himself he should know his own art alphabet. He should acquire his own art vocabulary or else he produces infantile chatter.

There are artists, natural born artists (genuine Primitives, we are told), who sometimes succeed. But the phenomena of the infant prodigy is rare among the sculptors. The techniques and esthetic logic of this art must be mastered. An infant prodigy may put some words together and we have a poet. Or he sings a few sounds (or learns to play the fiddle) and we have a musician. Or he may scribble a few lines and dab a bit of color. There we are told is a sensitive, precious draftsman or a brilliant, natural colorist—a painter! But sculp-

ture cannot be fumbled into existence. Poking a little clay about or scratching on the surface of a stone will not produce a great piece of sculpture.

Novices, now is the time to know your material. Study and try to understand the esthetic principles evident in all nature, in the great masters, and acquire your art alphabet and your art vocabulary. Listen to good music, contemporary or ancient, read the poets, read the philosophers. A sculptor must be a rounded individual. Such study will help you form your inner shape. If you are a sculptor—if yours is a contributing personality—your individual style will come through. In time you will begin to realize certain individual preferences, certain preferred shapes, certain preferred relationships. And you will develop preferences for tools, techniques, and materials that will help you to express your own concern with certain shapes and relationships. That will be your individuality as an artist asserting itself. From then on your battle begins, the battle to preserve these preferences. Until then prepare yourself for your emergence as a personality so that you can preserve your individuality as an artist.

Do not let yourself be caught in the rigid limitation of a personal style until you have reached some maturity—not until you feel within yourself a competence and an understanding of the esthetic principles and practice that make sculpture.

ARTISTIC TEMPERAMENT AND THE FIRES OF INSPIRATION?

The term "artistic temperament" has been talked about and misused to such an extent that it has become a synonym for charlatanism, an excuse for laziness and cheap license. Yet ar-

tistic temperament is an honest malady that occasionally afflicts the novice as well as the mature artist.

Of course, the temperament of sculptors is usually more controlled than that of a mezzo soprano. The operatic diva must be set to give out with her very best at 9:15 P.M. on some particular Tuesday in March. She might become jittery, nervous, and scared to death she will never reach the high C she has practiced for months in the aria *To a Hummingbird* or something similar. Therefore, there is an outburst of temper, bad manners, and violence that rocks the old opera house to its foundation —and it is called artistic temperament.

There are other manifestations of this malady. There are other forms it takes—a deep despondency, a feeling of hopelessness. A fit of artistic temperament may be brought on because of the innate honesty of the creative artist. The sincere effort to give fully in every work he creates often plagues the creative worker. In spite of using the finest material and tools, the best technique at his command, and all his esthetic logic, no artist can guarantee that his new work will come up to the standards of quality he has set for himself. On the contrary, it often happens that working under adverse conditions with bad materials, broken tools, and indifferent technique an artist has realized his most important work.

The qualities of even the great masters fluctuate, now reaching heights beyond any work they have ever created, then again sinking to more commonplace accomplishment.

Cézanne, the great painter, interpreted "temperament" as meaning the inner fire, the force that drives the artist to create and to realize in his medium his innermost emotions. His most severe criticism of any of his gifted contemporaries was to say that a particular artist lacked "temperament."

Cézanne was known to let out bursts of his own temperament by slashing his completed canvases to ribbons. I know a gifted sculptor who after three months' work on a granite carving smashed it to smithereens with a sledge.

The artistic temperament of sculptors as a general rule is of a cooler variety. The inner fires must burn steadily for years sometimes to carry out one sculpture idea.

Even though there is no way one can gauge the quality of one's output, I find when my work seems to swim along and I am full of elation at what seems to be my dexterity and brilliant esthetic conclusions, when I look back at my work on the following day—I find I have created nothing. More often when the work is going hard and I find myself struggling desperately for even a little quality, the work as I review it later seems to have advanced.

The novice may be plagued with temperament even as he studies. Be wary if your work seems easy. You may just be slick. And do not tear your hair if the work moves slowly and with difficulty. You may be accomplishing more than you can judge right now. If the work becomes unbearable, put it aside carefully and take a walk. Do not blame your poor materials, poor tools, lack of technique, or your dead fires of inspiration. (And that brings us neatly into a discussion on the Fires of Inspiration.)

Much has been said of inspiration, the most elusive of all the elements that go into making a work of art: An uninspired work of art, Sources of Inspiration in a work of art—Inspired Creative Effort, and so on.

But what is inspiration? Can this essential esthetic element be isolated and examined?

My contribution to that discussion is directed to the novice sculptor. Inspiration the

dictionary tells us is: 1. the act of drawing air into the lungs, 2. creative influence of genius, 3. elevating influence derived from association with great minds and scenery. . . .

There is not much help there. Yet these three interpretations may contribute something. Inspiration, as I understand it, in its relation to a work of art is the first spark that stirs an artistic conception into existence. Then through the chain of esthetic logic and technical execution a work of art is born.

But the novice sculptor must bank his fires of inspiration and store them up. There is so much esthetic logic and technical training that he needs. Yet he should not neglect acquiring as much material as possible that will serve as sources of inspiration. His training is directed towards the day when as a mature artist he can turn on the *tap of inspiration on demand!*

Consider that phrase "turn on the tap of inspiration on demand" and do not let it shock you. The world's greatest art was produced on demand and the world's greatest creative artists turned on their taps.

"Mr. Phidias," someone (it may have been Pericles) said one day, "go and feel like designing and creating a Parthenon for the next fifteen or twenty years."

Or someone else may have said, "Leonardo da Vinci, paint the Last Supper."

Both of these artists were commissioned (ordered) to create their great art and they did it. That is true of the major works of Michelangelo, Donatello, Fra Angelico, El Greco, and the rest of the great sculptors and painters of the Renaissance period (incidentally, Fra Angelico charged so much for one saint's head, so much for two, so much for a saint's panel with one hand showing and more for two, so much if he used cobalt blue . . . there is documentary proof of that). And great music and poetry was also created on demand. Beethoven's *Egmont Overture* was ordered. Handel was told to go and feel like creating (commissioned to compose) his great *Largo*. They were all trained artists and they had trained themselves to turn on the tap of inspiration on demand.

Of course these artists were free men (comparatively). They could have refused to work on demand but we are all very thankful they did not. But definitely the art produced in the earlier great art periods was produced on demand.

The greatest sculpture the world knows, the Egyptian, the Chinese, the early Greek, the Gothic, the Hindu, and all the others were inspired, composed, and executed on demand. Not only was that true but the subject, style, method, and material were prescribed. The Pharaohs, the Sphinxes, Buddhas, Greek Gods, Holy Trinity, Apostles and Prophets, the Vishnus were ordered—none of those sculptors could run their fingers through their hair and say, "No, today I don't feel inspired to do a Pharaoh, Sphinx . . . and so on."

In our own day these conditions do not exist. Yet the novice sculptor must train himself so that he can work as if they did. And he must pile up within himself sources of inspiration so that he, too, can turn on his tap of inspiration on demand. Exercise with esthetic problems demanding of yourself ideas and shapes which you must create in sculpture.

Where and what are the sources of inspiration for the sculptor?

They exist everywhere, in all of nature—sea shells, rocks, tree shapes, living creatures, and the great art produced by the masters.

Here is one final statement on inspiration. A long time ago an old sculptor said to me, "Wait on inspiration with a sculpture tool in your hand."

Think about that!

A GALLERY OF
GREAT SCULPTURE

ONE of the main purposes of this gallery is to direct the attention of the student to those periods and masters of sculpture which I believe will provide the healthiest influences for his development. This sculpture emphasizes and points up the principles and qualities that have already been discussed.

I am not overly concerned whether the novice sculptor will clearly understand or appreciate the following pictures I have chosen for this gallery. If he does not enjoy them now as I do, if he cannot see the fine esthetic logic of the sculpture pictured here, I believe he will some day.

The sculpture shown here is not presented chronologically, nor does it illustrate the interlocking chain of periods of culture or have any historical sequence. I have chosen a group of photographs of sculpture that I love each for its own sake and all because, for me at least, they embody the principles and qualities of all great sculpture.

Great sculpture, like all great art, has many facets. What seems strange in an ancient or contemporary art expression may be just another facet and another emphasis on either certain shapes, certain color qualities or one of the other esthetic or emotional elements that make up the many facets of all great art.

In my selection here I do not attempt to criticize or pass judgment on the work reproduced or mentioned. Nor do I comment on the periods, influences, or sources with the pretence of infringing on the domain of the art scholars, archeologists, historians, ethnologists, sociologists, and others who have given studied and considered opinions on these matters. My role here is mainly that of one of the grateful audience who has benefited by these works.

I comment only on what the work has meant to me and how it affects my thinking about sculpture, keeping in mind always the relation of such thinking to the development of the novice for whom this book is intended.

Some of these great works are reproduced only as a detail from some grand architectural scheme. Others are intimate, smaller units of sculpture that were as much a part of community life as the great architectural work. The bulk of this sculpture was carved and modeled by one of the world's most gifted and prolific family of artists—the anonymous family. These unknown artists have contributed more to the world's culture than any of the great publicized names. Anyone seriously concerned with creating sculpture may be consoled if he is destined to become a member of that great family. He will be in the very best of company.

Hercules. DETAIL FROM THE TEMPLE OF ZEUS AT OLYMPIA. 400 B.C., PARIAN MARBLE. LOUVRE.

Strength does not depend upon muscle nor nobility on stuffy gesture. Even though I have referred to the Parthenon repeatedly, that was because I thought the name Parthenon would be more familiar to the novice. I prefer the carving on the Zeus Temple to the work on the Parthenon. Familiarize yourself with these carvings. Reproductions are available in books and museums.

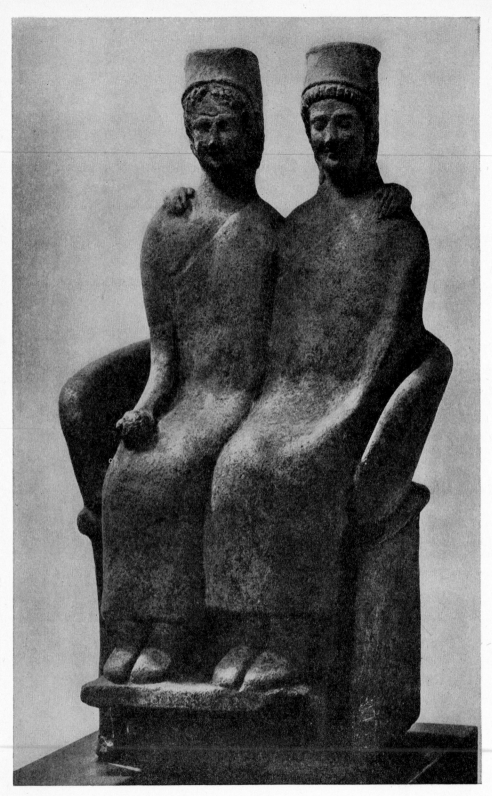

Funeral Group. SOUTH OF ITALY, TERRA COTTA. LOUVRE.

Modeling and casting small terra cottas painted with gay colors was a prosperous business for the sculptors who lived on the islands and peninsulas of the Mediterranean from the Sixth Century B.C. to the First Century A.D. The most famous of these were from the town of Tanagra. These figurines were dolls for children; also, they were buried with the dead to keep them company or to represent gods to give them divine guidance. This gracious pair from the south of Italy are very beautifully and simply shaped.

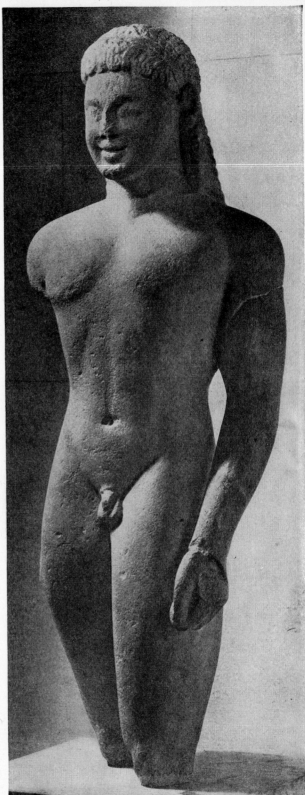

Archaic Apollo. SIXTH CENTURY B.C., MARBLE. LOUVRE.

Archaic Apollo. SIXTH CENTURY B.C. MARBLE, ISLAND OF PAROS. LOUVRE.

It was not until I saw the Archaic Greek such as these that I really enjoyed Greek sculpture. The softer, suave Greek figures that have had such great popularity never moved me as much as the work by their predecessors. Look at the work done by the Cretans, Mesopotamians, Etruscans, Archaic Greeks and know the great sculpture of these gifted peoples.

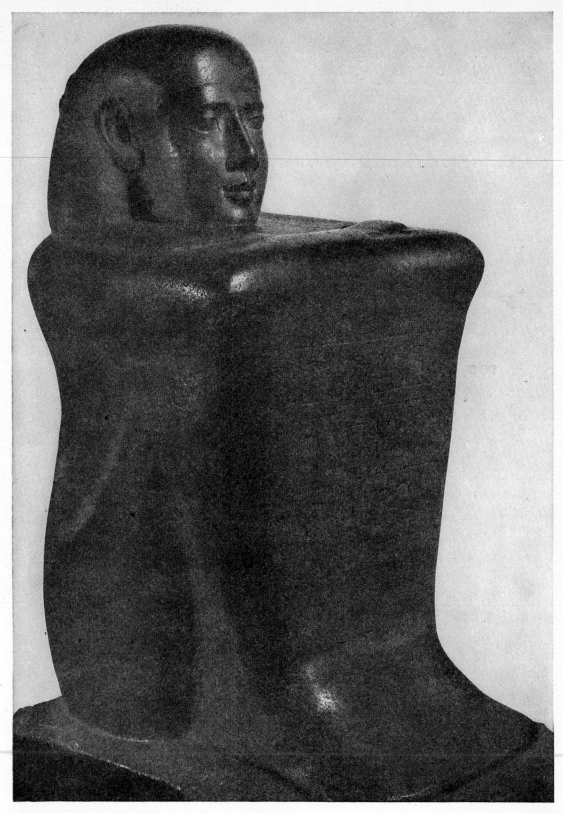

Block Statue. EGYPTIAN, SIXTH CENTURY B.C., GRANITE. LOUVRE.

The Egyptians were the giants of sculpture. No people have reached their heights before or since their great periods. Their sculpture seems to include all the possible facets of great art, and they worked all mediums of sculpture with equal dexterity.

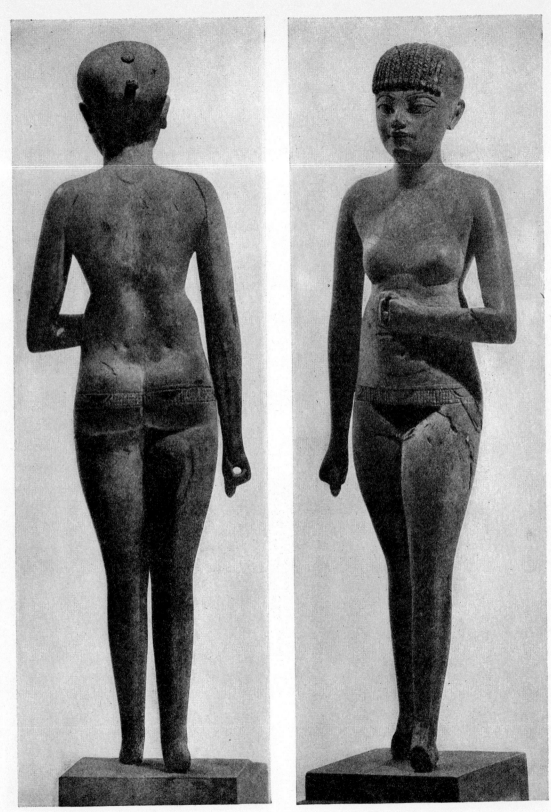

Nude Girl. NEW KINGDOM (1580-1090 B.C.), WOOD. LOUVRE.

Dignity, strength, unity, flow, economy of form are always present in Egyptian sculpture. Nor do they neglect tenderness or even charm. This little 8-inch wood figure is witness to that.

Cat. SAITE PERIOD (1090-342 B.C.), BRONZE. LOUVRE.

The cat was a sacred animal in Egypt. It was always represented in a thoughtful attitude. But so is all Egyptian sculpture. I cannot remember any work I have ever seen by Egyptians that had any attitude that could be considered gross or thoughtless.

Baboon. MIDDLE KINGDOM (2475-1580 B.C.), LIMESTONE. LOUVRE.

There is nothing to be said for this fellow that he does not say for himself.
This baboon shape includes all the great Egyptian qualities, and they have
endowed this usually ridiculous beast with immortality.

Servant Figure. SIXTH DYNASTY (2980-2475 B.C.), LIMESTONE. MUSEUM OF FINE ARTS, BOSTON.

Such little figures were carved and buried with the dead to serve them in the tomb.

Seated Female Figure. STONE. THE AMERICAN MUSEUM OF NATURAL HISTORY, NEW YORK.

This is not an Egyptian figure. I am certain that the Indian sculptor who
carved this work in Vera Cruz, Mexico, never saw Egypt or its sculpture.
Note the similarity of shapes, the rich, rounded arms and shoulders.

North Wei Maitreya. CHINESE. FIFTH CENTURY, STONE. MUSEUM OF FINE ARTS, BOSTON.

After looking at the Egyptians it is almost impossible to decide what sculpture can follow them without losing face. I believe this Chinese piece is so wisely wrought there is less danger for it than for any other piece in this collection. The novice might have difficulty seeing the quality in this Chinese stone and its appeal is difficult for me to explain. Look at it a while. I hope you can enjoy it as I do.

Head of a Divinity. INDIAN, CAMBODIAN. FOURTEENTH CENTURY, STONE. MUSEUM OF FINE ARTS, BOSTON.

This serene head has always been one of my favorites.

Female Polo Player. T'ANG DYNASTY, CHINESE POTTERY FIGURE.
MUSEUM OF FINE ARTS, BOSTON.

This might have been an American cowboy. The Chinese
pottery horses are wonderful beasts. Acquaint yourself with
these beauties.

Chinese Warrior. T'ANG DYNASTY, TERRA COTTA.
FROM THE COLLECTION OF COLONEL SAM BERGER.

This cheerful warrior does not seem very warlike. But he is
very beautiful. Such Chinese pottery figures were manufactured
in mass the same as the pottery figures created by the Mediter-
ranean people. They were usually painted.

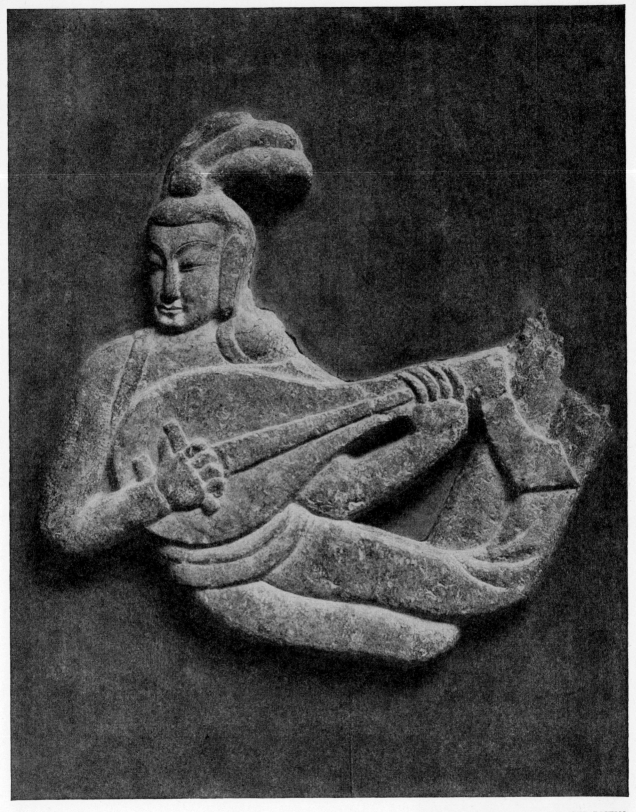

Apsaras. CHINESE, SIXTH CENTURY, LIMESTONE RELIEF. MUSEUM OF FINE ARTS, BOSTON.

Here is another piece that I will not try to explain. It just delights me.

Deity as High Priest. SOUTHERN INDIA, FIFTEENTH CENTURY, STONE. MUSEUM OF FINE ARTS, BOSTON.

The sculpture of India is lush and sensuous. The rich ornamentation they used was so incorporated into the sculpture shape it emphasized that lush quality. Do the same principles of sculpture prevail in this work as in the Egyptians? The answer is yes. The only difference is in the emphasis placed on certain art facets.

Indian Deity. SOUTHERN INDIA, SIXTEENTH CENTURY, COPPER. MUSEUM OF FINE ARTS, BOSTON.

This gay, perfectly balanced figure has obvious qualities. Anyone can
enjoy the fine full rhythm of its fat shapes.

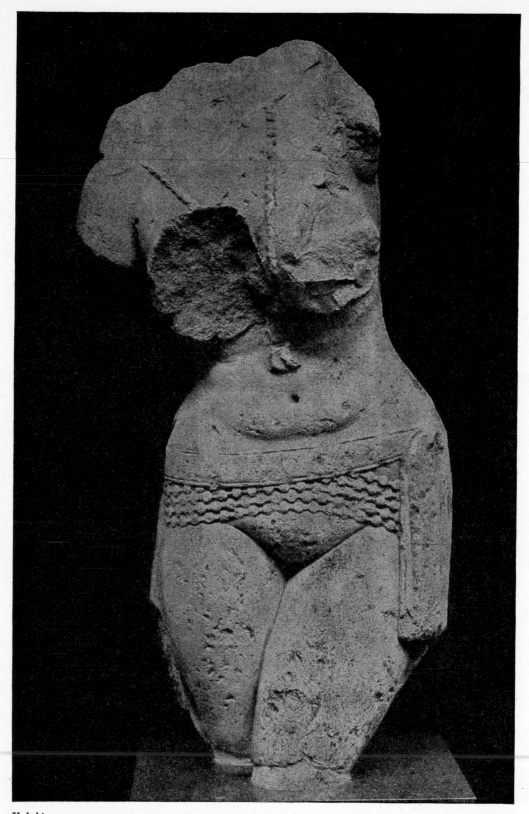

Yakshi, FRAGMENT. INDIAN, 100 B. C., STONE. MUSEUM OF FINE ARTS, BOSTON.

Some sculpture such as this piece is so battered that the observer must be able to overcome the repellent wounds before he can see the beauty of the work.

Torso. EARLY CAMBODIAN, SEVENTH CENTURY, STONE.
MUSEUM OF FINE ARTS, BOSTON.

This torso may have gained by having its arms broken off.
What could the arms have added to this fine shape?

Devi as Uma. SOUTHERN INDIA, FOURTEENTH CENTURY, COPPER.
MUSEUM OF FINE ARTS, BOSTON.

This mother goddess (Devi) represented here in her manifesta-
tion as "splendor" (Uma) is the epitome of the female prin-
ciple. Why is her arm so long? Perhaps for balance, or design.
A shorter arm might throw the over-all shape off balance.

Journey to Emmaus, DETAIL. SPANISH, TWELFTH CENTURY, STONE. S. DOMINGO DE SILOS, CLOISTER.

A Prophet. FROM THE CHARTRES CATHEDRAL, FRANCE, TWELFTH CENTURY, CAEN STONE.
COURTESY OF THE METROPOLITAN MUSEUM OF ART.

The sculptor who carved this piece into the Chartres Cathedral has stressed
the same qualities as that sculptor who carved the first Chinese piece in
this gallery. Here again is the bodiless body of a spiritual leader clothed
in exquisite drapery, on a severe fleshless core. The physical, the sensuous
are completely eradicated in this carving of a gentle old Prophet.

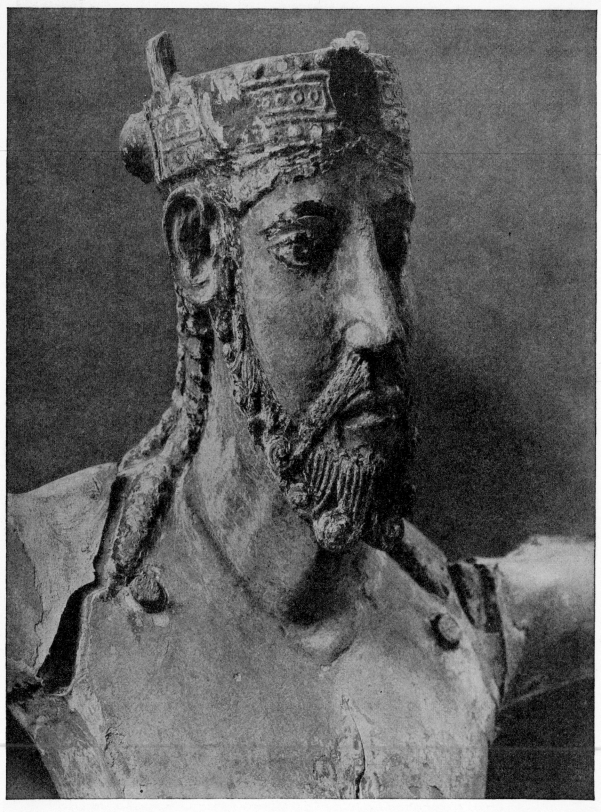

Crucifix, DETAIL. SPANISH-ROMANESQUE, 1150-1200. COURTESY OF THE METROPOLITAN MUSEUM OF ART.

This polychrome wood is one of the countless Christ interpretations created by the European sculptors during the period when all artists had to limit their source of subject matter to the Old or New Testament. In spite of that limitation this compassionate subject matter was interpreted as individualistic and varied as the thumbprint of the sculptor. The same emotion was expressed again and again with thousands of nuances.

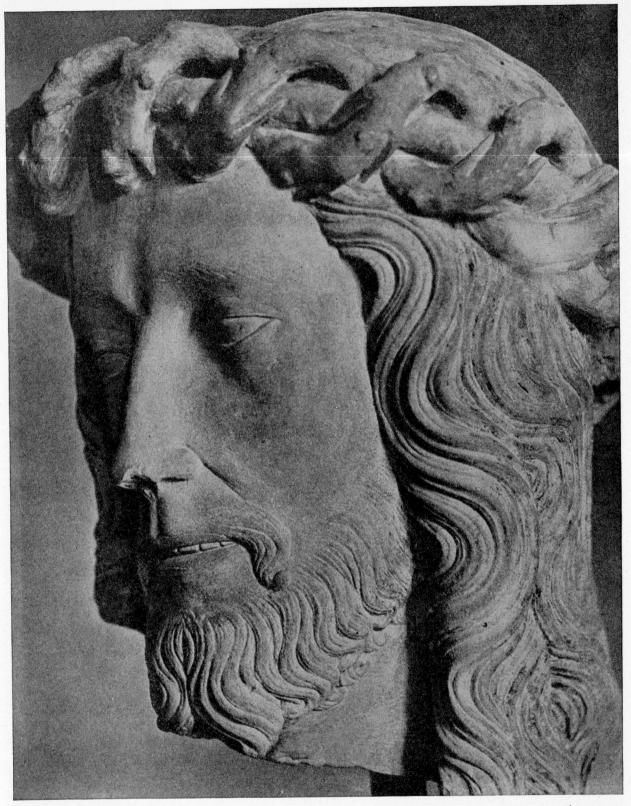

Head of Christ. FRENCH, LIMESTONE. COURTESY OF THE METROPOLITAN MUSEUM OF ART. PHOTOGRAPH BY ANDRÉ DE DIENES.

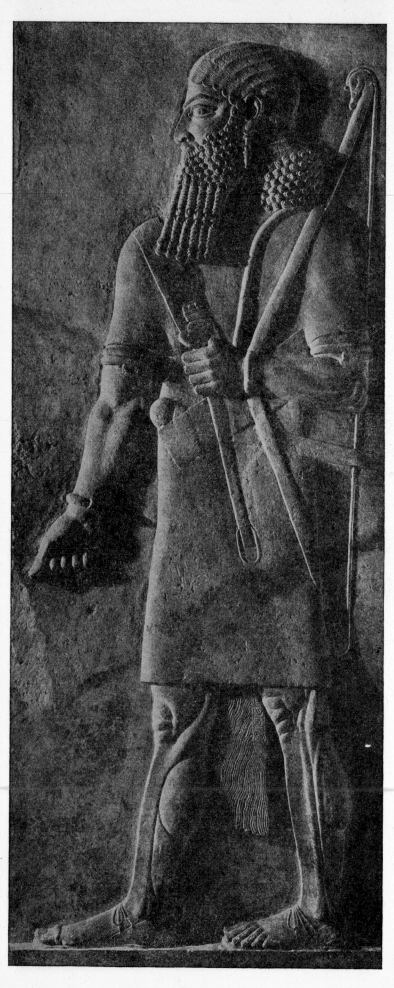

Warrior. ASSYRIAN, EIGHTH CENTURY B.C., ALABASTER.
LOUVRE.

This powerful sculpture from the series of reliefs on the Temple of Ashur-nasir-pal is in a fine state of preservation after 2,700 years, in spite of the fact that it was carved in soft alabaster. The inverted forms carved in the leg shapes are a new esthetic experience for the novice (assuming his sculpture experience has been limited to this book). Nowhere in my text have I discussed inverted or concave shape. Until a student is fully mature, he should concentrate on full convex forms.

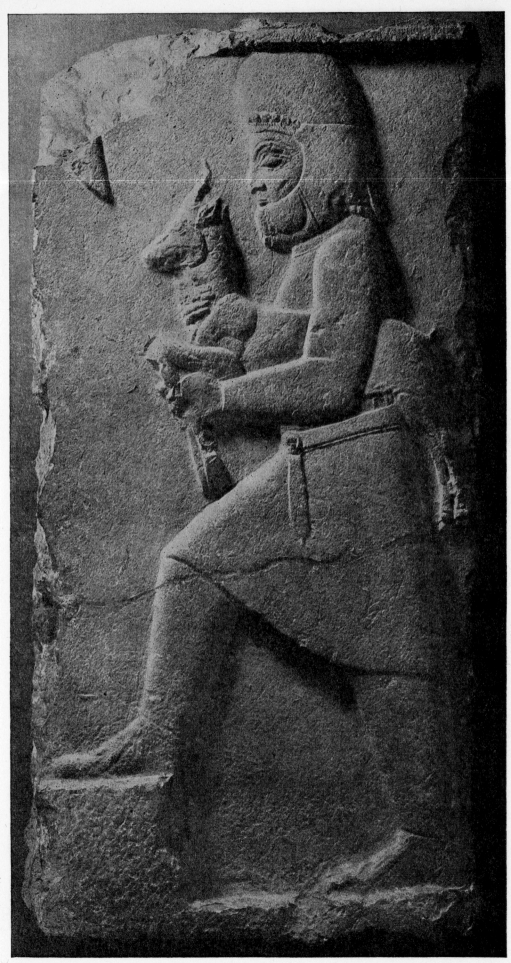

Kid-Bearer. PERSIAN, SIXTH CEN-
TURY B.C., HARD LIMESTONE. LOUVRE.

This servant tenderly carrying a
lamb embellishes a staircase wall.
It is one of a series of figures. The
shape is so simple, so direct, and
so easy—the fragment of a hand at
the kid's throat is an adequate ex-
planation for the whole arm that
is not there.

MICHELANGELO. *The Medicean Madonna.* MARBLE. SAN LORENZO, FLORENCE.

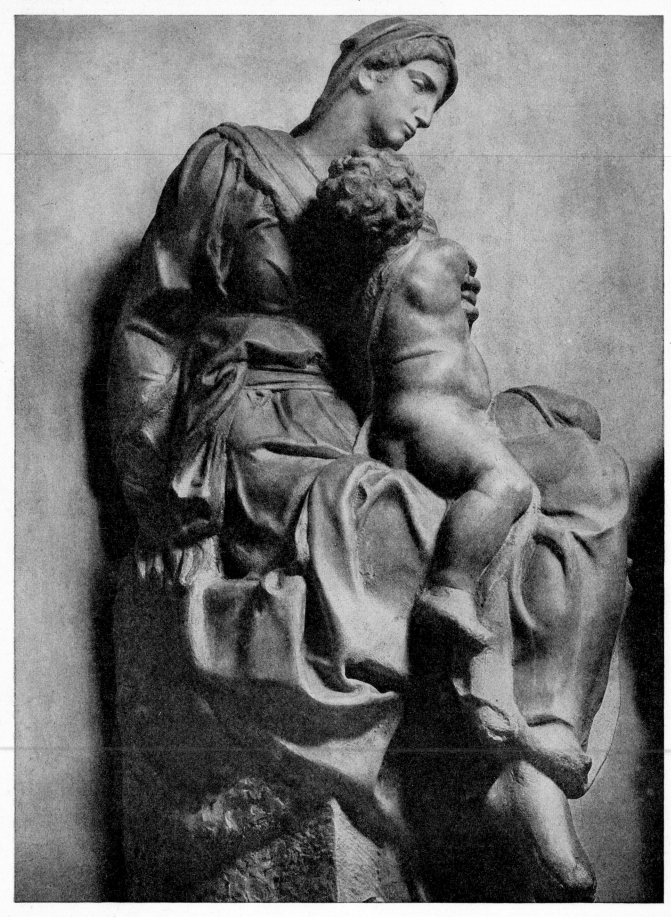

MICHELANGELO. *The Medicean Madonna.* MARBLE. SAN LORENZO, FLORENCE.

The name of Michelangelo has been the synonym for sculpture throughout our western culture for almost 500 years. His powerful individuality overshadows that of any sculptor since America was discovered. His ebullient shapes are so personal it is difficult to believe he too was influenced in his formative years. Yet the masters (Greeks and Romans) and his own immediate predecessors Jacopo della Quercia and Nicola Pisano, and to some degree Donatello, helped form his ideas about sculpture. Motives for shape in some of Michelangelo's great works can be traced directly to the influence of his first teacher, the painter Ghirlandaio. Michelangelo left few modeled works. His work was mainly in Carrara marble. His carving technique developed early and was flawless from the beginning. But this mature work left in what might have been an unfinished stage expresses the best of his accomplishment.

MICHELANGELO. BROKEN SKETCH IN TERRA COTTA FOR THE MEDICEAN MADONNA. BUONARROTI GALLERY, FLORENCE.

MICHELANGELO (1475-1564). *Captive.* MARBLE. THE ACCADEMIA, FLORENCE.

[235]

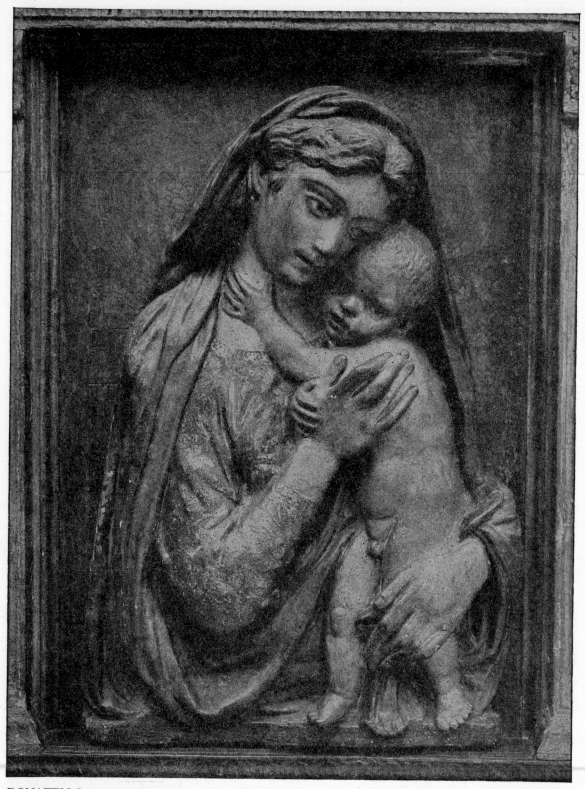

DONATELLO (1386?-1466). *Madonna and Child*. COURTESY OF THE METROPOLITAN MUSEUM OF ART.

Were I allowed to pick the sculptor who, by his work showed the highest
attainment and esthetic logic in all branches of sculpture, my choice (in
spite of my great admiration for Michelangelo) would be Donatello. He
worked in all mediums with equal success, tackled confidently a great
assortment of sculptural problems and solved them beautifully. And he was
capable of producing fulsome, strong shapes as well as an almost tense
economy of form. There is no sculptor in the whole sphere of western
culture for the past 500 years who can give more rewarding study to the
serious sculpture student.

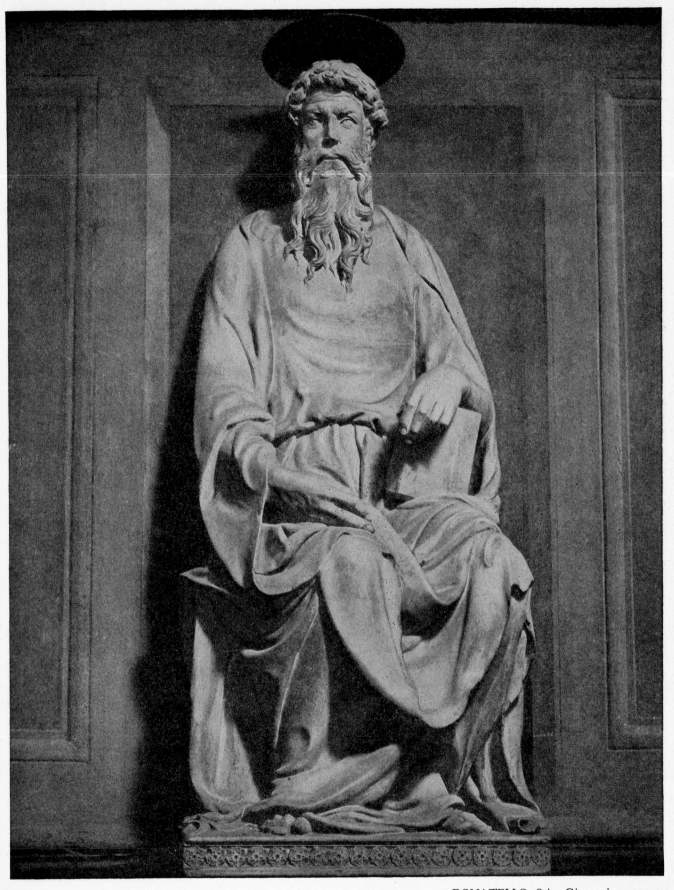

DONATELLO. *Saint Giovanni.* FLORENCE.

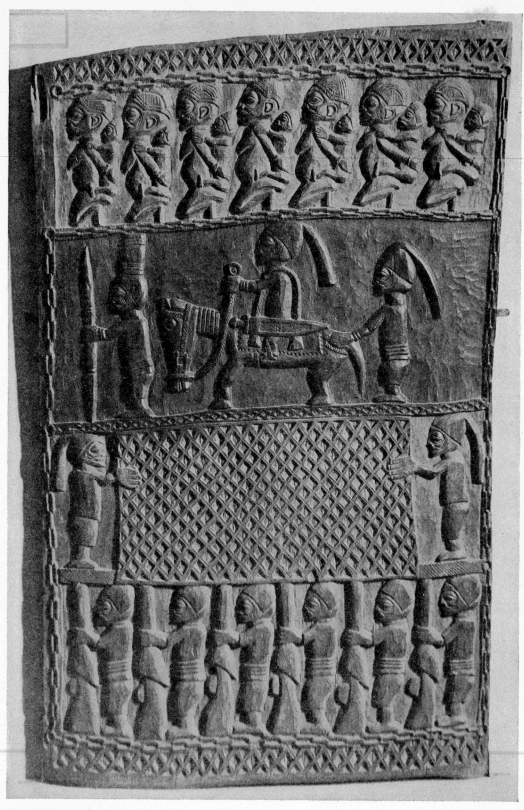

Carved Wood Door FROM NIGERIA, AFRICA. COURTESY OF BROOKLYN MUSEUM.

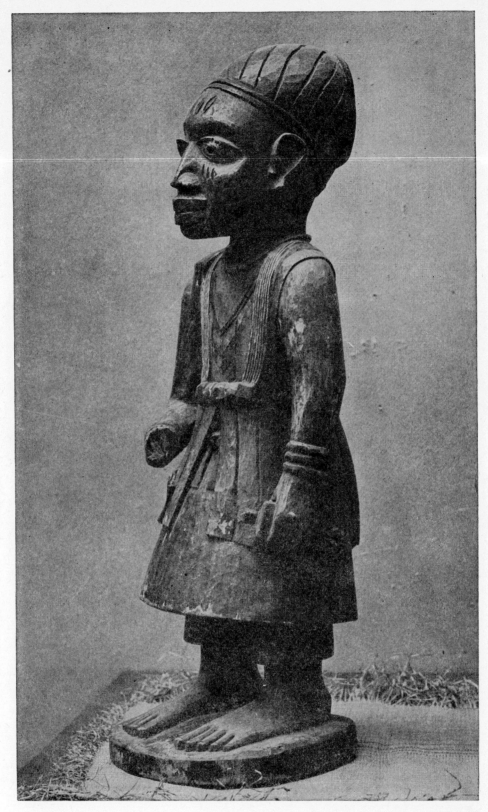

Wood Fetish. AFRICAN SCULPTURE. YORUBA, BELGIAN CONGO. COURTESY OF BROOKLYN MUSEUM.

Here is the strongly individualistic sculpture of the Africans. African
sculpture has had a great influence on many of our contemporary works.
A study of this work may help one to understand the sources of much
of our contemporary sculpture.

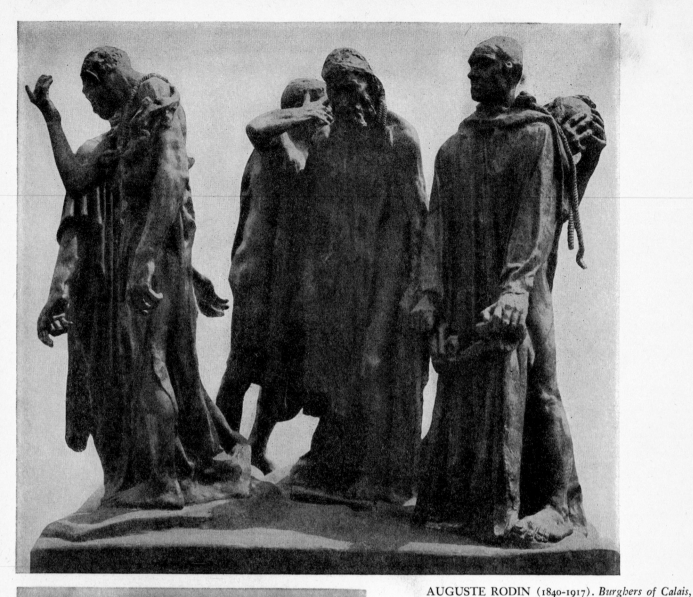

AUGUSTE RODIN (1840-1917). *Burghers of Calais,*
BRONZE. PHILADELPHIA MUSEUM OF ART.

RODIN. *Portrait of the Sculptor's Father,* BRONZE, 1860.

The stress and fight to preserve the individuality of the artist
after the middle of the last century was led by Auguste Rodin.
This very plastic bronze shows that he would not even permit
his plaster caster to tamper with the surface of a cast. This
fight to preserve the intimacy of the artist's precious touch was
sometimes carried to extremes. But Rodin was a great sculptor
and influenced some of the most important artists who followed
him. Maillol, Despiau, Bourdelle had worked in his studio.
Their work shows his influence. Lehmbruck, that great indi-
vidual, was also affected by Rodin.

Much of his larger work was inspired by Michelangelo. As
far as I am concerned, his most important work is not domi-
nated by that influence. This monument, the *Burghers of Calais,*
is rendered in such fluent bronze forms that they are truly
amazing. I have seen the *Burghers of Calais* exhibited out in the
open in a Philadelphia park. They are a wonderful monument.

CONSTANTIN BRANCUSI (1876-). *The New Born*. 1915, BRONZE. COLLECTION MUSEUM OF MODERN ART. PHOTOGRAPH BY SOICHI SUNAMI.

Brancusi is perhaps the most important influence in this century, not only for sculpture but for architecture, painting, and industrial design. No one succeeds in imitating him directly but his philosophy of simplifying a shape to its very essence has affected all our contemporary thought on shape. He is a sculptor's sculptor. This *New Born* bronze may be explained thus to anyone who resists it: Here is the egg or the embryo beginning to break up and stir. It stops being a perfect egg shape and stirs into life. It flattens out at one side and seems to open up like a baby crying to be fed. That is not the esthetic reason for this work. It is an interpretation, a defense, an answer to one who asks, Let him make shapes, any kind of shapes, but why give them a name? Brancusi works in all mediums with equal success.

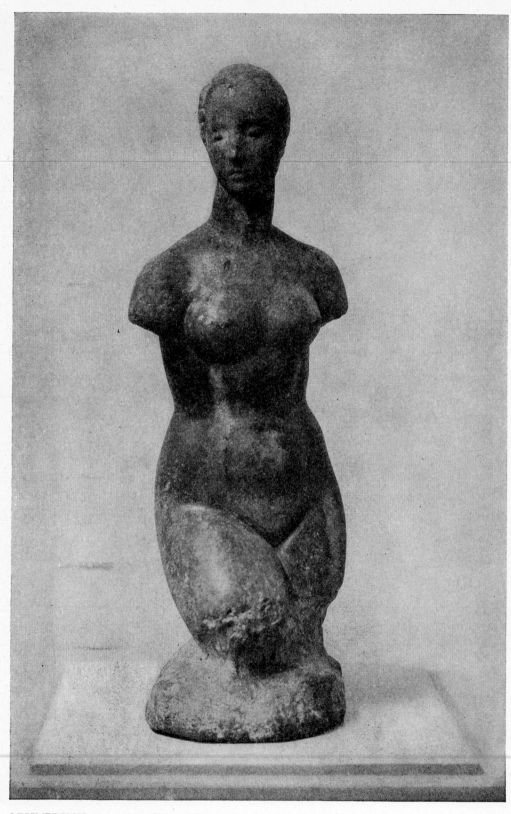

LEHMBRUCK. *Torso of a Young Woman*. TERRA COTTA.
COLLECTION MUSEUM OF MODERN ART. PHOTOGRAPH BY PETER A. JULEY.

In this full-flowing Lehmbruck, the plinth is as rich a form as exists through the whole torso.

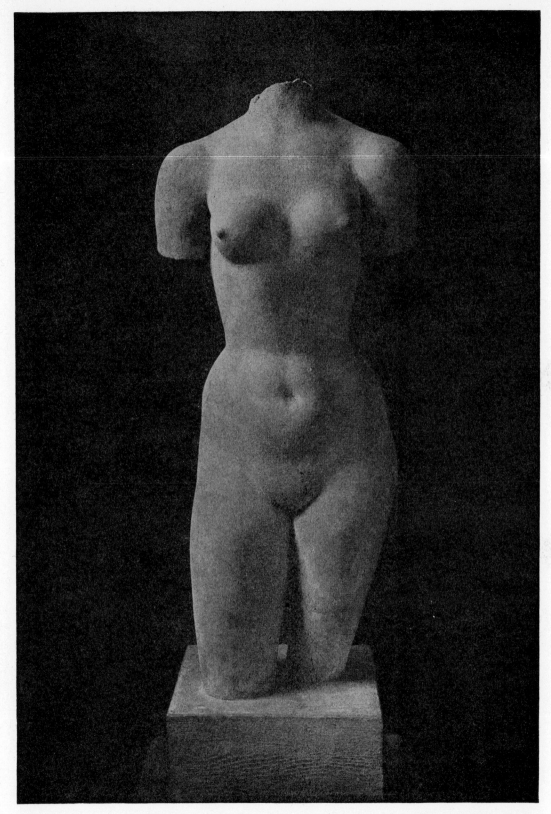

WILHELM LEHMBRUCK (1881-1919). *Torso of a Woman.* ARTIFICIAL STONE.
SMITH COLLEGE MUSEUM OF ART, NORTHAMPTON, MASS.

Having gone this far, it seems to me the novice can readily see the sensitive beauty of Lehmbruck. Since Rodin, no sculptor has been so warmly human. There is not much anyone can say about Lehmbruck's work. You love him or you don't. And if you do not, you miss something very important.

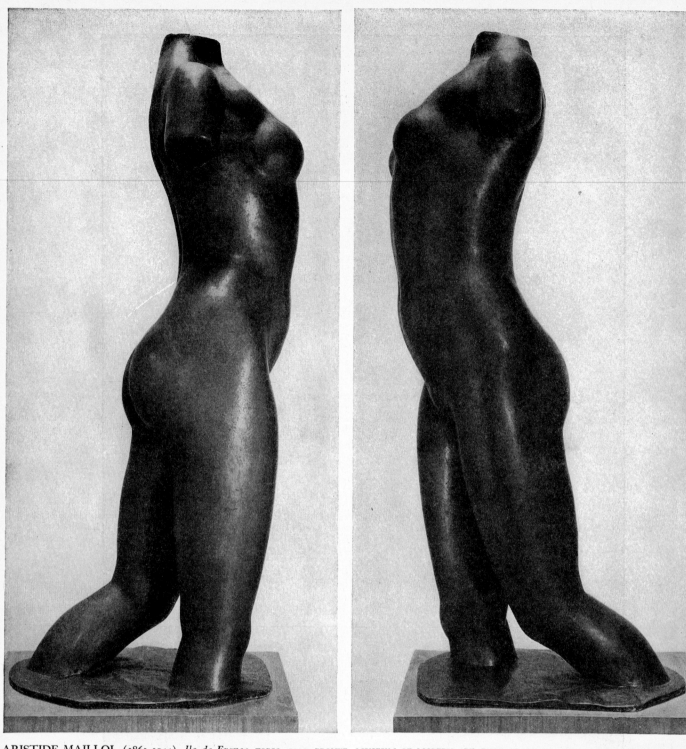

ARISTIDE MAILLOL (1861-1944). *Ile de France*, TORSO. 1910, BRONZE. MUSEUM OF MODERN ART. PHOTOGRAPH BY SOICHI SUNAMI.

The beauty of Maillol is obvious. Led by Rodin he found sources in the Greeks but he created plastic shapes as individual as any that ever existed. It has been said he had worked as a stone carver for Rodin. But his own work has been executed in clay for bronze and terra cotta. Occasionally wood and occasionally stone. His bronze and terra cotta are most successful.

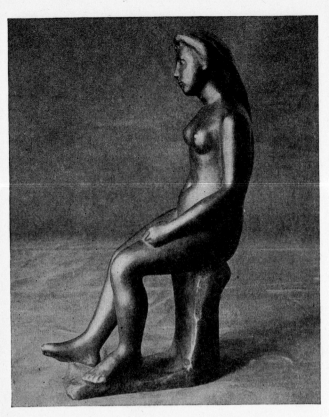

MAILLOL. *Seated Nude*. BRONZE. WEYHE GALLERY, NEW YORK.
This tiny bronze is a good example of Maillol's idea of a
figure's structural core. It is a very individual concept.

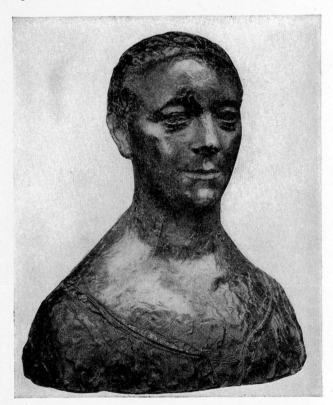

C. DESPIAU (1874-1946). *Portrait Head*. BRONZE. COLLECTION
MUSEUM OF MODERN ART. PHOTOGRAPH BY WILLIAM SMEDLEY.
Despiau seems to have been influenced mainly by the heads
of the Chartres Cathedral figures. Portraiture was his forte,
and bronze his medium. He created some figures and worked
in stone, but his importance has centered in his sensitive
portraits.

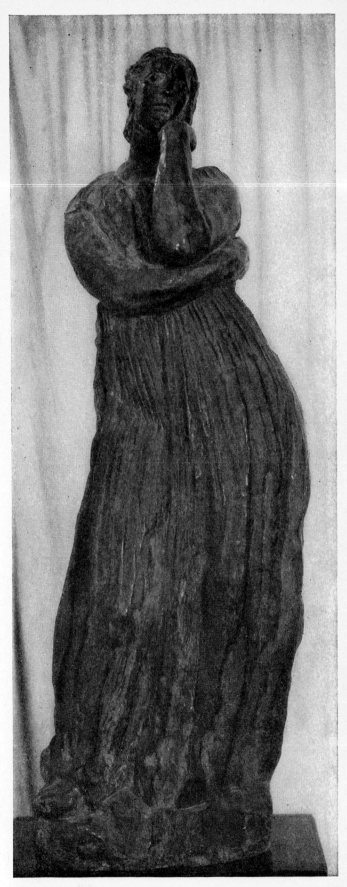

EMILE ANTOINE BOURDELLE (1861-1929). *Penelope*. BRONZE.
PHOTOGRAPH BY PERCY RAINFORD.

Bourdelle's dramatic architectural sculpture is most successful. His
massive plastic shapes are evident even here in this comparatively
small bronze.

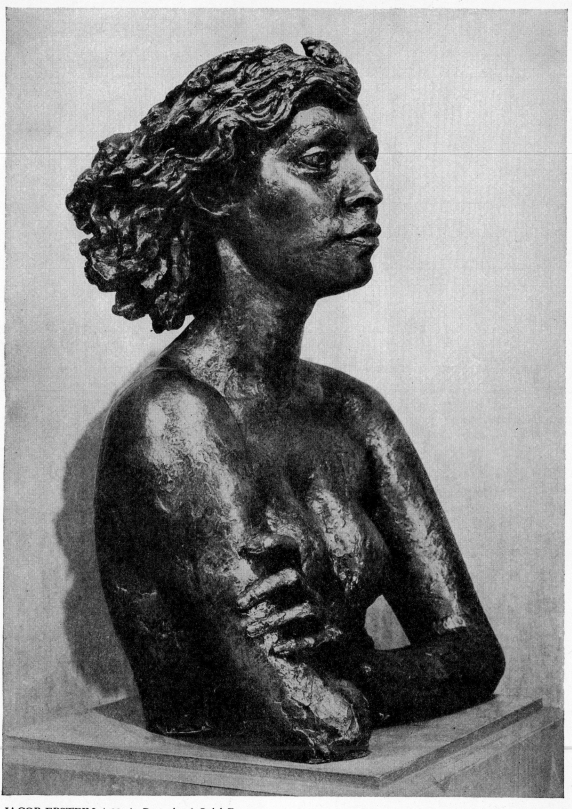

JACOB EPSTEIN (1880-). *Portrait of Oriel Ross.* 1931, BRONZE. COLLECTION MUSEUM OF MODERN ART.

PHOTOGRAPH BY SOICHI SUNAMI.

There is a disturbing plastic turbulence to the work of Epstein. There is fire in everything he touches. He has shown an equal brilliance in all phases of sculpture from monumental architectural work to intimate portraits of children, and he has worked in all mediums. Throughout his work there is tremendous humanity.

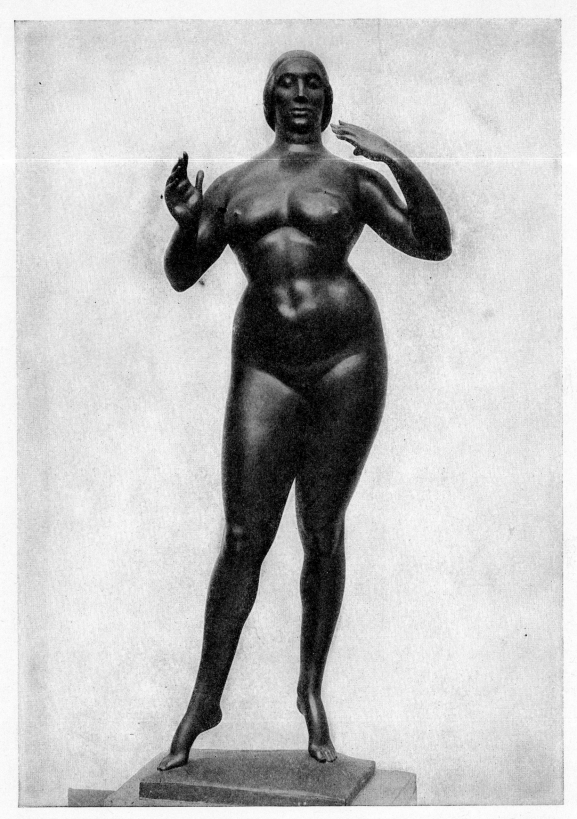

GASTON LACHAISE (1882-1935). *Standing Woman.* BRONZE. COLLECTION WHITNEY MUSEUM OF AMERICAN ART. NEW YORK. PHOTOGRAPH BY JOHN D. SCHIFF.

The lush powerful sculpture of Lachaise has held its own with any sculpture created in our generation. His work has been mainly in bronze. But he has shown equal competence in all other mediums of sculpture. It is unfortunate that this great American sculptor died before he had expressed himself in some major architectural sculpture creation.

Here are a few fine pieces of sculpture. Can you place them? Are they the most recent experiment in modern art forms? No. All three are in the Louvre. They are thousands of years old and were not created in the last few years by Picasso or some other contemporary master.

Figures A and B are playful girls from Boeotia in the Mediterranean. Figure C is a marble head belonging to a primitive image from the island of Amorgos.

New ideas in art are old and old ideas are new. When looking at sculpture relax. Don't fight it. It will not attack you. If you have looked at the work with an open mind, and it has given you nothing, just turn and walk away from it. It cannot ambulate. It will not follow you, or maybe it will in your mind's eye. Keep your mind open.

A

B

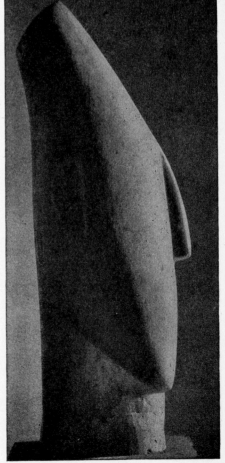

C

LIST OF ILLUSTRATIONS

All photographs of work in process, demonstrations, sculpture tools and equipment (unless otherwise noted) were made by SAM SANDROF.

INDEX

[253]